The Culture Business

This book presents new theoretical and empirical data on the organization of firms whose main business is the selling of aesthetic experiences.

The ephemeral nature of the aesthetic experience causes considerable uncertainty about the commercial reception of cultural products. Dealing with this uncertainty in the market is one of the most challenging tasks for managers in the culture business. By searching for similarities between different businesses the book aims to provide future managers in the arts world with the tools to deal with the special organizational and managerial problems they will encounter.

The Culture Business is a reflection of the growing awareness in the business world that managing culture requires a different frame of reference from that of other areas of industry.

Dag Björkegren is Associate Professor in Organization and Management Theory at the Stockholm School of Economics, Sweden.

The Culture Business

Management Strategies for the Arts-related Business

Dag Björkegren

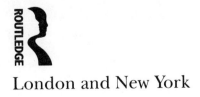

London and New York

First published 1996
by Routledge
11 New Fetter Lane, London EC4P 4EE

Simultaneously published in the USA and Canada
by Routledge
29 West 35th Street, New York, NY 10001

© 1996 Dag Björkegren

Typeset in Baskerville by
Ponting–Green Publishing Services, Chesham, Bucks
Printed and bound in Great Britain by
T J Press Ltd, Padstow, Cornwall

British Library Cataloguing in Publication Data
A catalogue record for this book is available from the
British Library

Library of Congress Cataloging in Publication Data
A catalogue record for this book has been requested

ISBN 0–415–12234–1 (hbk)
ISBN 0–415–12235–x (pbk)

Contents

Acknowledgements

The initial inspiration for this book came to me during my year as a visiting scholar at Harvard University in 1983–4. I began to notice there that culture, especially popular culture, seemed to be integrated into society in a way I was not accustomed to in Europe. Graffiti artists like Keith Haring and Jean-Michel Basquiat drew cultural attention to themselves both as artists and media personalities. Action films were reviewed alongside arty films, and trashy novels alongside serious literature. New TV shows received just as much attention as avant-garde art exhibitions. At the venerable Harvard Business School TV serials and Hollywood films were used as teaching tools. Could this situation be the result of the activities of arts-related businesses?

This book represents an attempt to describe how such organizations function – hitherto a little-explored area in the study of organizations. I make no claim to be providing a full-blown study of the production and distribution of cultural commodities, but simply to offer the reader an introduction to a potential new field of research.

The book grew out of a research project in the Department for Management and Organization at the Economic Research Institute of the Stockholm School of Economics. Thematically it is a part of a larger research programme in this department which is addressing the area of arts and media management.

The book is of course partly the result of my own interest in the production and distribution of culture. But it also owes a great deal to the efforts of others. Among many others, I am greatly indebted to Eric Abrahamson, Gunnar Alhström, Mats Alvesson, Chris Argyris, P-O. Berg, Pippa Carter, Bob Cooper,

Barbara Czarniawska-Joerges, Jane Dutton, Lars Fredriksson, Jack Gabarro, Henrik Gahmberg, Dennis Gioia, Pierre Guillet de Monthoux, Claes Gustafsson, Carl Hamilton, Staffan Hultén, Norman Jackson, Manfred Kets de Vries, Theresa K. Lant, Hugo Letich, Björn Linnell, Steve Linstead, Frances Milliken, Charles Perrow, Lance Sandelands, Vijay Sathe, Don Schön, Sven-Erik Sjöstrand, William H. Starbuck, Emma Stenström, Birgitta Södergren and Anna Wahl. A special word of appreciation goes to Nancy Adler for helping me come to terms with certain linguistic failings in my first English text.

The Swedish Council for Research in the Humanities and Social Sciences has provided financial support for the project. The Board of the Stockholm School of Economics has generously contributed funds for the travelling that was necessary in connection with the project. I am especially grateful for the time I spent as a visiting scholar at New York University during the spring of 1989, which gave me the opportunity to experience the very intense cultural and intellectual life of New York at first hand.

This book was originally published in a Swedish version under the title *Kultur och Ekonomi* with Carlsson Bokförlag in Stockholm in 1992. The book's excursus has appeared in a slightly different English version in Parker, M. and Hassard, J. (eds) *Organisations and Postmodernity* published by Sage in London in 1993.

My thanks to all!

<div align="right">

Dag Björkegren
Stockholm 1995

</div>

Chapter 1

Introduction

> They come streaming out of the best universities, from Wall Street, from business school and law school. Through hard work, sometimes even inspiration, but mostly a canny knowledge of the insiders' game, they discover, refine and fight over the ideas that shape the public discourse. They are among the most powerful young people in the country, and they take what they do very seriously. They make movies like *Three Men and a Little Lady*.
>
> (Dana, 1991, p. 82)

This quotation comes from the February 1991 issue of the business and fashion magazine *Manhattan-inc*. It is just one expression of the growing economic importance of the culture industries.

The significance of organizations in the technological and social transformation of society is not in dispute. Nor is the importance of their role in the creation and dissemination of new cultural manifestations. In the United States, for example, cultural products such as bestsellers, popular music, Hollywood films and television programmes are at present the country's second-largest export (Kent, 1991). Italy's fashion industry has in recent years grown bigger than its car industry (Coleridge, 1988). During the 1980s the invention of the compact disc and the videotape led to a technical revolution in the music industry, reversing the economic slump which had hit it in 1979 (Eliot, 1989). The production of culture, and especially popular culture, has become an international multi-billion-dollar business. Before the industrial revolution, the consumption of culture was mainly an upper-class activity, but with the growing

general economic welfare created by the industrialized society this kind of consumption became available to all classes, helped along by technological innovations which enabled the mass production and distribution of cultural commodities.

Up to now it has been the cultural products themselves and their aesthetic status and moral desirability that have attracted the most notice. The activities of the culture industries associated with them have received less attention. The present book takes a tentative step towards charting this rather unexplored field in the study of organizations. Traditionally, organization and management theory have been mainly concerned with the activities of industrial companies, despite a little more interest lately in the doings of the service sector and of knowledge-intensive firms. But while industrial companies sell physical products, service firms sell services and knowledge-intensive firms sell knowledge, we could say that the firms which produce cultural commodities are primarily in the business of selling aesthetic experiences. To make money from the production and distribution of such experiences requires certain managerial skills, just as the production and distribution of physical products, services or knowledge make their own specific demands on management's capabilities. Aesthetic experience is a much more ephemeral commodity than, say, detergents or cars, and this creates considerable uncertainty about the commercial reception of cultural products. Dealing with this uncertainty in the market is one of the most challenging tasks for managements in the culture business.

This book is thus an example of differentiated rather than general organization and management theory. The second of these involves the search for similarities between different businesses, with a view to developing universally applicable and non-firm-specific theories. The feasibility and fruitfulness of such all-embracing theories have recently been questioned by the proponents of postmodern organization and management theory, and the need for more situation-specific and firm-adjusted theories has been emphasized (Berg, 1989). In the field of institutional theory, for example, scholars have long been calling for a multirational organization and management theory, allowing for the effect on the way a business is run of other rationalities apart from the purely commercial (Sjöstrand,

1985; Perrow, 1986; Etzioni, 1988). In arts-related businesses, for instance, the conduct of business is subject to a commercial *and* a cultural/artistic rationality. Not even traditional manufacturing industries are governed solely by a commercial rationality, but are affected also by other kinds such as a technical-engineering rationality and even an aesthetic one in the shape of industrial design.

In line with this differentiated and multirational view of organization and management I will seek to identify and examine what appears particularly characteristic of arts-related businesses, and from these characteristics will try to formulate an organization and management theory especially appropriate to the organization and management of just such ventures. In doing so I do not presuppose the existence of any 'best' way to organize and manage a business. Rather, I recognize that there are various ways of running businesses, each with its own advantages and disadvantages.

The focus here will be on the industrialized production of arts-related commodities in Western societies. For illustrations of this kind of cultural production I have looked chiefly at the activities of publishing houses and record and film companies. I have taken my data mainly from existing literature about the functioning of these culture industries, but have paid special attention to the production of popular culture, which dominates the activities of record and film companies in particular. The concept of culture is used here primarily in its older sense of the 'best' that mankind has accomplished in various fields and that is manifest mainly in the arts. Cultural products are seen as artefacts or phenomena whose main function is to be the object of aesthetic contemplation.

OUTLINE OF THE BOOK

The business of an arts-related organization is multirational in the sense that it is governed by aesthetic as well as commercial considerations. To acquire a deeper understanding of the workings of such organizations, we thus have to turn to aesthetic as well as economic theories. Chapter 2 examines the emergence and development of aesthetic theory in Western society. The focus is on theories that are particularly concerned with the production and consumption of cultural commodities.

The commercial considerations that are associated with arts-related businesses are discussed in Chapter 3. A theoretical framework is formulated for analysing the processes of arts production in managerial terms. Two business strategies for arts production are identified. The strategies are multirational in the sense that they take into account the commercial as well as the cultural considerations that characterize the business of an arts-related organization. The application of these strategies in the production and distribution of literature, music and films is described in detail in Chapters 4, 5 and 6, and the way in which the management of artistic innovations actually works is also discussed. As we all recognize, the production of cultural commodities is inherently innovative in character, with the expectation that every product should be unique. The latest hit record may be a marvel of musical triviality, but the technical and social production processes necessary to create it are not as simple as this might imply. The importance of technical innovation in the arts production is emphasized, since the culture industries have been able to exploit new technology more efficiently than many other industries have done (Hutter, 1991). The theories outlined in Chapter 2 are used to show how the aesthetic development in each cultural form (literature, music and film) is linked to the particular industry's economic and technological development. The focus in these chapters is on the production aspect. How the consumption of culture affects the activities of arts-related businesses is discussed separately in Chapter 7, which concludes with a summary of the observations and conclusions reached, and some suggestions for the possible direction of further investigations.

The relation between art and science is examined in an epistemological excursus, and I note some lessons which organization and management theory could perhaps learn from the experiences of the culture business.

The primary goal of the book is to orientate the reader theoretically and empirically in a new and potentially exciting field of research, namely the organization and management of arts-related businesses.

Chapter 2

The aesthetic dimension

The production of cultural commodities has thus become an international multi-billion-dollar industry. In this chapter I shall try to describe very briefly the development of aesthetic theory in Western society, and to look at the way this has been influenced by, and has contributed to, the increasing level of arts production in that society. Since the production of popular culture predominates today, I shall pay particular attention to the aesthetic reception that the products of this culture have received. The description makes no claims to be exhaustive. On the contrary, I have limited its focus to certain aesthetic theories which are concerned primarily with the relation between art, society and commerce.

HISTORY

The word *aesthetics* derives from the Greek *aesthesis*, a perceiving of the external world by the senses. *Aesthetics* as a branch of knowledge is concerned with the study of the arts, of their differences and similarities, of the conditions under which art is created and of the criteria whereby manifestations of the arts are judged to be good or bad (Brunius, 1986). An aesthetic object can perhaps be defined as an artefact whose main purpose is to be an object of contemplation. If a wine-rack is redefined as an aesthetic object, its function is no longer to store wine; it is to be an object of contemplation. Aesthetic contemplation involves the concentrated observation of a certain object or phenomenon and its characteristics; furthermore, at the time, the observation of the object is more important than any impact the act of observing may have on

subsequent action (Berefelt, 1977). According to Brunius (1986) and Becker (1982) anything can be art, but what is actually perceived and defined as art is restricted by the prevailing conventions in the field.

Systematic thinking about the arts is first known to us from around 400 BC, in the writings of Plato and Aristotle (Ödeen, 1988). The oldest known conceptions of the arts are associated with notions of inspiration and ecstasy. Such emotional states were thought to stem from contact with the gods, a condition that could be achieved by the intake of various drugs; the artist was an intermediary for the gods. In ancient Greece a group of professionals known as rhapsodes specialized in reciting the poems of Homer under divine inspiration. In the *Ion* Plato lets Socrates criticize the rhapsode Ion for being a mere mouthpiece of the gods, possessing no skills or knowledge of his own.

In the *Republic* Plato introduces his concept of art – especially visual art – as mimesis, and elaborates too on the poet's mission in the ideal state. Mimesis refers, very roughly, to the imitation of nature, and Plato uses it to explicate the relation between art and reality. He illustrates this by reference to the representation of a sofa. The Idea of a sofa is the sofa's ideal or true form, which is common to and exists in all sofas. Below the Idea of the sofa comes the carpenter's sofa in the material world, which imitates the Idea. Lowest down and furthest from the ideal form is the artist's painting of a sofa, which is but a distorted picture of an imitation of the Idea of a sofa. Such imperfect images of imitations were forbidden in Plato's republic, where poets too were gently but firmly shown the door. Such art as could be allowed was the kind that praised desirable ideals and fostered moral character – that is, art with a political value. Artistic knowledge was inferior knowledge. A carpenter who knew how to make sofas was better equipped to have an opinion about sofas than an artist who only painted pictures of them.

Aristotle, who was Plato's pupil, adopted a more benevolent attitude to such matters and tried to study the arts on their own merits. He argued that the imitation of nature need not merely mean making imperfect images of ideal forms. Rather, works of art could represent a first step towards knowledge of nature. Aristotle also turned his attention to rhetoric, the art of eloquence, which is concerned with audience reactions to artistic performance and ways of influencing audiences in a

desired direction. This concentration on audience reception, and the practical and technical means of affecting it, enjoyed considerable predominance during the Middle Ages, particularly of course in the frankly didactic art of the Church. But as far back as classical times Horace had claimed – in gentler mode – that the poet's mission was to entertain his audience, and had made recommendations about suitable subjects and appropriate compositions and styles for artistic performances. This approach to artistic performance has much in common with that of the rhapsode Ion, who may not have had much factual knowledge about the texts he recited, but who definitely knew a good deal about how to influence an audience. Even if he was only a mouthpiece for the gods, he was a very active mouthpiece, fully capable of adjusting his recitals to the audience at hand, and exploiting its reactions to achieve the effects desired.

Two of the strands we have been following in historical thinking about the arts – the interest in audience response and the practical/technical means for achieving it, and the conception of art as mimesis – remained dominant until the end of the eighteenth century, which saw the reappearance in a new guise of the inspirational strand. Art theories concerned with expression appeared as part of the Romantic movement. The artist was regarded as a divinely gifted being, an intermediary purveying truths about nature in a state of ecstasy. The philosopher Kant amplified this esoteric and transcendental conception with his speculations about the 'thing in itself' and the notion of the artist as the mediator of the essence of things. The idea of mimesis now had less to offer, since the Romantic artist was concerned with expressing himself, and using the language of symbols to do so. Thus the oldest known conception of art had risen again, but with one important difference: until the Romantics the thing created, not the creator, was the main object of interest. Paintings and poems were commissioned in much the same way as a house might be: the work was to have a certain subject, it was to be painted or written in a certain style and was to be of a certain size or length, all as decided by the buyer. Who painted or wrote the work was of less importance, so long as the person in question possessed the necessary technical skills (Wolff, 1987). But now, during the Romantic age, the artist – that elect and divenly gifted being – became the centre of attention. The idea of the artist as the lonely genius,

raised above the rules imposed on the rest of society, originates from this time. Creativity was a question of emotion and intuition, not something based on artistic skills or knowledge.

During the nineteenth century diverse ideas about art began to succeed each other at an ever-increasing pace. Realism and Naturalism arose in reaction to Romanticism. Symbolism and expressionism represented Romanticism's reaction to realism. Futurism signalled the invasion of the machine into the modern world. Plato's idea of utility, combined with the mimesis concept, reappeared in Stalinist Russia under the banner of social realism. The rhetorical strand, with its emphasis on perception and response, enjoyed a powerful renaissance in the entertainment and advertising industries that were evolving in the mass media, where the crucial thing was to catch the attention of an audience.

After the Second World War a slightly new idea of art arose: the work of art was conceived as a world of its own, obeying its own rules, independent of the artist's intentions (Beardsley, 1981), and interest focused on formal composition. Structuralism and poststructuralism are both examples of this formal conception of art, which can be traced back to Aristotle's analysis of the formal construction of drama.

In the area of 'high' culture conceptions of art since the Second World War have been dominated by the formal and Marxist views. In the area of popular culture the rhetorical aspect has dominated, combined with the Romantic/ecstatic conception as manifest in the idolatry surrounding the superstars.

AESTHETICS AND MODERN SOCIETY

The birth of modern aesthetics can perhaps be located in the late eighteenth century (Lash, 1990; Eagleton, 1990). As a result of the industrial revolution society was becoming governed less by religion and more by a variety of other spheres of interest: theoretical-technical, moral-practical and aesthetic. These life-spheres had been fairly well integrated with one another in feudal society. What was believed to be true, good or beautiful had been decided to a large extent by the words of the Bible. Art works such as paintings had been commissioned in the same way as other required objects. Artists in the feudal

society were craftsmen, who supported themselves by undertaking commissions. No more than the carpenter built a house for its own sake did the artist paint mainly for the sake of the picture.

With the emerging industrial society, governed more by science than by religion, art, in the broadest sense, became an autonomous societal sphere which had to justify its existence on worldly rather than spiritual grounds. This differentiation of live-spheres reflected the need of an industrial society for more division and specialization of labour. The new society required a different kind of social differentation compared with the old feudal guild system. Industrialization also generated a need for new and more subtle mechanisms of social control. In the feudal society social control was external and direct; in the new society it had to be less obtrusive (Foucault, 1991). Society's rulers became interested in ways of internalizing social control, so that the people could control themselves without too much interference from the authorities.

Modern aesthetics, autonomous art's way of justifying itself, thus focused at first on ways in which emotional life could be investigated, controlled and civilized with the help of the means which aesthetics could provide.

The German philosopher Immanuel Kant, from whom modern aesthetics stems, spent much time asking himself how, through the disinterested (aesthetic) apprehension and contemplation of the world, man could refine the sensory impressions evoked by that world and express them in a civilized and socially acceptable manner.

British philosophers such as David Hume paid more attention to emotion and sympathy. Hume argued that if man opened himself to the 'passions', the 'good' would become apprehensible: it would manifest itself as the beautiful; the bad as the ugly. From this aestheticization of human life the good and harmonious society would arise, always assuming that our emotions were kind and not harmful.

These two approaches – letting either reason or emotion govern social life – continued to dominate aesthetic philosophy. Philosophers such as Schiller, Hegel, Schopenhauer and Kierkegaard followed Kant's cognitive tradition, with various suggestions as to how the emotions could be brought under reason's control. Nietzsche and Freud redirected attention to

the body and its sensations as the foundation of social life. For Nietzsche, the body's will to power and domination was the foundation of everything human. Nietzsche's 'passions', however, were considerably more passionate than Hume's.

> Healthy vital instincts, unable to discharge themselves for fear of social disruption, turn inward to give birth to the 'soul', the police agent within each individual. The inward world thickens and expands, acquires depth and import, thus heralding the death of 'wild, free, prowling' men who injured and exploited without a care.
>
> (Eagleton, 1990, p. 237)

Freud regarded the body's sexual desires as mankind's driving force. However, he also had a cognitive concern in that his goal was to bring the subconscious under the control of the conscious mind. Through psychoanalysis, in the course of which subconscious urges were uncovered, reason would be able to invade and conquer these uncivilized forces. Instead of letting the dark urges loose, which was Nietzsche's solution, Freud wanted to make them subject to the control of the conscious mind.

Early twentieth-century cultural modernism entailed a more traditional direction for aesthetics, with a growing interest in artistic form. The status of the arts as an independent life-sphere, separate from other realms of society, was considered to be essential. According to critical theory, the mission of the arts was to criticize bourgeois society and to rationalize aesthetics by the systematic exploration of the possibilities of different artistic media. Consequently, cultural modernism became hostile towards popular culture because it was located within society, because it did not criticize society and because it showed little interest in exploiting the possibilities of different artistic media to the full. Adorno, one of the founders of critical philosophy, became one of popular culture's harshest critics.

At the beginning of his career Adorno had been mainly interested in the way people could realize their full potential as human beings, under the tutelage of reason. During the Second World War, which he spent in the United States as a refugee from Nazi Germany, he began to despair of the potentiality of rational thinking, declaring that the 'Enlightenment' project

had ended in Auschwitz. Thereafter, he devoted himself primarily to the philosophy of aesthetics. The later Adorno saw art as the only free zone in modern society, the only thing able to make living more human.

The critical philosopher Habermas, who was one of Adorno's disciples, grew up in Germany during the Second World War. Habermas too became deeply depressed by the atrocities of the Nazis and what these might mean for the future of Western civilization. Habermas did not take refugee in the arts, however, but decided to pursue the 'Enlightenment' project. He focused on the moral-practical life-sphere. It was clear to him that something other than mere instrumental rationality was needed for human action, and the alternative he proposed was communicative rationality. In an ideal speech situation, from which power, prestige and self-interest are withheld, people would be able to conduct a democratic dialogue and to let the 'best' argument win.

Postmodernism, which followed cultural modernism, constituted a reaction against modernism's faith in reason and a return to an aesthetic based on the emotions.

AESTHETICS AND THE POSTMODERN SOCIETY

According to Lash (1990), postmodernism entails a dedifferentation of society in the sense of a reunification of the different life-spheres. Lash underlines in particular the role of the aesthetic sphere in this process. In this, he represents a slightly unusual view of postmodernism, which is perhaps more commonly associated with an increase in the differentiation and fragmentation of society. However, the fact that Lash's view of postmodernism does not accord with earlier views on the same subject only serves to confirm the prevailing notion that postmodernism is not a coherent or unified theory. Postmodernism seems generally to be perceived as a patchwork of ideas that occur in a variety of cultural and academic fields, such as architecture, literature, philosophy and sociology (Berg, 1989). One common denominator in postmodern thinking is the rejection of rational discourses which assume the existence of all-embracing explanations of the functioning of social and cultural phenomena. Examples of such discourses or 'grand narratives' (Lyotard, 1989) include Freud's psychoanalytic

theory of man's psychological development and Marx's theory about society's economic development. Postmodernism, according to this view, constitutes a reaction against the 'Enlightenment' project's belief in the emancipation of mankind as a result of the growth in knowledge.

A common assumption among postmodernists is that no profound truths remain to be discovered in the world. As a result, postmodernism has taken a particular interest in the surface properties of things. The presumed absence of any profound truths leads to the assumption that nothing genuine exists. Art objects are seen as mere copies, imitations, collages or bricolages of one other. There is no such thing as an original work of art.

In the linguistically orientated branch of postmodernism efforts are being made, through various forms of text deconstruction, to show that what is perceived as 'true' is a social construction rather than the discovery of an aboriginal world. A basic assumption of postmodern linguistics is that the relationship between a concept and its reference object, that is, the extra-linguistic world, is arbitrary and socially determined (Norris, 1987). As a result of this, an artificial hyperreality is said to have arisen, consisting of pictures, signs, words and concepts that float around in various media such as television, radio, films, books, newspapers and commercials (Eco, 1987; Baudrillard, 1988). Eco, for example, describes how the word 'New Orleans' floats around in the ultimate hyperreality which, according to him, is constituted by Disneyland.

> When, in the space of twenty-four hours, you go (as I did deliberately) from the fake New Orleans of Disneyland to the real one, and from the wild river of Adventureland to a trip on the Mississippi, where the captain of the paddle-wheel steamer says it is possible to see alligators on the banks of the river, and then you don't see any, you risk feeling homesick for Disneyland, where the wild animals don't have to be coaxed. Disneyland tells us that technology can give us more reality than nature can.
>
> (Eco, 1987, p. 44)

Lash offers a perhaps more earth-bound explanation of the origins of this postmodern hyperreality. At mankind's beginnings the world consisted largely of natural facts. Throughout

history the world has become increasingly more humanized, and cultural facts such as symbolic representations of human life (art) have come into existence. During the industrial revolution the aesthetic sphere that produced these symbolic representations became separated from other life-spheres. With the rapidly growing popular culture and advertising industries of the nineteenth century, the production of symbolic representations increased dramatically. During the twentieth-century the world in which we live came to consist of a growing mass of cultural facts, such as commercials, highways, skyscrapers, department stores, films, television programmes, popular music, etc. This was a sign that the aesthetic sphere was invading the social sphere by way of the ever-increasing production of symbolic goods.

It is this invasion that lies behind the creation of the postmodern hyperreality. And, according to Lash, postmodernism itself – perceived as a dedifferentation of society – stems from the activities of the culture industries. The mass production of art, on which popular culture was based, caused art to lose its 'aura' (Benjamin, 1936). Thus, once again art became a part of society as a whole (the life-spheres merged) during the twentieth-century. This reunion between the aesthetic and the social spheres in general, however, can hardly be said to have occurred on art's terms. Rather, the reunion came about on the terms dictated by the theoretical-technical sphere, by way of the increasing commercial exploitation of artistic knowledge.

Postmodern aesthetics, which has to do with the postmodernist rejection of rational discourses, has its origins in the Surrealist movement of the 1930s. Surrealism was based on Freud's psychoanalytic theory and was concerned to portray bodily desires in non-discursive ways. This could be achieved by letting reason be invaded by the subconscious. One technique for accomplishing this involved the use of automatic writing, which was based in turn on the free association technique of psychoanalysis, whereby patients are encouraged to say whatever comes into their minds. Automatic writing meant that poets could write whatever came into their heads without any editing.

Lash claims that this conception of art has been revived in postmodern aesthetics, where the subconscious rather than the conscious is supposed to be the organizing force. Postmodern art therefore becomes non-discursive and figurative. Art's mis-

sion is to transmit emotional energy through the portrayal of bodily desire and by the application of a sensational and spectacular logic, whereby the immediate sensation evoked by a work of art is the crucial pay-off.

In view of the dominating role of popular culture in arts production today, I will now turn to the aesthetic reception which has greeted popular culture.

AESTHETICS AND POPULAR CULTURE

Much of the attention that popular culture has aroused has revolved round the discussion of one topic: 'is it art or is it not?' The cultural sociologist Herbert Gans is one of those who have tried to fathom the aesthetic status of popular culture, and he posits that culture production occurs within different 'taste cultures' (Gans, 1974). The main difference between popular and high culture is that the latter is culture on the artist's terms, while the former is culture on terms set by the audience. Gans then describes four taste cultures which he has identified.

1 *High culture* High culture is the smallest of the taste cultures but also the one that receives most attention in the media; it is also the culture that is often used as a yardstick in evaluating all the other taste cultures. In high culture the creation process and the artistic form are of prime importance. Artistic content is expressed in sophisticated and subtle ways, such that in literature, for example, introspection and the development of character are more important than plot. The arts products of high culture often break with prevailing norms in the arts and society. Artists are held in high regard. To be able to enjoy high culture, it is necessary to be interested in, and often to possess academic knowledge about, the arts.

2 *Upper-middle-class culture* Within this taste culture arts production occurs on the audience's terms. The audience itself consists mainly of professionals, such as doctors and lawyers. This audience does not usually have any academic interest in the arts and may therefore find it difficult to digest the products of high culture. They are not interested in the process of creation or artistic form as such, but are more interested in content and, for example, plot. This audience

relies on the 'Arts and Entertainment' section in the news-papers as a source of information about arts products worthy of their attention.

3 *Lower-middle-class culture* In this taste culture, too, content and action dominate over artistic form. Here, however, the content becomes stereotyped and has a moralistic and con-ventional character. Breaks with existing cultural conventions and moral norms are not appreciated. Arts products are expected to uphold traditional values, preferably with 'the common man' as hero.

4 *Working-class culture* The moralistic and tradition-preserving view of the arts of the lower-middle-class culture becomes even more pronounced in the working-class culture. The world is painted in black and white, without any disturbing grey zones. Action is emphasized. The moral content is of a simple Wild West variety.

Since it is mainly the products of high culture that get the attention of the media and the critics, the products of the other taste cultures tend to be evaluated in relation to the aesthetic values of high culture. Popular culture is therefore often portrayed as vulgar, crude, trivial or brutalizing. An evaluation of the aesthetic qualities of rock-'n'-roll in Bloom (1988) provides an example of this.

Bloom compares the consumption of rock music with the late nineteenth-century Wagner cult, when Wagner was seen by his admirers as a genius who created the meaning of life with his music. This reduced their existence to waiting for 'the next Wagner opera' and made the rest of life seem pretty dull. The Wagner cult did not have any great impact on society as a whole, since Wagner was a slow composer and only a privileged few could afford to visit the opera. No such restrictions affect the consumption of rock music, since, or so Bloom claims, orgies of music continue all the time. He then goes on to compare listening to rock-'n'-roll with the abuse of drugs.

In my experience, students who have had a serious fling with drugs – and gotten over it – find it difficult to have en-thusiasms or great expectations. It is as though the color has been drained out of their lives and they see everything in black and white. The pleasure they experienced in the beginning was so intense that they no longer look for it . . .

> They may function perfectly well, but dryly, routinely. Their energy has been sapped, and they do not expect their life's activity to produce anything but a living . . . I suspect that the rock addiction, particularly in the absence of strong counter-attractions, has an effect similar to that of drugs.
>
> (Bloom, 1988, p. 80)

Classical music, which, he says, might have functioned as an antidote, has become marginalized. The man who detected both the threat and the opportunities of music was Plato, who saw dancing to wild rhythms as an expression of the barbaric side of the soul. Untamed music thus represented a direct threat to reason, while civilization could refine the raw passions of the soul by music expressed in controlled and artistic form.

> To Plato . . . the history of music is a series of attempts to give form and beauty to the dark, chaotic, premonitory forces in the soul – to make them serve a higher purpose, an ideal, to give man's duties a fullness.
>
> (Bloom, 1988, p. 72)

Nietzsche, who believed that the soul had suffered long enough under the yoke of reason, was also aware of the power of music. He saw Dionysian music as a means of freeing the human soul from the chains of reason. Bloom traces rock-'n'-roll's intellectual roots back to this Dionysian philosophy of music, and claims that the sole attraction of rock music lies in offering young people immediate sexual gratification.

> Rock gives children, on a silver platter, with all the public authority of the entertainment industry, everything their parents always used to tell them they had to wait for until they grew up . . . Young people know that rock has the beat of sexual intercourse.
>
> (Bloom, 1988, p. 73)

All humanity's accomplishments are about to be lost in the endless production of masturbatory fantasies for 13-year-olds triggered by the alluring rhythms of rock-'n'-roll.

> Picture a thirteen-year-old boy sitting in the living room of his family home doing his math assignment while wearing his Walkman headphones or watching MTV. He enjoys the liberties hard won over centuries by the alliance of philo-

sophic genius and political heroism . . . And in what does progress culminate? A pubescent child whose body throbs with orgasmic rhythms; whose feelings are made articulate in hymns to the joys of onanism or the killing of parents; whose ambition is to win fame and wealth in imitating the drag-queen who makes the music. In short, life is made into a nonstop, commercially prepackaged masturbational fantasy.

(Bloom, 1988, p. 75)

That popular culture often arouses such negative reactions on the part of the critics may depend, according to Gans, on aesthetic disappointment. He calls for cultural pluralism. The products of every taste culture should be evaluated according to the values of that culture. It makes no more sense to criticize Ingmar Bergman's films for the absence of physical action than to criticize James Bond films for their lack of existential dialogue.

None the less, although the aesthetic theories used in judging popular culture usually originate in high culture circles, there are some examples of assessments of popular culture made by its own people.

The art of fine distinctions

Joe Bob Briggs (1989) provides an aesthetic investigation of the cineastic values of B films. Joe Bob, so he tells us, is a critic of drive-in movies for the *Dallas Times Herald* in Rockwall, Texas. He does not like censorship.

I guess we hit our peak around 1956, the year we passed the five thousand figure on American drive-ins. But then we leveled off, stayed around that number for the next ten, fifteen years, and I'll tell you why. That's when the Passion Police showed up. I don't know why, I don't know how, but there were people calling theirselves Americans who didn't want the drive-in to survive. The first time it happened was up in Canada, where the Quebec Catholic Church banned all their members from going to the drive-in, in spite of the fact that the drive-in has been the biggest supporter of that great Catholic double feature, *I Drink Your Blood* and *I Eat Your Skin*. Then they started sending out the Gestapo down here.

(Briggs, 1989, p. 9)

He does not care much for indoor movies.

> some *brilliant* mind is bringing out *Chainsaw [The Texas Chain-Saw Massacre]* again for one reason and one reason only: Tobe Hooper made some kind of indoor trash film called *Poltergeist*. I haven't seen it, of course, because I don't watch movies indoors, and I specially don't watch any *so-called* horror films that are suitable for family viewing. Let's face it – Tobe Hooper has been slummin ever since he made *Chainsaw*, and he's probably lost to us as a drive-in director.
>
> (Briggs, 1989, p. 51)

Joe Bob Briggs identifies three types of drive-in movies – blood, breasts and beasts. In connection with this classification he makes clear his own integrity as a movie reviewer.

> There's always been basically three kinds of drive-in movies: Blood, Breasts, and Beasts. (A lot of people would throw in Boots, for kung fu, but ever since Bruce Lee went to the big Tae Kwon Do Academy in the sky, I just can't include it as a separate category. I'm sorry. It's the way I feel. I know it's not a popular opinion, but I've gotta be my own person.)
>
> (Briggs, 1989, p. 10)

On the ethics of film-making he has the following to say.

> I am opposed to power drills through the ear, machetes through the stomach, decapitations with barbed wire, flame-thrower attacks, and mutilation with a ball peen hammer, unless it's necessary to the plot.
>
> (Briggs, 1989, p. 12)

If high culture reviewers are upset by the crudity and lack of a plot in B films, Joe Bob is disturbed by plots that get in the way of the action.

> *Hell's Angels on Wheels* was one I kinda like because it didn't have any plot to get in the way of the orgies and busting-of-heads scenes, and it was one of Jack Nicholson's best flicks before he started making indoor bullstuff.
>
> (Briggs, 1989, p. 185)

With profound hesitation he goes to the film festival in Cannes, where he happens to see an arty film.

> There were a bunch of people walking around who looked like they were from California – pink hair and stuff – so I

figured that must be Cannes . . . Since we got there in the middle of the night, we just went in and started watching the first thing that came along, and it was this flick called *Parsifal* by a guy named Hans-Jurgen Syberberg, and as you all know, Joe Bob will watch anything, but this was ridiculous . . . this Parsifal was one screwed-up guy. It takes him a couple hours just to figure out his own name, which is not my idea of a good plot.

(Briggs, 1989, p. 39)

He takes a slightly unusual attitude to sequels (*Rocky I, II, III,* and so on). He only appreciates sequels that are identical with the original film.

I've said it before, but I've got to give credit where it's due. Some people know how to make sequels and some people don't. Like *Halloween III*, the one that didn't have Jamie Lee Curtis, we all *know* that was a joke. But these *Friday the 13th* people know their sequels. These people don't just make up a new story. These people made the exact same movie four times in a row.

(Briggs, 1989, p. 246)

This does not stop Joe Bob from recommending film audiences to see the dubious *Halloween III*.

These *Halloween* jerkoolas have Gone Hollywood. They obviously got stoked up on cocaine and forgot their roots . . . You can go see it anyway because this is not Communist Russia. Body count nine. Zombie body count fifteen. Two breasts. Not much kung fu, unless you count a little zombie kick-boxing. Hands rolls, arms roll, and, yes, heads roll. Only two stars because it was made by Arabs. Joe Bob says check it out.

(Briggs, 1989, pp. 89–90)

Collins (1989) offers a somewhat more intellectual criticism of the aesthetic qualities of the popular films. He presents his view of popular culture in a polemic against critical theory. Critical theory presumes the existence of a genuine (commercially unexploited) folk culture before the arrival of industrialized society (Tomlinson, 1990). Capitalist society allegedly destroyed this genuine popular culture by turning folk culture into a commodity.

> What such arguments assume ... is that there is some
> essential human activity ... which has been colonized by
> commerce ... something human is taken from us and re-
> turned in the form of a commodity.
>
> (Frith, 1988, p. 12)

Adorno and Horkheimer, the originators of this view of popular
culture, argued that the production of culture was standardized
and transformed into commodity production under capitalism,
and that the culture industries were in total control of pro-
duction (Adorno and Horkheimer, 1989). This industrializa-
tion of culture resulted in a totally uniform supply of cultural
goods, such that it was hard to tell one film from another.

According to Collins there is no evidence that culture is
produced in such a standardized and centralized manner.
Adorno and Horkheimer's theory is probably mainly a product
of their experience of Nazi Germany in the 1930s, and of the
previous decade's fear of a future totalitarian society.

> This notion of culture czars in master control rooms orches-
> trating all forms of mass culture bears a striking resemblance
> to the vision of the State constructed by Fritz Lang films of
> the twenties, especially *Metropolis* (1926), in which the State
> is conceived as one enormous circular Grand Hotel where the
> evil capitalist bosses reside at the top and the workers reside
> in the basement.
>
> (Collins, 1989, p. 10)

Assuming that no master control room for a society's pro-
duction of culture exists, Collins seeks to understand how the
production of culture operates, with the help of an intertextual
field theory. He tries to capture the way different texts define
themselves in relation to one another and how competition and
power struggles arise between different cultural discourses.
Field movements are illustrated by the development of the
modern detective novel, with authors such as Dorothy Sayers
and Raymond Chandler, among others, striving for literary
legitimacy by positioning themselves in relation to serious
literature, in an attempt to show that the detective novel was
even more serious and innovative.

In an analysis of a science fiction film (Joe Dante's *Explorers*,
1985) Collins demonstrates how it is possible to build a cultural

field of our own in the form of a bricolage in which we assemble our own world-view out of suitable parts of other existing world-views. The film *Explorers* deals with three American boys who visit some space creatures in their space ship. The space creatures are constant viewers of American television, but they cannot distinguish between the different cultural discourses taking place on the screens. The space creatures are very surprised that a boy who is covered in hair and answers to the name of Lassie has managed to become so popular. The visiting Earthlings, in contrast, are able to choose and build their own cultural discourse from the ongoing discourses, thereby creating a meaningful and understandable world for themselves.

> The three explorers from earth represent a very different kind of Post-Modernist subject, one who has been bombarded by these same signals, but due to that very bombardment, has seized on one particular discourse . . . The central figure, Ben, is obsessed with Science Fiction and believes that it is the only discourse that can explain his world for him. He keeps a secret library of Science Fiction novels . . . watches videotapes of Science Fiction classics, quotes from *Star Trek*, etc. The privileged discourse becomes a kind of *bricolage* of his own devising, especially when the boys build and name their spaceship. The ship is constructed out of the refuse of the modern technologized world – doors from washing machines, a shell from a carnival ride, a worn-out television set, a stolen computer . . . The key point here is that the *bricolage* may be made up of disparate components, but they form a recognizably differented discourse.
>
> (Collins, 1989, pp. 118–19)

Collins thus stresses the productive and sense-making character of cultural consumption. I shall now look more closely at this feature of popular culture, in an analysis of the emergence of pop music.

Commodity aesthetics

According to Frith (1988) pop music is industrialized music in the sense that production and the final product are so integrated that the product (the pop record) incorporates technical, commercial and musical elements that cannot be

separated from one another. Frith is critical of the common perception that the production of pop music is simply the commercial exploitation of an original popular music. This view assumes that the music is the point of departure of the manufacturing process rather than its end result. Instead, the starting-point consists of a number of musical, commercial and technical ideas that together engender the pop record.

> The industrialization of music cannot be understood as something which happens *to* music, since it describes a process in which music itself is made – a process . . . which fuses . . . capital, technical and musical arguments. Twentieth-century popular music means the twentieth-century popular record; not the record of something . . . which exists independently of the music industry, but a form of communication which determines what songs, singers and performances are and can be.
>
> (Frith, 1988, p. 12)

There has never been any genuine popular music that has been turned into a commodity and exploited commercially. The twentieth century's popular music is a genuine industrial product, produced by the record industry.

British art schools, whose students came to play an important role in this industrialization of music, trace their origins to 1836, when a government report declared that the aesthetic quality of British commodities must be raised to increase the international competitiveness of British industry (Frith and Horne, 1987). The creation of art schools would steer artistic knowledge in such a direction that it could be used for the design of industrial commodities.

One problem for the art schools and their students was the prevalence of the Romantic ideal of the artist. In feudal society the work of art had been the object of interest, but during the Romantic era attention shifted to the artist as the chosen and divinely gifted being, and the idea was born of the artist as the lonely genius exempt from the rules applying to the rest of society. Creativity was a question of emotion and intuition, and was not based on artistic skills and knowledge. Either you had the gift or you did not. This ideal conjured up a vision of the artist as the chosen genius, raised high above the demands and trivialities of everyday life. Instead of going to work

between nine and five, the romantic artist was expected to live a Bohemian life and to create unique works revealing profound truths about the world.

This artistic ideal, which prevailed in the British art school world in the late nineteenth century, fitted ill with British industry's need for commercial artists to design industrial commodities during regular office hours. To work as a 'commercial artist' was seen as a career failure. But very few art school students could support themselves by their art. Most of the population found their aesthetic pleasure in the products of the emerging popular culture industry (films, records, comic strips, advertisments, postcards, photographs, etc.) rather than in the art galleries. Art school students found themselves spending less and less time on their artistic endeavours. At the same time they felt uneasy about becoming commercial artists, since this would entail a betrayal of the Romantic artistic ideal. The pop music industry of the 1960s offered a solution to this dilemma.

During the 1950s future pop musicians such as John Lennon (the Beatles) and Keith Richards (the Rolling Stones) were art school students. The intellectual music and clothing of the times were jazz and a duffel-coat. Working-class music and clothing were rock and biker's gear. Both John Lennon and Keith Richards rebelled against the intellectual art school style by dressing in biker's gear, combing their hair like Elvis Presley and listening to rock instead of jazz. At the same time, John Lennon and Keith Richards were learning how the artist role worked – knowledge which was used to sell their music. The famous Beatles mop-top was an art school haircut that provided an excellent way of getting attention. The Rolling Stones' rebel look started with the way Keith Richards chose to dress after his Teddy boy period.

> Keith Richards had come through his 'teddy boy period' and was wearing his own idiosyncratic version of 'art school "gear"', with denim drainpipe trousers, a jean-jacket and mauve-striped shirts'.
>
> (Frith and Horne, 1987, p. 85)

This Bohemian individualism endowed art student musicians like Keith Richards and John Lennon with commercial potential as personalities. The art student musicians could preserve

the Romantic artistic ideal by turning it into a commodity with which to sell their music. Personal originality became a commercial asset. The music initially posed a problem. Rock was just as holy to Keith Richards and John Lennon as jazz was to the jazz fans. Rock was seen as genuine music, made on the artist's terms. It was not artificially fabricated music on the market's terms, like the pop tune. Rock music performances should therefore stick as close to the original as possible. At the same time, though, the art school musicians' personalities started to influence the music as well. Instead of playing exactly like Chuck Berry, they performed their own versions of Chuck Berry. They also began to write music of their own. Being 'original', in the sense of creating, became as important as making a faithful reproduction of another original work. In this way the music was also transformed to become original art. Not only the form (the musicians' personalities and appearance) but also the content (the music) became original.

This art-influenced music became a commercial success. The commodity that was being offered made a point of difference (different music and clothing). By consuming this commodity teenagers were given a chance to be a little bit different and original themselves.

> Being a star means playing on a sense of difference, becoming a pop and rock star involves selling the difference to the masses.
>
> (Frith and Horne, 1987, p. 65)

The Rolling Stones provided a packaged rebellion for mass consumption, while the Beatles 'just *were* the zany foursome they were sold to be' (Frith and Horne, page 102). The English art school students who became pop musicians had invented a new business concept, which sold lifestyles in commodity form for mass consumption. At the same time they preserved the Romantic artistic ideal, since that was the lifestyle being sold, albeit in mass-produced form.

However, it became difficult to maintain any original artistry in the commercial mass-exploitation to which the new music was subjected. Gail, wife of the pop musician Frank Zappa, simply could not understand how her husband could believe he was doing anything serious when his audience consisted mainly of screaming teenagers.

Two solutions to this problem emerged. The first came from the musicians. The distinction between pop and rock was re-established. Rock was seen as genuine music made on the artists' terms; pop as artificial music made on the market's terms. The more successful pop groups started to make art-rock on their own terms, for which there proved to be a huge market.

> In fact progressive (or art) rock was to become the most commercially successful British sound of all in the early 1970s, with Pink Floyd's *Dark Side of the Moon* one of the bestselling LPs ever. The group had resolved the tension they'd originally felt between artistic and commercial logic by asserting complete artistic control and becoming astonishingly rich anyway! . . . The Floyd's fans were equally determined to be different from ordinary pop people and they realised this through superior *consumption*.
>
> (Frith and Horne, 1987, p. 98)

This solution to the problem of being an original artist while one's art was being mass-produced, increased product diversity and created a new market segment. The other solution, which gained full force during the 1980s, had its roots in 1960s' pop art and the related aesthetic ideology. Pop art was art's way of signalling that it was ready to approach the contemporary consumer society with a positive rather than a negative attitude (Lippard, 1988). Pop artists such as Andy Warhol sought to highlight the aesthetic qualities of ordinary consumer goods in their art, although Warhol himself pushed this pop art ideology further even than this. In his view, all art was commercial. High art simply used different marketing techniques. Since all art was commercial, the best art must be the most popular art, and the best measure for judging aesthetic quality must be money. Everything had become a commodity and the only thing left for artists to do was to celebrate the market. Since all art was commercialized, the artists might just as well take advantage of this and turn commerce into art.

> Business art is the step that comes after Art . . . Being good in business is the most fascinating kind of art. During the hippie era people put down the idea of business – they'd say "Money is bad", and "Working is bad", but making money is art and working is art and good business is the best art.
>
> (Warhol, 1975, p. 92)

Andy Warhol had started his art career in the 1950s as a commercial artist (Bockris, 1989). He became famous during the 1960s as a pop artist and avant-garde film director. During that period Warhol was chiefly interested in the creation of artistic value. He was astonished by the commercial successes of some of his films. His paintings from the same period portrayed mass-consumption articles (Coca-cola bottles etc.), but they were still unique paintings. Warhol's concrete everyday subjects and his simple painting technique were mainly a reaction against the abstract expressionism of the 1950s. Important to him in the 1960s was not his art's commercial potential but its aesthetic value.

During the 1970s he gradually shifted the emphasis to the commercial potential of the art products. In the 1960s, when Andy Warhol had his studio in a deserted factory building ('The Factory') in New York, his management style had been geared towards helping people to do what they wanted to do. In the 1980s he moved to an ordinary office building in a skyscraper in New York with a formally employed staff, and changed his management style to getting his employees to do what he wanted them to do. At the end of his life (he died a very wealthy man in 1987) Warhol was best known for his silk-screen portraits of famous people, such as Mick Jagger, Liza Minelli, etc. Warhol charged $25,000 for the original paintings. But he made much more money from the signed lithographs of the portraits, which were manufactured on a mass-production basis. Warhol even tried to standardize the artistic work itself, to speed up production. His later portraits of famous people consisted of enlarged and coloured polaroid photographs of various stars. This production technique meant that others beside Warhol himself could take the photographs, and could enlarge and colour them. His role in this process became mainly that of production manager and creative director, to ensure that the quality remained high enough in his 'business art'.

In music, this aesthetic ideology made the packaging of the music more important than the music itself. Artists, like David Bowie, with strange stage personalities but fairly traditional pop music were an early signal of a trend that would gain momentum during the 1980s. But first came punk.

Punk was subversive pop art that aimed at exposing instead of praising the functioning of the modern consumer society.

Malcolm McLaren, one of the originators of punk, was also an art school student. He wanted to expose the record industry's mechanisms

> by burrowing into the money-making core of the pop machine, to be both blatantly commercial (and thus resist the traditional labels of art and Bohemia) and deliberately troublesome (so that the usually smooth, hidden, gears of commerce were always on noisy display).
>
> (Frith and Horne, 1987, p. 132)

He accomplished this by creating the Sex Pistols. They became famous for gross and indecent behaviour, especially in their dealings with the record companies. Their misbehaviour was covered in detail by the media, thanks to McLaren's efforts.

Punk directed attention, not only at the record industry's way of functioning but also at its own and society's artificial and constructed character. The stereotyping of women as either whores or saints by the predominantly male rock musicians was questioned by the fashion artist Vivienne Westwood in her punk bricolages, composed of contradictory clothing: 'woman as innocent/slut/mother/fool – was rendered ludicrous by *all being worn at once* (Frith and Horne, 1987, p. 155)

The male rock stars, for their part, had problems with the sexualization of their role as rock musicians. They had become consumption objects for their fans' sexual urges. Punk created an opportunity to de-problematize sexuality. As a result of gender-bending, sexuality could be made less threatening: 'I wore my mum's most flowery blouse, and a toilet seat on my back . . . it was like Captain Sensible gone absolutely haywire (Frith and Horne, 1987, p. 127).

Punk ended the same way as art rock – in a new market segment. Out of punk's doubts about the existence of anything genuine and natural, a new Romanticism emerged in the 1980s. Revolt was turned into style and rock into fashion. If nothing genuine existed, then the packaging of music was more interesting than the music itself. If personality had sold music in the 1960s, image sold it in the 1980s, as the pop star Boy George discovered: 'to be a pop star, as Boy George found out, meant to be a Pop Star, all performances – on stage, in bed, for the press . . . performance art (Frith and Horne, 1987, p. 145).

The art school students experienced another triumph in the

pop fashion magazines of the 1980s. They may have been unsuited to designing teacups, but they proved all the more skilful at designing a popular culture comprising music, fashion and advertising.

> Redefine design to serve popular culture rather than manufacturing industry and commercial art becomes successful and street credible . . . The competitive individualism that fine art and fine-art-influenced design education cultivates may not train graduates well for traditional industrial activity . . . but it blends perfectly with the commercial careerism, the profit ideology of popular cultural production.
>
> (Frith and Horne, 1987, p. 68)

The integration of art and commerce could continue undisturbed, even if the punk movement had tried to make the consumption of cultural commodities less bland.

> How . . . does one approach an album . . . of quiet melodic . . . guitar music . . . which is packaged in a sleeve of coarse sandpaper, inverting the usual package-commodity relationship whilst simultaneously threating to destroy its rivals in the market, i.e. the consumer's record collection?
>
> (Frith and Horne, 1987, pp. 136–7)

This subversive packaging style became just another marketing concept since 'co-option has always been the name of the commodity game' (Frith and Horne, 1987, p. 179). The culture industries developed this marketing concept further by turning the act of consumption into an art form. In this context it was argued that judging the aesthetic qualities of different brands of toilet paper was just as much an aesthetic activity as judging the aesthetic qualities of a painting. This development was facilitated by the pop art argument that expendable art was no less serious than permanent art (Alloway, 1988). Through the creative consumption of the 'right' commodities, the consumers could signal their own creativity and originality, their 'art'. And the artists could become superconsumers, setting fashion trends by their innovative consumer behaviour. As a result of the British art schools' influence on the production of popular music and culture, the consumption of commodities had become the dominating art form in England at the end of the 1980s. Everyone had become a pop artist.

Jackie's other major concern had been the inauguration, including what clothes to wear to the various functions . . . It was Halston who devised the fur-trimmed pillbox hat that Jackie wore on the back of her head. The pillbox . . . helped boost "Her Elegance" (as *Women's Wear Daily* dubbed Jackie) to the top of every best-dressed list in Europe and the United States, giving rise to "the Jackie look," a revolution in style that included low heels, cloth coats in bright colors and Chanel-type suits.

(Heymann, 1990, p. 258)

The managerial dress consultant John T. Molloy provides a less dramatic example than Jacqueline Kennedy on how to dress in style. Molloy tells us how to survive in the world of business by mastering the correct dress code (Molloy, 1988). A 'must' is to avoid any deviating clothing, i.e. all fashion, since fashion is created through deviations from existing dress codes (Bourdieu, 1975). Molloy's prototype is the upper-middle-class man. His target group consists of people on the rise from the lower classes, who do not know how to dress.

If the waist is too high or too low and cannot be corrected, take off the pants and do not buy the suit. You do not want to look like Lou Costello with his pants under his armpits, and you do not want to look like a member of the lower middle class.

(Molloy, 1988, p. 47)

Molloy observes that Ronald Reagan probably lost the Republican presidential nomination in 1976 because he wore a brown suit instead of a grey one. In 1980 he wore a suit of the right colour, and we all know who won that election. Black suits should be avoided, since they are associated with death and funerals. One should never carry an attaché case or an umbrella. Men of importance have servants who carry such things for them. If one does not have a servant it is perfectly possible to hire a local cab driver for such a purpose.

You can either have someone carry your papers, or you can carry a small leather envelope. If you bring more papers to a meeting than can fit into that envelope, I suggest you have them brought by messenger or even hire an assistant for the

day. You can hire the local cab driver to carry in your bags. I have seen that done, and it works well.

(Molloy, 1988, p. 189)

Molloy confesses that his 'dress for success' has become so common in the US business world that the CEOs can no longer separate the wheat from the chaff during office hours. They have been forced to arrange office picnics, where the staff's leisure wear might help them to see who's who. Members of the upper classes are used to having leisure, and therefore also have leisure clothing in their possession, which members of the lower classes do not.

The first rule of sportswear is that you should have some. The difference between men who are established in the upper middle class and those who are not is probably most noticeable in their sportswear, because men who wear suits and ties to the office every day find it impractical and boring to wear the same type of apparel when engaging in physical activity or leisure pursuits. Therefore they tend to buy apparel specifically for leisure wear.

(Molloy, 1988, p. 253)

Molloy's discourse on dress really comes down to the importance of invisibility. If you notice how a man is dressed, something is wrong. Such a man is probably dressed like a clown. And you don't do business with clowns.

Tom had to attend that very important meeting wearing the crumpled suit he had worn on the plane, with the stained tie, and the only shirt he could buy in the few free minutes he had before the meeting, one with broad blue stripes . . . one look at him and the officers of the firm decided he was a loser . . . *Man came dressed like a clown; don't do business with clowns.*

(Molloy, 1988, pp. 151–3)

The aesthetics of everyday living

Bourdieu (1986) puts Molloy's aesthetics of everyday living into a wider perspective, in a dissection of the cultural behaviour of different social classes. Bourdieu's theory of cultural taste and consumption has its roots in a critique of Kant's theory about pure and vulgar taste. According to Kant it is the faculty

for cultivated (aesthetic) behaviour that separates man from nature. To stuff oneself with food just to quench one's hunger is vulgar. Even an animal can do that. But only man can set a table and arrange the food in an aesthetically pleasing way. Bourdieu sees this capacity for sophisticated taste experiences as a function of the level of education, social background and material standard of living. It is not a faculty given by nature. Nor is aesthetic taste limited to the appreciation of artistic objects. It influences the whole lifestyle of a person: the choice of clothing, food, housing, interior design, bodily care, etc. Members of the upper class place form and aesthetic quality above substance and function; members of the working class do the opposite. Working-class members strive for the maximum effect for the minimum price, while upper-class members find that 'less is more'. This explains why the interior design of working-class homes often is often perceived as vulgar, while the homes of the upper class are perceived as more discreet and balanced.

It should be mentioned here that Bourdieu's empirical data were gathered in the early 1960s, and his descriptions of the French working-class way of living, in particular, is unlikely to agree with the way the French working class lives today.

As regards eating habits, substance is the most important thing for the working class. There should be plenty of food on the table, so no-one has to leave the table still hungry. For members of the upper class, form is more important. The table should be laid in an attractive way, the food beautifully arranged and the courses served one at a time in the proper order, starting with the hors-d'oeuvre and ending with the dessert. In working-class homes all the courses may be placed on the table at the same time. It is not unusual for the women and children to be eating the dessert, while the men are still occupied with the main course.

Eating habits influence attitudes to the body. Among members of the upper class it is considered important for the body to be aesthetically attractive. It is therefore important to eat healthily, and not too much. Among members of the working class bodily strength is what counts, not the body's aesthetic qualities. It is therefore important to eat as much as possible.

These perceptions of the body influence sporting habits. Members of the working class tend to engage in boxing,

wrestling and weight-lifting, since these are body-building sports. The upper class favours aesthetically appealing sports such as tennis, skiing, sailing and golf.

Crossing class barriers is not without its problems. It is not enough to learn the ways of the upper class by pursuing a higher education. A real upper-class lifestyle is based on having the right social background. It is necessary to have been brought up in an upper-class environment, so as to favour instinctively aesthetic form over substance and function. The upwardly mobile middle class does not have this 'pure' taste; what taste it has, it has acquired. If members of the middle class follow their own taste, they make the right choices from a middle-class perspective, but the wrong choices from an upper-class point of view. The problem for the middle classes is not that they do not have taste, but that they have the wrong kind of taste for the upper-class milieu to which they want to belong. The taste of the upwardly mobile middle-class person thus becomes un-natural and strained, in contrast to the 'natural' good taste of the upper class. As a result, the upwardly mobile middle-class person tends to overdo things in an attempt to acquire the ways of the upper class. Members of the upper class might prefer a certain style of furnishing and acquire the best examples of it. Members of the middle class are more postmodern, in the sense that they tend to mix different styles. They compensate for their lack of natural good taste by buying the most expensive of everything, without giving much thought to how their various possessions will look together.

This uncertainty also puts members of the middle class into a permanent state of educating themselves. Lacking the upper-class sense of style, members of the middle class are permanently worried about being perceived as ignorant. If an upwardly mobile member of the middle class has not read the latest Nobel Prize winner, she feels compelled to do so, since that is the kind of literature she would read if she really were the cultivated person she portrays herself as being. A member of the upper class does not have such worries since it is taken for granted that people in this position are well read.

According to Bourdieu, it is primarily intellectuals of middle-class origin who devote themselves to aesthetics, as a way of learning how to separate good art from bad. The upper classes frown upon such activities, since they have lived their whole

lives in cultivated circles and can therefore automatically recognize what is good art. They just 'know'. Members of the middle class do not, and so they need help to avoid ending up with art of inferior quality. Members of the working class are more secure in their appreciation of art. They prefer sensual, figurative art, in which the content rather than form is the important thing.

Not merely a matter of taste

There are signs, however, that what is perceived as beautiful is not only a matter of taste or aesthetic philosophy, but also a consequence of the level of cognitive development. Parsons (1987) studied different ways of understanding paintings, and formulated a theory of aesthetic development based on his observations. His theory builds on Piaget's cognitive development theory and interviews with 300 people of different ages, who interpreted eight paintings in eight different styles in the presence of an observer. The different ways of making aesthetic sense of the paintings revealed a hierarchic order. Starting from this discovery, Parsons emphasized the element of learning in art perceptions and proposed a development theory regarding the capacity for aesthetic experience. This capacity consists of ideas about what art is and how it functions.

The first stage of aesthetic development, which encompasses young children, is characterized by favouritism: small children tend to judge paintings by whether or not they include the child's favourite colours or objects that the child recognizes and likes.

The second stage is characterized by a demand for realism. Without this, the paintings are perceived as distorted pictures of reality and the artist as incompetent. The subjects of the paintings should follow prevailing art conventions. At this stage the observer is able to differentiate between what belongs to the painting and what to the viewer. Hence, a painting that does not contain the observer's favourite colours or loved objects can nevertheless now evoke an aesthetic experience.

At the third stage the artist's ability to express strong emotions becomes important. The mission of art is no longer to mimic reality but to express someone's feelings as powerfully as

possible. The development occurring at this stage lies in the observer's ability to take the artist's intentions into account as well.

At the fourth stage, style and form and the painting's relation to different art conventions come into play. People at this aesthetic stage appreciate art reviews, whereas at the previous development stage these were seen as destroying the aesthetic experience.

At the highest stage of development observers are able to see how their own taste and existing art conventions are influencing their perception of the painting. They can distance themselves from their own aesthetic taste and show greater tolerance of various artistic traditions.

Parsons' observations of different stages of aesthetic development find support in a study of child culture (Rönnberg, 1989). Rönnberg found that small children watching animated films are drawn to the strong colours of these films, their simple plots, the characters delineated in clear outline and the uncomplicated visual language. She also found that small children had a hard time understanding more complex pictures, plots or personality characterizations. Characters should preferably be stereotyped and very predictable in their actions, if a sequence of events is to be easily understood. In view of these observations Rönnberg finds it hard to see it as an expression of laziness or poor taste when small children prefer to watch Donald Duck rather than listening to their parents reading Hans Christian Andersen's fairy-tales to them, since small children at this level of aesthetic and cognitive development are able to understand characters of Donald Duck's relative simplicity but not Andersen's more complicated stories and characters.

Given the widespread popularity of many light entertainment films, which may not be too far removed from Donald Duck in artistic complexity, we might ask ourselves whether some people have become arrested in their aesthetic development at a fairly early stage. Many people may prefer uncomplicated Hollywood films because they do not understand art of a more complex kind. Parsons (1987) finds, for instance, that very few people have progressed beyond the third stage in their aesthetic development, which may be a consequence of the fairly low status of the arts in our society.

On the whole, we take the arts much less seriously than science or morality. The average person in America is not much engaged in the arts, and does not often discuss them seriously; and newspapers and magazines pay much less attention to aesthetic questions than to scientific or moral ones ... Of course this situation is reflected in our educational system, where the arts have a notoriously marginal place in the curriculum ... The result is that most people in our society understand the arts much less well than they understand science or morality.

(Parsons, 1987, Preface)

If this is the case, it should come as no surprise that simple arts products such as Donald Duck or James Bond spread more widely and achieve far greater popularity than more complex works of art.

SUMMARY

In this chapter I have looked very briefly at the development of aesthetic theory in Western society and at the way this development has been influenced by the growing production of art in society. Modern aesthetics has its origins in the aesthetic philosophy formulated by Kant in the late eighteenth century. At that time the industrialization of Western society had already begun, and society could be described in terms of three life-spheres: a theoretical-technical, a moral-practical and an aesthetic sphere. This differentation reflected industrialism's need for a less organic and more specialized society. The industrialization of society also created a need for less obtrusive and more subtle mechanisms of social control. Modern aesthetics, which gave autonomous art the means with which to justify itself, therefore originally focused on ways in which emotional life could be investigated, controlled and civilized with the help of aesthetics. Kant's aesthetics enabled reason to control the emotions. Through the disinterested aesthetic contemplation of the world, sensory impressions could be refined and expressed in a civilized manner. British philosophers such as David Hume relied more on the goodness of the heart. If man followed his passions, the good society would arise, since the good would manifest itself as the beautiful, and the bad as the ugly.

These two approaches, letting either reason or emotion govern social life, continued to dominate aesthetic philosophy. Philosophers such as Schiller, Hegel and Schopenhauer followed in Kant's cognitive tradition. Nietzsche and Freud redirected attention to the body and its sensations as the fundamental base of social life. The cultural modernism of the early twentieth century entailed a more traditional direction in aesthetics, with greater interest in artistic form. The status of the arts as an independent societal sphere was considered essential. The mission of art was to criticize modern society and to rationalize aesthetics by systematically exploring the possibilities of different artistic media. As a result, cultural modernism became hostile to popular culture, since this culture was located within society; it did not criticize society and was not very interested in exploiting the use of the possibilities of artistic media to the full. Postmodernism constituted a reaction against modernism's faith in reason, and heralded a return to an aesthetic based on the emotions.

Postmodernism entails a dedifferentiation of society in the sense of a reunification of the different life-spheres. The aesthetic sphere was of major importance in this reunification. The reunification originated in the activities of the culture industries. The mass production of art commodities on which popular culture is based, caused art to lose its aura and thus its privileged position in society. During the later twentieth century art therefore became integrated once again into the life-spheres of society as a whole. The reunion between the aesthetic and social spheres took place on the terms of the theoretical-technical sphere, through the increased commercial exploitation of artistic knowledge. In the following chapter a theory will be presented about the way in which such commercial ventures operate.

The culture business

A much-repeated message in the post-industrial discourse is that we are 'on the threshold of the knowledge-based society', i.e., a society in which knowledge is the primary product and material products are derivatives of the knowledge produced (Harvey, 1989). In line with this approach, I shall regard the arts here as narrative knowledge which is commercially exploited by arts-producing organizations. Two business strategies are applied in effecting this exploitation, and these will be described in some detail in the second part of the chapter.

ART AS NARRATIVE KNOWLEDGE

In 1977 the French philosopher Jean-François Lyotard wrote a book, later published in English as *The Postmodern Condition: A Report on Knowledge* (Lyotard, 1989), in which he discusses the role of knowledge in the post-industrial society. He identifies three types of knowledge in the history of mankind, as follows.

1 *Narrative knowledge* Narrative knowledge he claims as the oldest form of knowledge. It has its origins in the narrative skills of the Greek rhapsodes and justifies itself in the individual personal performance, in so far as the narrator succeeds in making his narrative credible to his audience. Aristotle saw the narrative knowledge of the rhapsodes as providing a first step towards a scientific knowledge of nature. People probably engage in aesthetic contemplation and artisitc creativity because it is necessary to attend to a phenomenon in order to understand what it is and how it functions (Berefelt, 1977; Brunius, 1986). By observing something in a

concentrated manner ('consumption' of an art object), we acquire knowledge about the object's or phenomenon's appearance and its way of functioning. This knowledge can then be used as a base for future action. Artists are people who choose to express their insights in an aesthetic form. For this to happen the following constituents are necessary:

- An aesthetic sensibility in the form of aesthetic observation and judgement.
- The transformation of an idea of a desired art object through a certain medium. An idea is embodied in a piece of music, for instance, and is then performed on a piano. This transformation (the ability to translate an idea into a form pertaining to the senses) is the most important step, and is what makes art and the artist.
- Technical knowledge stemming from familiarity with the medium (music) and its instrument (the piano).

'Narrative knowledge' is regarded here as synonymous with, or as a branch of, artistic knowledge. This implies an expansion of the narrative knowledge concept, since it allows narratives about the world to be communicated even in media other than the written or spoken word.

2 *Scientific knowledge* The idea of scientific knowledge can be traced back to Plato's criticism of the rhapsode Ion's narrative skills. The scientific form of knowledge aspires to communicate 'true' knowledge about the world. It justifies itself by presenting the data on a basis of which statements about the world are made, thus allowing the audience to control the truth content of the statements (their correspondence with reality). Unlike the way narrative knowledge justifies itself, this form of legitimation is impersonal and independent of the transmitter.

In a study of dramatic story-telling Ödeen (1988) makes an interesting comparison between narrative and scientific knowledge. He sees rhetoric (here seen as a form of narrative knowledge) as a way of creating order out of chaos. This order is a social construction which is temporary and changeable. No assumption is made about the existence of a true reality. Which versions of reality acquire followers is a question of rhetoric, depending on the various narrators' ability to present their versions of reality versions in an appealing and credible way. Rhetoric tries to portray material reality,

and interacts with a specific audience in its construction of reality. It is realistic in its character and is geared to change.

In the area of scientific knowledge, the existence of a true reality is assumed. This true reality should be represented as exactly as possible. The scientist does not address any specific audience with a view to portraying the material world; rather, he addresses the whole of humankind, and his ambition is to communicate knowledge about true reality. Scientific knowledge is therefore by nature Utopian and idealistic.

Since rhetoric distorts reality, scientific knowledge can be said to be anti-rhetorical. But the problem about an anti-rhetorical communication strategy is that little attention is paid to audience reaction, with the consequent risk that the audience loses interest in the performance. To avoid this, scientific knowledge is often forced to use rhetoric, albeit in a disguised form. Plato's use of the dialogue as a vehicle for communication is one example of this. Although scientific knowledge tends to regard narrative knowledge as an inferior and potentially dangerous form of knowledge, it still has to use elements of narrative knowledge to make its own knowledge sound convincing.

3 *Performative knowledge* Lyotard describes performative knowledge as a more recent form of knowledge, which came to the fore particularly with the industrial revolution and which has been the dominating form of knowledge since the Second World War.

In performative knowledge, whose foremost representatives are probably engineers and business school graduates, the important thing is what Lyotard calls 'system-technical efficiency'. This is achieved as a result of technical and administrative innovation and rationalization.

This form of knowledge justifies itself by changing the world. Since the technical and commercial exploitation potential of knowledge is what matters, this has led to growing demands that scientific knowledge should possess a performative value, in order to attract the funds needed for the production of such knowledge (i.e., for research).

This exploitation and commercialization of scientific knowledge has been well documented by writers on the management of innovation (see, for example, Tushman and Moore, 1988). However, it is not only scientific but also narrative

knowledge that can be transformed into performative know-
ledge. Even within the arts it is not 'art for art's sake' any
more. Narrative knowledge has been exploited in the same
way as scientific knowledge ever since the coming of the
industrial revolution, although less attention has been paid
to this in organization studies than to the exploitation of
scientific knowledge. It should also be noted that in the
liberal economies of the world, society's production of art is
organized on commercial lines, with privately owned com-
panies financing and distributing the major share of all
culture products. This means that it is not enough for a work
of art to have an aesthetic value; it must also possess a
commercial value, even though this may create problems for
the artists: 'You make the deal, you shoot the deal, you edit
the deal, and you release the deal. It's no longer a movie, and
you forget why you wanted to make films in the first place
(Oumano, 1985, p. 292).

But if it has become art for money's sake in Hollywood, it
became art for politics' sake in the former command eco-
nomies of Eastern Europe, where the production of art was
organized on political instead of commercial terms (Haraszti,
1987). In these economies artists were vehicles employed by
the government for the construction of a communist society.
Since artists in this system received a regular salary from the
state, they did not have to worry about the fluctuations of a
fickle art market. It was not necessary for art to possess a
commercial value, but it did have to have a political value. If
the capitalists demanded an economic pay-off, the commun-
ist state demanded a political pay-off. Art for art's sake met
with even less tolerance in Eastern Europe. In a market
economy artists can normally do more or less what they want;
it is only if they want to earn a living from their art that they
have to pay attention to its commercial value.

How, then, is the commercial exploitation of narrative know-
ledge accomplished?

BUSINESS STRATEGIES

It is not easy to make money from the arts. Most arts products
fail. Only a few yield any profit. A common perception is that it

is more or less impossible to predict the commercial reception of individual arts products.

> Given the built-in uncertainties of the market for many types of books, the book trade, like the fashion business or the movie industry, often operates on the shotgun principle. As one Hollywood mogul is said to have told an inquisitive reporter, "One of the films on this list of ten will be a big success"; but when the reporter queried, "Which one?" the producer answered, "I have no idea".
>
> (Coser, Kadushin and Powell, 1982, p. 7)

A significant feature of cultural production from a commercial point of view is thus the great unpredictability of the market response to individual products (Coser, Kadushin and Powell, 1982; Neuman, 1991; Ryan, 1992). Postmodern theory, with its focus on cultural changes in society, offers a tentative explanation of this unpredictability.

The postmodern view of arts production has defined itself in a critique of the view adopted by critical theory. According to critical theorists (e.g., Adorno and Horkheimer, 1989), society's production of art is controlled by a small number of commodity capitalists (media conglomerates) who mastermind society's production and consumption of culture by maintaining monopolistic control over the supply of culture products. This notion has led critical theorists to condemn popular culture in particular, and to look back with nostalgia to the allegedly genuine (commercially unexploited) folk art of the pre-industrial age (Tomlinson, 1990). Critical theory's ideas about the way arts production functions have attracted criticism from a growing number of researchers in the field (see, for example, Frith, 1987; Eisenberg, 1988; Eliot, 1989 on the way the record industry works; and Kerr, 1986; and Jowett and Linton, 1989 on the film industry; and Coser, Kadushin and Powell, 1982 on the functioning of the publishing industry).

Collins (1989), in a general critique of the critical theorists' view of arts production, argues that their conception of the way culture is produced is an oversimplification which makes it difficult to acquire any deep understanding of the phenomenon in general and of the production of popular culture in particular. The critical theorists' view rests on the assumption that culture is produced centrally by a power elite. However,

Collins sees no signs of this being so; indeed, the opposite seems to be the case. The production and consumption of culture occurs in a decentralized and unforeseeable way, as the result of the interaction of a variety of cultural discourses. It is therefore impossible to achieve totalitarian control over the production and consumption of the arts. Thus, while critical theory assumes that the 'text' is under control, postmodernism assumes that it is out of control, and stresses the unpredictable and random way in which arts products arouse wildly varying amounts of attention.

The market response to arts products is also influenced by the act of consumption, since arts-producing organizations sell potential meanings rather than finished products (Fiske, 1989; 1990). It is not so obvious how a film should be seen as it is clear how a car should be driven. Culture consumption therefore resolves itself into the production of meaning. For a culture product to gain commercial success, its potential meaning has to be transformed into a popular meaning. This usually happens by word-of-mouth, i.e., consumers recommend each other to see a certain film or to buy a certain record or a certain book. The producers do not have much control over this process – nor can they have, according to Fiske, if a product is to become popular culture. Popular culture is culture on the audience's terms (Gans, 1974). It is therefore the public and not the producer who transforms something into popular culture. High culture on the other hand is culture on the artist's terms. In high culture it is the artist's and not the public's meaning that is emphasized. The public therefore has to be educated if it is to grasp and understand the artist's meaning. High culture entails a more controlled creation of meaning than popular culture, which does not usually have any educational ambitions.

'I'm not interested in culture. I'm not interested in pro-social values. I have only one interest. That's whether people watch the program . . .' says Arnold Becker, CBS' . . . vice-president for television research.

(Gitlin, 1985, p. 31)

Potential popular culture products aim instead at attracting the widest possible audience. The products must therefore be easily accessible, so that as many people as possible can understand them. To be able to enjoy the products of high culture, the

consumer usually has to be very interested in the arts. Academic knowledge is often required. For this reason it is rare for high culture to succeed in becoming popular culture. In the case of a potential popular culture product, it is more important that the consumers can create their own meaning with respect to the product than that the product enables the consumers to discover a meaning which the producer attaches to it. In popular culture the creative activity lies in the consumption, whereas in high culture it lies in the production. None the less, just why certain products rather than others do get transformed into popular culture, is still unclear.

> The reasons for some American productions' smashing box-office records were unpredictable . . . An erratic public composed of irregular spectators . . . would run to see only one film . . . and creating thus a fashion, they would draw in their wake audiences amounting sometimes to over 10 million people in one country.
>
> (Sorlin, 1991, p. 156)

A prominent feature of arts-related businesses is thus a high level of uncertainty in the market response to individual products. Because of this uncertainty, the business strategies of arts-producing organizations tend to be 'emergent' rather than deliberate, an outcome of interaction with the environment rather than the result of internally generated business plans.

If it is to be possible to set up and to realize a deliberate business strategy, the internal and external business environments both need to be reasonably stable and predictable (Mintzberg and McHugh, 1985; Mintzberg and Waters, 1985). Many of the contributions to the serious literature on strategy – such as Michael Porter's theory of competitive advantage through strategic industry analyses (Porter, 1980; 1985) – assume a fair amount of control over a company's internal and external affairs. In such a situation, it is further assumed, management is able to formulate strategic plans (touching upon all the activities of the company), which can also be implemented without any major internal or external disruptions.

This idealized description of strategic management does not seem equally appropriate to the business of the arts-producing organizations, given the high degree of uncertainty in the

market response to their individual products. The control which such organizations can exert over their environment is often limited, which is why I have described their strategies as 'emergent', evolving from their interactions with the environment. It is therefore important for arts-related businesses to *learn* from their interaction with the environment; otherwise the risk is great that the strategy-as-realized will diverge in an undesirable way from the strategy-as-intended.

This is not to say that arts-related businesses are totally at the mercy of an unpredictable environment. From Bourdieu's observations on the handling of book publishing (Bourdieu, 1977) it would seem that there are two dominating business strategies when it comes to managing the market uncertainty of arts production – one cultural and one commercial. A commercial strategy means art on the market's terms. It concentrates on controlling the supply with a limited amount of arts products on the market; these are then supported by forceful marketing and are expected to yield a rapid return on the money invested.

> the more 'commercial' the orientation of a firm ... the shorter its time perspective and the greater the tendency to produce books that will meet an existing demand and fulfill particular readers' interests. Such houses, in Bourdieu's view, are geared to the rapid turnover and quick obsolescence of their products, and to the minimization of unnecessary risks.
>
> (Coser, Kadushin and Powell, 1982, p. 44)

A cultural business strategy means art on the artist's terms, and such a strategy takes a long-term view. It reduces the uncertainty by developing a number of artists and hoping that some of these will eventually become commercially succesful.

> Firms that are intent upon acquiring symbolic capital must follow different strategies from those geared to quick accumulation of financial capital. Bourdieu highlights the fact that those firms concerned with symbolic capital are by no means engaged in philanthropy. They, too, are geared to the logic of profitability, but they operate within an extended time perspective in which immediate returns and quick maximization of profit are not the primary considerations.
>
> (Coser, Kadushin and Powell, 1982, pp. 44–5)

Bourdieu himself only applied this conceptual framework to the production of literature. However, his strategic concepts about the way the production of literature functions can also help us to understand the production of films and records. Bourdieu's framework will therefore be extended below to encompass the activities of record and film companies.

We can illustrate the commercial strategy in action by looking at the way in which major Hollywood movies – around one hundred of which are released each year – are marketed. *Batman* (1989) was such a major movie; it was also an example of a marketing campaign that went according to plan, i.e., the film was a hit.

As a major movie *Batman* was given a nation-wide blockbuster campaign, entailing $20–30 million in marketing costs and encompassing a wide variety of promotional activities (Jowett and Linton, 1989). A potential blockbuster opens at the same time all over the United States. Thousands of copies of the film have to be available. During the opening week the film is launched with trailers on television and at cinemas, full-page ads in the newspapers, billboard advertising, interviews with the stars and the director on TV and in magazines. The box-office revenues of the opening weekend decide the film's future. If a film shows poor box-office returns on its first showings, marketing activities are discontinued and the film is withdrawn after a couple of weeks. Part of the cost of such a film can be recovered on the export and video markets, but if a film has done badly at the cinema it does not usually do any better in the auxiliary markets (Kent, 1991). If a film is a box-office success, the marketing continues and can then be supported by favourable reviews and reference to box-office figures already achieved. But in the long run the marketing activities of the film companies are not enough. For a film to be a long-term success it must become genuinely popular. This happens when a film becomes part of popular culture, and this is what happened to *Batman*.

The advance interest in this film was so huge that people went to see other films just to be able to catch the *Batman* trailer The film music had become a hit record before the film opened. During its opening weekend *Batman* grossed $42.7 million in box-office revenues at the 2,194 opening screens; it covered its production costs of $35 million in less than three days. The

queues for the film were so long that people started to spill over to other films with shorter queues.

> The crush to get into movie theaters across the country was so enthusiastic that it carried the entire boxoffice for all movies to more than 90 million dollars for the three days. (Frustrated by unbearably long lines at some of its 2,194 screens, many people dashed to Disney's modest comedy, *Honey, I shrunk the Kids*, in large numbers, so that this film collected 14.2 million dollars for the weekend.)
>
> (Jowett and Linton, 1989, p. 60)

After 10 days *Batman* had grossed $100 million, and five months later $250 million. When the film was released on video it generated another $400 million in revenues.

For an example of the functioning of the cultural business strategy we can look at the relations between the French publishing house Edition de minuit and the Irish author and playwright Samuel Beckett. This also provides us with a case in which investment in an author went according to plan, i.e., the investment in cultural capital yielded economic returns in the long run.

In 1950 the owner of Edition de minuit decided to publish three novels by the then unknown Beckett – novels that had been rejected by six other publishers (Bourdieu, 1977). Two years later the publishing house accepted and published Beckett's best-known work, the play *Waiting for Godot*. This sold less than 200 copies the year it was published, but 25 years later it had sold 500,000 copies. This dramatic increase in the sales of Beckett's play was the result, not of huge marketing efforts, as in the case of *Batman*, but of the author's growing literary reputation which culminated in 1969 when he received the Nobel Prize for literature. The cultural business strategy thus adopts a much longer view, focusing on cultural values that may ultimately yield economic returns, while the commercial business strategy adopts a shorter view and focuses on commercial values and an immediate economic pay-off.

European trade publishers seem to work according to a predominantly cultural business strategy, to judge from Sutherland's investigation of the European publishing industry (Sutherland, 1981), where the common business practice is to make a long-term investment in particular authors who are

expected to yield a profit in the long run – an approach that has some similarities with the portfolio strategy. Film companies in general can be said to follow a predominantly commercial business strategy (Jowett and Linton, 1989). There are indications that record companies adopt a mixture of the cultural and commercial business strategies. Rogan's investigation of the work of British pop star managers, for example, shows that the managers invest in individual artists but in a much shorter time perspective than publishers, and with much more marketing (Rogan, 1988). A musician is given two or three years at most to achieve a commercial breakthrough. If this does not appear the manager drops the musician concerned.

These different ways of managing arts-related businesses such as publishing houses and record and film companies can be summarized as follows:

Publishing houses	Record companies	Film companies
Cultural		Commercial
Business strategy		Business strategy

This is not to say that all publishers have a cultural business strategy, all film companies a commercial strategy and all record companies a mixture of the commercial and cultural business strategies. What can be said is that film companies in particular, but often record companies too, tend to choose a more commercial business strategy than publishing houses, because of the much bigger investments required for the production of films and records. It is easier for publishers to choose a cultural business strategy since it is less costly to print a book than to make a record or a film. With the huge investments, particularly in film-making, where it is not unusual today for the production of a major Hollywood movie to cost $50 million, market considerations tend to become the dominating concern of the film companies.

> Audiences must be attracted to provide revenue to cover costs and provide a return on investment, and this is done by 'giving the people what they want.' While art may be the result of such a quest, it is more a by-product of the process than a primary focus.
>
> (Jowett and Linton, 1989, p. 16)

While a quality publishing house might put its money on a whole stable of authors, in the hope that one of them will eventually achieve a commercial breakthrough, it is much harder for film companies to follow the same strategy, putting their money on a stable of directors in the hope that one of them will become a new Steven Spielberg or Ingmar Bergman. It is quite a different thing to risk losing a $20 million investment in a young director than to risk losing $20,000 on a young author.

The differences between the business strategies are neatly pinpointed by the different ways in which publishing houses and record and movie companies use their economic surplus. If a popular novel from a culturally inclined publishing house yields a profit, the surplus is used to finance the publication of more literary books. If a pop group with a record company makes a commercial breakthrough, the resulting economic surplus is used to finance investment in more pop groups. If the publishing house had applied the record company's business strategy, its economic surplus from the succesful book of popular fiction would have been invested in more popular fiction.

If a popular film becomes a hit, the economic surplus is used to generate more popular films. The difference as against the record company is that the film company recruits even more famous directors and stars for the next film, instead of spending money on developing new directors and stars. A publishing house applying the film company's strategy would use any economic surplus to try to attract even more famous authors.

The employment of a commercial strategy in arts production has risen sharply since the 1980s, and is continuing to do so (Twitchell, 1992). The application of a predominantly commercial business strategy is no longer limited to Hollywood. The American publishing industry has also become more commercially inclined. Large American publishing houses no longer dare to put all their faith in favourable book reviews, when they are paying advances of $2–300,000 for book manuscripts. Consequently, they try to turn their authors into public personalities, so the publication of a book automatically gets media coverage. Even in the field of high, culture more commercial thinking can be observed, with classical concerts promoted by the presence of international megastars like Pavarotti or heavily

hyped museum exhibitions such as the Andy Warhol show at the Museum of Modern Art in New York in 1989. One reason for this development could be that the general noise level in the media has become so high that only very loud signals can be heard. Thus, it no longer seems enough for an arts product simply to be 'art'; if it is hoping to find an audience, it must also become a media event.

The manufacturing of celebrities, as a way of gaining media attention for new products, has turned into an industry of its own (Rein, Kotler and Stoller, 1987; Fowles, 1992; Gamson, 1994). Celebrity is a product of the industrial revolution. In the old feudal society potential celebrity candidates mostly had to make do with local fame, unless perhaps they managed to get their portrait printed on coins and bills. In pre-industrial village society the need for social identification objects could be satisfied at the local level. When the countryside in the Western world was depopulated during the nineteenth century, daily living became an impersonal and anonymous affair for the new city-dwellers. It proved difficult to find social identification objects among the anonymous crowds in the towns.

The new society was not slow to answer this unsatisfied need for social role models, especially since it proved possible to make money from it. The theatrical entrepreneurs of the nineteenth century soon discovered that some actors became more popular than others and that audiences were often drawn by the actor rather than by the particular play. This star phenomenon rapidly spread to the emerging film industry in Hollywood. As early as the First World War, actors such as Charlie Chaplin or Mary Pickford had become well established as film stars. Nor did the stars function only as objects of social identification: as the family institution largely ceased to be a production unit and became a consumer unit in the new society, the stars also came to be perceived as consumer role models. They became 'star' consumers, by exhibiting their conspicuous consumption of an abundance of goods and services.

During the 1920s and 1930s, when the film studios in Hollywood discovered that film stars were a great commercial asset in the sense that they automatically created attention around a film, the industrialization of the production of stars began. Potential film stars were given an appropriate market image,

such as the romantic hero (Clark Gable) or the romantic heroine (Greta Garbo). This market image was an artificial product, linked very loosely, if at all, to the person's real way of being or living. The romantic hero of the 1950s, Rock Hudson, for instance, was homosexual in his 'real' life. But celebrity consumers care little about missing links between the media image and the person behind it; they are quite content to talk about the media images as some kind of fictive beings who exist in a parallel world where the most fantastic things can happen. Instead of the local gossip of the pre-industrial society, which revolved around village personalities, the gossip of today fixes on to the lives of national and transnational celebrities (Gamson, 1994).

Ever since the Second World War celebrities have been becoming an increasingly important marketing device. To communicate a message on any greater scale it has become necessary to turn to the media (radio, TV and the press). This need for media attention that is required for the marketing of a new product has endowed the media with a double role, whereby it functions as an actor in its own right as a critical examiner of society as well as constituting an arena for other actors' interests. Celebrities, whose main commercial asset is their ability to attract attention, entice people to buy newspapers and magazines, to listen to the radio and watch television programmes. The media performance provides publicity, not only for the celebrity in question but even more – it is hoped – for the product the celebrity is representing, be it a book, a record, a film – or even a car. The film star Michael Douglas, for instance, was paid around $5 million for appearing in a 30-second commercial for the Japanese Nissan car. Celebrities can therefore be regarded as arts products with a commercial mission, as living advertisments for a variety of products and services.

In the three following chapters the functioning of the commercial and cultural business strategies will be illustrated more fully with examples from the production of books, records and films. To demonstrate the emergent, as opposed to the deliberate, character of the strategic development in the three industries, I open each chapter with a description of the historical development of the industry in question.

SUMMARY

In this chapter a strategic framework for the functioning of arts production has been presented. Art is regarded as narrative (artistic) knowledge that is exploited commercially by arts-producing organizations. A prominent feature of such undertakings is the high level of uncertainty about the market response to individual products. One explanation of this unpredictability is that the production and consumption of culture products happen in a decentralized and unforeseeable way as the result of the interaction of a variety of cultural discourses. Two business strategies for managing this market uncertainty have been identified. A commercial business strategy means art on the market's terms. It focuses on controlling the supply, with a limited amount of arts products on the market, which are then supported by forceful marketing and expected to yield a rapid return on the money invested. A cultural business strategy means art on the artist's terms, and this strategy takes a longer view. It reduces the uncertainty by developing a number of artists and hoping that some of them will eventually become commercially successful. Publishing houses generally adopt a predominantly cultural business strategy, film companies a commercial one, and record companies a mixture of the cultural and the commercial strategies. Film and record companies are inclined to choose a more commercial type of business strategy than publishing houses because of the much greater investment involved in the production of films and records.

Chapter 4

A profession for gentlemen

> The avalanche of books this year comes to about 10,000 titles. But what we're seeing is not a golden river of spiritual wealth; it's the big-business delivery of printed goods.
>
> (Halldén, 1989, p. B4)

Thus spoke a literary critic in Sweden, trying to grasp just what had been published in her country in 1989. Then she added that, of course,

> the main difference between old and new literature is that the new is still unwinnowed. Of the old, only the best remains. For each great poet who has become familiar to us, there have been a thousand minor versifiers. What we see in contemporary literature is a kind of nursery or laboratory.
>
> (Halldén, 1989, p. B4)

But it is the publishers who start the winnowing process. What the critic sees is only the top of the iceberg. The odds are almost a hundred to one against the publication of unsolicited manuscripts, with which the major publishing houses are inundated. We might therefore wonder how an industry with such a high rejection rate still manages to produce an 'avalanche' of books every year.

In this chapter I shall try to describe the basic character of book publishing, referring to the rather limited academic output that has been devoted to the industry. Most academic interest has concerned the books themselves and their authors. However, some excellent studies of the publishing field as such have also appeared. Coser, Kadushin and Powell (1982) and Powell (1985) together represent a very thorough study of the

American publishing industry, covering 56 American publishing houses. Sutherland's study of bestsellers provides interesting insights about differences between American and European publishing (Sutherland, 1981). Pettigrew's and Whipp's (1991) study of two major British publishers, in connection with a larger study of strategic development and change in the British industry and service sector, furnishes useful information about recent developments in the British and the international publishing industry. The description of book publishing in the following pages owes much to these four studies. Book publishing in Sweden, which on the whole reflects a European publishing tradition, is described in some detail on the basis of a study of one of Sweden's major publishing houses, Norstedts (Björkegren, 1990). The chapter concludes with a brief overview of the history and development of literary theory, in which the changing roles of literature in society are particularly noted. This description is based on the writings of Eagleton (1989) and Kernan (1990), both of whom have paid special attention to this question. The overview is therefore concerned primarily with Anglo-American literary theory.

HISTORY

The art of printing was invented in the fifteenth century. The modern publishing industry, however, with its system of mass-production and distribution, did not emerge until the nineteenth century, when improved printing technology made it possible to mass-produce printed matter at low cost, and when a great many more people than before could read. Before the nineteenth century the reading of books had been limited to the educated upper classes, since books were very expensive and illiteracy was widespread.

Literary agents and agencies began to appear around the turn of the century. The literary agents saw their work as a professionalization of the publishing business. Publishing had become so complex that the authors were no longer regarded as capable of handling their relations with the publishers on their own. Literary agents, with professional knowledge of the business and legal aspects of publishing, stepped into the gap. Publishers disapproved of this at first, since the agency system weakened their advantageous bargaining position *vis-à-vis* the

authors. However, they discovered fairly soon that the literary agents could help them to sort out the ever-growing piles of unsolicited manuscripts that otherwise landed on their desks, and so began to take a kindlier view of the work of these upstarts in the publishing world.

The publishing industry continued to expand and flourish until the arrival and rapid spread of television in the 1950s and 1960s, after which its growth slowed down. The spread of television meant that the printed word lost its privileged position as society's primary source of knowledge and information. The print culture had to face a new competitor in the visual and electronic culture of the emerging information society, in which knowledge and information could now also be purveyed by the flickering images of the television screen (Kernan 1990). In the hardening business climate mergers were common in the publishing world in both Europe and the United States during the 1960s, as publishers sought a way of improving the efficiency of book production. The industry acquired an oligopolistic structure, with a small number of publishing and media companies accounting for a large part of the market. The American publishing industry, for example, was dominated at the beginning of the 1990s by five media conglomerates (Blecher, 1990). In the UK 11 book publishers accounted for 62 per cent of the market in the mid-1980s (Pettigrew and Whipp, 1991). On the international publishing scene six international publishers dominated the international market in the mid-1980s. The rationalization of publishing also spread to the bookshops, with fast-growing nation-wide chain stores taking over from other bookshops in the 1980s (Pettigrew and Whipp, 1991).

In the United States attempts were made to rationalize publishing by introducing some standardization into production. This meant concentrating on a few titles, which were released to a fanfare of publicity. Judging from Sutherland's study of bestsellers, an American publisher apparently experiences his greatest joy when an author breaks out of the literary strait-jacket and goes commercial.

> There are, of course, American writers of literary distinction who make a modest, and sometimes a spectacular showing in American bestseller lists . . . But often one senses an ulterior purpose in their publishers' motives, an itch to convert

quality into cashable, mass-market quantity . . . It is as though for the American trade an author, whatever the literary brilliance, is only fully realized with the 'novel of bestselling caliber'.

(Sutherland, 1981, p. 26)

Mario Puzo is an excellent example of this thesis.

'I was forty-five years old and tired of being an artist . . . It was time to grow up and sell out' . . . Once published *The Godfather* assumed the #1 spot on the *New York Times* list, and held a place in the top ten titles for sixty-seven weeks . . . By 1978 it was one of the select half-dozen novels to have broken the 10 m. sales barrier in the US, and is credited by Hackett as being the bestselling novel ever.

(Sutherland, 1981, pp 38–9)

The value of a bestseller is thus primarily commercial. The important thing is that it sells and attracts commercial attention, not that it is reviewed and attracts literary attention. A bestseller is a book that sells 1–6 million copies over one or two years. Books with best-selling ambitions are not written for eternity but are expected to yield a high return on investment as quickly as possible. Books that do not become bestsellers therefore enjoy a very short life. 'Up to 50 per cent of all American paperbacks are reported to die on the shelf after an average of two weeks' display life' (Sutherland, 1981, p. 37).

The greater part of a publisher's output is still not in the best-sellers category, however, even though there is a clear tendency in this direction in the American publishing industry. The major American publishers have become more commercially inclined and tend to concentrate on the production of the literary 'hit' – the bestseller. The editor-in-chief of the prestigious American publishing house Pantheon, was fired in 1990 because he gave priority to literary rather than commercial interests in his publishing list. This was presumably a straw in the wind.

This event confirmed the suspicions of many that the media conglomerates only want to publish bestsellers. These are even becoming known as mega-sellers or, better still, "global books", and may be written by . . . Stephen King, Danielle Steele, Sidney Sheldon, or, indeed, Umberto Eco, Gore Vidal, Gabriel García Márquez. These names sell all over the

world, like the records and cassettes of Michael Jackson or
Luciano Pavarotti.

(Blecher, 1990, p. B2; our translation)

This commercial mentality has not come to prevail to the same
extent in Europe, where publishing has continued to be re-
garded, in the main, as a profession for gentlemen. To sell
books with the help of best-seller lists is considered unbecoming
for a serious publisher. It is the cultural and not the commercial
value of a book that is important. 'The value of a book lies not
in how well it sells . . . but in what the best critics make of
it, how well it stands the various tests of time' (Sutherland,
1981, p. 17).

But European publishers are no strangers to the idea of using
the revenues from bestsellers to subsidize less-selling books.
But the focus has so far stayed on the publication of culturally
rather than commercially valuable works. European publishing
houses, therefore, tend to avoid massive advertising campaigns,
since a book's literary character is still regarded as more
important than its commercial value.

In publishing it is often argued that a publishing house
produces cultural as well as commercial capital. Economic
profit is not a goal in itself, but is seen as a means in the creation
of cultural value. Generally speaking, a publishing house has to
strike a balance between commerce and culture. It has to break
even financially while also ensuring the publication of the
products of society's written culture – even though this last
obligation is sometimes denied: '"We sell books, other people
sell shoes. What's the difference? Publishing isn't the highest
art"' (Michael Korda, Editor-in-chief at Simon and Schuster,
quoted in Powell, 1985, p. 2).

It can be noted here that the increasing use of electronically
based technology has helped to rationalize publishing con-
siderably since the 1980s (Pettigrew and Whipp, 1991). On
the production side, desk-top publishing has done much to
rationalize editorial work. More and more authors deliver their
manuscripts in electronic form, and computer-assisted publish-
ing and printing can now be handled by people other than
professional printers.

On the new product side, multi-media products such as
CD-ROM (compact disc read only memory), which combine

data, video and audio information, are attracting the growing attention of the publishing industry. Some observers even speculate that the printed book may eventually be supplanted by the electronic book, given the enormous storage capacity of a CD-ROM (Petersson and Zetterqvist, 1994). So far, the main usage for CD-ROM is in the field of reference books and encyclopaedias, where the superior storage capacity, the up-dating possibilities and the search enhancement functions of the electronic media offer an obvious competitive advantage over encyclopaedias in printed book form.

However, the emerging multi-media industry, which provides a new way of distributing the publishers' products, is still in its infancy. We can therefore only speculate on the future of the electronic and the printed book. An educated guess might be that except in the encyclopaedia field, the printed book will be joined rather than supplanted by digitalized products, since the multi-media products are less effective as an information medium than the printed book. It takes much longer to learn something by watching a person talk to the accompaniment of moving pictures, than by reading a printed article or a chapter in a printed book about the same topic. Furthermore, the use of multi-media products requires access to a computer, which means that electronic books are less easily transportable than printed books. Initially, electronic books are also more expensive to use, since they require an investment in computer hardware.

Notwithstanding the mergers and rationalizations that have been going on since the 1960s, the publishing industry has remained a mixture of mass production and handicraft. Since each book title is unique, it is impossible to standardize the products completely. And although the concentration of power has raised the barriers to entry, these are still low enough to allow new publishers to enter the market fairly easily.

In the United States the concentration on potential best-sellers helped to create unexploited market segments, of which small publishers with an eye to a niche were able to take advantage. At the end of the 1980s there were around 12,000 publishing houses in the United States (Erlandsson, 1987) and 9,500 active publishers in the UK (Pettigrew and Whipp, 1991).

In relative terms, however, the publishing industry is rather small. The American publishing industry, even in its entirety,

came only 50th among *Fortune*'s 500 companies in the early 1980s (Coser, Kadushin and Powell, 1982). The annual turnover of the American publishing industry was a mere $4 billion at the time (Sutherland, 1981). In the mid-1980s the UK publishing industry only accounted for 0.4 per cent of total consumer spending (Pettigrew and Whipp, 1991). But the cultural import-ance of publishing is much greater than its status in pure economic terms, since what publishers decide to print has a powerful influence on the general debate in a society. During the 1980s around 40,000 titles were published in the United States every year. Around 50,000 new titles were published in the UK in the mid-1980s. In both countries this avalanche of print probably did much to determine what caught the atten-tion of the general public at the time.

ORGANIZATION

Publishing is a decentralized and heterogeneous business. Coser, Kadushin and Powell (1982) emphasize that it is mis-leading to talk about American publishing as a homogeneous industry, since it encompasses many different publishing sec-tors, each one with its own logic. Pettigrew and Whipp (1991) come to a similar conclusion about the British publishing business. Publishing tends to be a decentralized activity because many parts of the publisher's operation are performed by subcontractors on a free-lance basis – including the authors of books, who are not employed by the publishing houses but who act as subcontractors producing book manuscripts.

Publishing, to most people, is perhaps associated with what publishers themselves call their 'trade' books, i.e., fiction and non-fiction intended for general readership. This is the part of the publisher's output that receives media attention and is available in general bookshops. In fact, of course, such publica-tions represent a minor part only of the publishing industry's total output. Most of its revenues come from the less glamorous publication of textbooks and practical manuals such as cookery books, gardening manuals, and so on.

The uncertainty attached to publishing springs from its very limited control over supply and demand. This is clearly illus-trated – to take one example – by the workings of the Swedish publishing industry at the end of the 1980s, when the individual

publisher had hardly any control over supply at all, so that their own books were easily submerged in the annual flood of print and a book's life expectancy was often less than three months.

Publishing is rather a slow process, and will continue to be so even with the new technology. It is slow by nature. It's not like magazine publishing. One reason for our current problems is that books have become perishable goods, but they are not made to be so. We make them to last for ever, but they are becoming perishables, which is not good at all. So many books are published by so many publishers, and the retailer's space is limited and overcrowded with new titles all the time. And there is a natural feeling among booksellers that the new should be displayed, and the old – which may only have appeared months ago – should be removed.

(Acquisitions editor, Norstedts, quoted in Björkegren, 1990, p. 64)

Publishers have even less control over the books the consumers buy. On the one hand, it is possible for the acquisitions editors to avoid books and authors they do not believe in; on the other, they can do nothing about all the books in the bookshops from other publishers. Which books sell is decided by the general cultural debate, by what is popular at the moment.

Changes in fashion do admittedly follow certain patterns (Sellerberg, 1987), and it is not unusual for a new fashion to emerge in reaction to an earlier one, often going back to an even earlier one in the form of a nostalgic regression. But exactly which of all the possible literary discourses will come to prevail at a certain time, is difficult to predict. Even if all the signs point in the same direction, a book can still fail. On the other hand, books no-one believes in can become bestsellers.

Publishers thus have to learn various ways of handling the uncertainty about which books will turn out to be popular. There are two business strategies commonly used for managing this uncertainty, one cultural and one commercial, as was noted in the last chapter.

A commercial strategy focuses attention on controlling the supply. A very limited number of titles is published, often at reduced prices and with the support of extensive advertising. The titles are chosen to fit the taste of a general audience. The output consists mainly of light entertainment literature such as love and adventure stories, mysteries and thrillers. The plots

often unfold in exotic settings, which are in themselves a source of excitement. Style, literary form and character creation are less important. The number of each of the most visible titles available to the consumer is thus reduced, making the demand more predictable: although the publisher still does not know which of ten spy stories the customer will buy, he is at least less uncertain than he would be if the customer had thousands of book titles to choose from. This business strategy is the predominant one among the big North American publishers. In the United States quality fiction is increasingly being published by small publishing outfits.

In Europe, the commercial business strategy is mainly employed by the book club market, in which a limited range of titles is heavily marketed and printed in big editions (10,000 or more). Otherwise, the operations of European publishers are dominated by the cultural business strategy (Sutherland). Norstedts' author-based strategy provides an example of the way this business tactic functions (Björkegren, 1990).

Norstedts is one of Sweden's major publishers. It is also one of the oldest, founded in 1823. In the 1980s Norstedts was owned by Esselte, a company specializing in office supplies and media products. Norstedts was at that time organized in two departments: fiction and academic textbooks in medicine and law. It published 400 titles a year. Seventy of the titles were academic and the rest fiction. Norstedts' academic textbook publishing was what gave the company the economic stability needed to maintain its relatively large but not always profitable fiction list. The company had 75 employees in 1989 and an annual turnover of $15 million.

Norstedts invested in authors instead of in the heavy marketing of single book titles, in the hope that some of its authors would eventually become commercially successful. Instead of investing in 10 book titles each year, the firm invested in 10 authors in each generation. By presenting a broad publishing list, Norstedts allowed the market to 'decide' which of its authors would eventually match some prevailing cultural current. Norstedts did not try, as the book clubs do, to influence current cultural trends directly by cutting down the number of titles published. Instead, they invested heavily in marketing, once one of their authors had become popular.

In the same way as the blockbuster strategy of the Hollywood

producers, Norstedts' business strategy led to a considerable reduction in market uncertainty. Hollywood producers know that of the 10 big movies of a particular year, one will be a hit, although they do not know in advance which one it will be. Norstedts described its own situation in similar terms. To get one successful author it was necessary to cultivate a whole stable of them. But a very great deal of patience was necessary, compared with the film industry, since it usually took 10–20 years before the best-selling author emerged and the return on the investment appeared.

> You have to be a crapshooter in this business. There is a rule of thumb saying that only 20 per cent of the books you publish will generate any profit. The rest don't make any money at all, or you even lose on them. If you're very foolish you might want to disregard that 80 per cent and deal only with the 20 per cent. But you won't get your 20 per cent if you don't bet on the whole 100. Let's say we have a stable of 10 authors. You then have to gamble on one of them making it big in future and generating a lot of money. The rest probably won't make it, but we don't know in advance which one will be the winner. It takes 20 years to find out. That's why we look on young authors as a long-term investment.
>
> (Management representative, Norstedts, quoted in Björkegren, 1990, pp. 42–3)

Manuscripts for possible publication are generated in various ways. The least common source is the unsolicited manuscript, of which the great majority are rejected. The huge uncertainty about the commercial potential of manuscripts is reduced in general by sticking mainly to books by established authors and well-known public figures. Money is seldom invested in unknown writers which, together with poor literary quality, explains the high rejection rate (almost 100 per cent) of unsolicited manuscripts. Another major cause of rejection is that many manuscripts fail to fit the particular publisher's profile. Some American publishers do not even bother to read unsolicited manuscripts, since they know that so few of them will be publishable. More commonly, publishable manuscripts arrive on recommendation from a reliable source, from a literary agent or as the result of an idea for a book originally suggested by a publishing editor. In the textbook and non-fiction fields it is often an

acquisitions editor who contacts suitable authors, asking for books that will fill a gap in the existing supply in a particular area.

The market response to academic textbooks is more predictable than the response to fiction, since academic publications are likely to follow prevailing scientific paradigms (Levitt and Nass, 1989). The textbook market is easier to influence, since the books have to be 'sold' not to their readers, the students, but to the teachers who decide on the required reading for a course. This makes the target group more manageable. Sales representatives can sell textbooks directly to the teachers. Further, external experts can judge the scientific quality of potential books in a way that is not possible in the case of literary manuscripts.

The logic of academic publishing (scholarly monographs) lies in small editions (often less than 1,000 copies) and high prices, since this market is fairly price-insensitive. Production costs can be kept down thanks to the relatively small amount of editorial and layout work required, compared to textbook publishing where editorial and layout accounts for a large part of the overall production costs. In this respect, academic publishing is similar to the publishing of serious literature, where editing and layout work is also kept to a minimum. Popular fiction, on the other hand, is more like textbook publishing on this point, with a lot of editing and high layout costs. This is because the content of such books varies very little; product differentation has to be achieved instead through the visual and physical appearance.

Academic literature is sold in university bookshops and by mail order. Advertising material is sent direct to the relevant academics. Quick delivery is then vital, since the books should preferably be dealing with the latest research issues. On this count there is a resemblance to popular ficition, due to the short life-span of books in this category.

Because a major part of total book production is contracted to external suppliers, i.e., authors, a well-functioning external network is vital. To create such a network is easier in academic than in fiction publishing, as academic opinion leaders can be found in the university system. In the case of literature it is harder to find the opinion leaders, since in this field the intellectual networks are not formally organized. Leading intel-

lectual groupings may appear, perhaps in connection with some literary journal, but the publication of a fiction list based on the activities of circles of this kind would be a much more unpredictable matter than the publication of academic literature.

What editors are primarily trying to decide is whether a manuscript is commercially viable. In a study of two academic publishers, Powell (1985) found that common reasons for the rejection of a manuscript were that it would involve too much editorial work, that the author was too demanding and difficult a person to deal with, that it would cost too much to publish the manuscript or that the editor did not understand its content. In so far as any literature of low commercial potential was published, Powell saw it mainly as a question of PR.

Nevertheless, even literature of dubious commercial appeal can yield a profit. Norstedts, for example, had developed several successful authors in both serious and popular fiction through its author-based strategy. The reputation which the firm had thus acquired as a quality house, was an important factor attracting the best-selling authors, who may not generate much cultural capital, but who are all the more succesful in augmenting the economic capital.

While a fiction editor's work consists largely of assessing manuscripts that are already written and have arrived unsolicited, or more commonly as the result of a personal recommendation, the non-fiction editors very often generate the ideas for potential books themselves. In this area of publishing unsolicited manuscripts are less common. The academic editors initiate books when they feel that a need for a certain textbook or academic monograph exists. If this is deemed to be the case, a suitable author, i.e., usually an expert in the relevant academic discipline, is contacted. The academic editors do not evaluate a book's scientific accuracy themselves, but rely for this on the author's own expertise.

Editors enjoy the highest professional status in publishing houses (Powell, 1985). They are responsible for the acquisition and editing of manuscripts. Often a person becomes an editor by chance ('the accidental profession' according to Coser, Kadushin and Powell (1982)). Since there is no formal education available for an aspiring editor, such people are expected to acquire the necessary knowledge in their daily work. The pay is low, since publishing is perceived as a glamorous and creative

trade. This situation is not unique to publishing, but applies to most culture-producing activities, where there is an excess supply of potential labour.

> young persons employed at substandard wages are important in almost all types of cultural endeavors . . . one of the marks of a "romance" industry is that it can get away with paying small salaries at its lower echelons because so many are lined up outside, waiting to get in.
>
> (Powell, 1985, pp. 64–5)

Most editors have some form of academic background. More important than academic qualifications, however, is intellectual curiosity and a genuine interest in books. The personal network an editor manages to build up is far more important than any expert knowledge of the particular publishing field.

Many editors are women, because of the low salaries and the opportunities for doing editorial work at home. Women who have become editors are sometimes ex-secretaries who have managed to advance to editorial positions. Others are promoted from assistant editorships. Assistant editors help the senior editors to produce books from accepted manuscripts, by editing the text in a variety of ways. Aspiring editors are also sometimes put to reading the never-ending stream of unsolicited manuscripts, whereby the discovery of a publishable manuscript might lead to promotion. Switches between the different publishing fields are rare, in the sense that it would be unusual for an academic editor, for example, to move into fiction or vice versa. According to a survey of editors' views on their own business (Gross, 1985), this is because editorial work soon becomes an area-specific occupation. Editing childrens' books is quite different from editing mystery novels. On the other hand, it is not uncommon for editors to switch from one publishing house to another to get an increase in salary.

A publisher's managerial control over its editors is informal, effected primarily through its own backlist – an important instrument in the socialization process. For example, in his study of academic publishing Powell found a recently employed sociology editor who systematically studied the firm's earlier publications (Powell, 1985). He asked her why, and she told him: 'These are books that the president asked me to look at.

He's exceptionally clever, always looking for old areas that can continue to be mined' (Powell, 1985, p. 149).

Powell then asked the president if he used to sift through the house's backlist, looking for resurrectible ideas.

> Oh, no that isn't an important part of my job at all. You see, (the sociology editor) is new here and unfamiliar with our backlist . . . I just thought that would be a good way for her to become comfortable with our image of the type of books we do.
>
> (Powell, 1985, p. 149)

A publisher's backlist thus expresses the house identity; editors can use it as a gauge by which to judge the status of new manuscripts. The editors' publishing decisions gradually generate certain publication profiles, since their lists consist mainly of established authors. An important task for management is to watch the editors' lists, and to see that the overall direction remains a profitable one, i.e., to ensure that the strategy-as-realized does not diverge in an undesirable way from the strategy-as-intended.

> This business is based on the constant accumulation of experiences, and an equally constant questioning of these experiences so we don't start to go the wrong way. Because if we do, we won't discover it until too late. It is difficult to change direction, because it calls for another network, and other authors. Or you have to tell your authors to write other books, which is difficult because they write what they want, not what we want. Publishing is rather like a stream of lava which can follow different tracks, but somewhere there is a track that is best. It can be very hard to find the right one. A stream can very easily take a wrong turning, if you don't have an internal evaluation process that never lets up. If you're on the right track it means you've managed to follow the trends, you've spotted the topics and events that are influencing the market. You have the books that are of real interest to the general public. But you might just as easily find yourself going in the wrong direction with almost the same books. An awful lot of books get written. There's always the risk that you slip into a stream whose books seem to have the right look, they seem to be of general interest, but in the end they're not the

right ones. Then you're in trouble, because you won't be able
to survive on those books in the future.

(Management representative, Norstedts,
quoted in Björkegren, 1990, p. 47)

A dilemma in publishing is that so much investment is necessary
to get a book published that the temptation is to go for larger
editions than are sure to sell. This applies especially to trade
books. In an academic publishing operation the return on
investment is considerably better. Small editions are no prob-
lem, since academic books are fairly price-insensitive. It is
possible to charge a high price for an academic book of limited
interest, which means that even small editions can be profitable.
To apply such a pricing policy to a novel with a limited audience
would be impossible, since fiction is very price sensitive. In
Norstedt's case this meant that the company's economic stability
came from its academic textbooks on law and medicine. Accord-
ing to Coser, Kadushin and Powell (1982), this is the normal
situation for a major publishing house. To run a large publish-
ing business based solely on fiction is considered more or less
impossible.

Once an editor has decided to accept a manuscript for pub-
lication, an internal marketing campaign has to be launched.
A book's external success is based to a high degree on the
amount of enthusiasm the editor first manages to generate and
communicate within the company. External reviewers can be
used here as rhetorical devices, to justify publishing decisions
already made. When a manuscript has passed through the
editorial process it is handed over to the desk editors who are
responsible for getting the books into print. At this point the
books are also submitted to graphic designers, who are given
aesthetic and technical guidelines by the editors and desk
editors.

Parallel with the editorial work, the marketing activities are
started. The problem in marketing and distributing books is to
get the products to their target groups. Since every book title is
unique, mass marketing techniques are difficult to apply. Book
reviews as a marketing device are of limited use: only a tiny
proportion of all published books are reviewed, and these are
mainly serious fiction and non-fiction. Of the 40,000 books
published in the United States in 1980 only 6,000 were reviewed.

And whether book reviews have any effect on sales is anyway unclear. Best-seller lists, on the other hand, do make an impact (Sutherland, 1981). The *New York Times* weekly best-seller list has a marked influence on the books which are sold in the United States. There is also a connection here with the way trade books are distributed in the States. The last two decades have seen the emergence of nation-wide bookstores concentrating mainly on bestsellers. And the books that become bestsellers there are the same ones that have appeared on the *New York Times* best-seller list, since the titles that are exposed and advertised in the bookstores are usually identical with those on the list (Coser, Kadushin and Powell, 1982).

Another effective marketing approach is to publish books with a long life expectancy, such as dictionaries and reference books which, just because they will be around for a long time, can bear heavy marketing costs. Yet another means of promotion is to publish series rather than individual books, so that marketing can be directed at the series as a whole rather than at each item separately.

Market surveys are rare in the publishing business: the high level of uncertainty and the fact that each book is unique makes it hard for individual books to carry any extra marketing costs (Brodin, 1979). The surveys that have been made are usually in areas where the market conditions are fairly predictable, such as textbooks. Otherwise, market surveys often represent something in the way of a stress-reducing ritual.

> A rampant belief in the fickleness and unpredictability of the public is matched only by a widespread belief that promotional activities are a kind of magic, which, if properly invoked, will sell books but which, if tainted by lack of faith or lack of enthusiasm, will utterly fail.
>
> (Coser, Kadushin and Powell, 1982, p. 204)

Word of mouth, i.e., people start talking about a book and recommending it to each other, is often regarded as the most efficient means of marketing.

According to a recent study (Brodin, 1995) about prevailing marketing strategies in publishing, there seem to be at least three commonly employed and often combined strategies that are used by major publishers: an assortment-based strategy, a distribution-based strategy and a publicity-based strategy.

An assortment-based strategy, which is especially useful for academic publishers, is built on the fact that while individual books cannot usually carry any extra marketing costs, the whole backlist of a publishing house can. Hence, a publisher's assortment can be marketed to the consumers and the retailers in the form of a seasonal catalogue including the backlist as well as the new books. Such catalogues can be distributed with the help of the bookshops, and in the case of academic publishers, via direct mail to the potential academic readers.

The distribution-based strategy aims at controlling distribution, thereby making it possible to sell a book through many channels. Publishers employing this strategy have their own distribution system and book clubs. The bookshops and the club members order the books directly from the publisher. To market the books to the retailers, the bookshops are regularly visited by the publisher's sales representatives. They promote the books in the bookshops and assist the bookshops with marketing activities revolving round the books. To market the books to the book-club members a membership catalogue is sent out, usually concentrating on a book-of-the-month choice that the members automatically receive unless they inform the book-club that they do not want it. The catalogue generally also contains the book-club's backlist and a couple of alternative new books to be ordered instead of the book-of-the-month. Members are normally obliged to buy a certain number of books, probably each year, in order to retain their membership.

The publicity-based strategy aims at marketing the books by creating media attention around their authors. Under this strategy a publisher does not stop at sending review copies to major newspapers and literary magazines. Instead, the media are actively tackled with information about books in publication, offers of interviews with authors or of the right to buy excerpts from coming books. In line with this strategy, some large American publishers started 'celebrity-making' as a way of marketing young first-time authors in the 1980s, trying to give the writers a market image that would excite attention in their books. The 'yuppie' authors Bret Easton Ellis (*Less than Zero*, *American Psycho*) and Jay McInerney (*Bright Lights, Big City*) are two succesful examples of this kind of marketing venture. Both attracted a huge amount of media attention, their books sold very well and were also made into films.

According to Brodin, the big publishers usually employ a mixture of these three marketing strategies, but with particular emphasis on one of them.

AESTHETICS

Modern literature, in the sense of independent literature, first really came into its own in the late eighteenth century with the emergence of the industrialized society (Eagleton, 1989; Kernan, 1990). Before this, literature did not have the same independent position in society, but was largely under the control of the Church and the aristocracy. In eighteenth-century England a piece of writing that was highly valued was perceived as literature, which thus included philosophy, history and theology. It was not until the birth of Romanticism that literature became identified with imaginative writing. The previous definition of literature in England in the eighteenth century had seen it as a cultivated language pertaining to the upper classes. Samuel Johnson changed this view in his dictionary of the English language late in the same century. Johnson chose to define the meaning of words according to the way they were used by established authors, including in his dictionary only words that had appeared in print. This signalled that control over words had passed to the professional writing class and that society had moved from an oral to a print culture. When, as a result, English literature lost its central role in the aristocratic culture, the proponents of the new literature had simultaneously acquired a new freedom.

> If literature had ceased to have any obvious function . . . then it was possible to turn this fact to literature's advantage. The whole point of 'creative' writing was that it was gloriously useless, an 'end in itself' loftily removed from any sordid social purpose.
>
> (Eagleton, 1989, p. 21)

'Literature' as a classification was limited to the best instances of creative writing, which in turn was seen as a universal product of the human imagination – even though literary theory came to be dominated by the study of Western literature. The authors themselves and the characters they created in their novels acquired growing prestige in society. Libraries were built,

courses in literature started and numerous secondary texts appeared in connection with books that had been declared to be literary classics. In the industrial society the arts became a free zone, sheltered from the demand for 'utility' which flourished in the other life-spheres. The arts represented an alternative ideology, stressing the creative rather than the mechanical element in human existence. The literature of romanticism provided a counterweight to nineteenth-century industrial society with its big cities and factories and its scientific rationalism. The Romantics yearned for the pre-industrial society, in which people were believed to have lived closer to nature and to themselves. The poets' mission was to preserve this older way of living in the new society. To accomplish this, it was felt that literature should not become completely assimilated into society.

Independent literature was first used in England as a way of educating the industrial society's working class. Reading literature was believed to create better human beings. Literature could therefore replace the Church as a device for the development of moral character. And because the authors wrote in the native tongue, no mastery of Greek or Latin was required. The teaching of literature in England thus started at the vocational schools, as a way of transmitting desirable moral values to the working class. Romantic literature went hand in hand with the liberal-market ideology of the early industrial society. Individualism, creativity and originality were highly valued qualities in business life as well. Notwithstanding its newly found role in society, the proponents of literature did not want it to be totally integrated into society. Literature should not merely serve society; it should also criticize it. This ambition acquired renewed force when the study of literature became an academic discipline in England in the late nineteenth century.

For English literature to become a university subject it was necessary for its representatives to define what literature was, how it differed from other forms of writing and what scientific methods could be used in studying it. To define literature as being limited to fictive texts did not work, because it was hard to draw a clear line between fact and fiction. To define literature as involving the innovative use of language required the existence of a specific norm for purposes of comparison. But that was to disregard the existence of innumerable dialects

and slang. Furthermore, such a definition captured, not what
literature was but what literary language usage was. That litera-
ture might be self-defining through a variety of qualities that
automatically transformed certain books into literature, did not
seem very plausible. Kernan and Eagleton therefore both prefer
an institutional definition of literature: literature consists of
highly valued texts. But the literary status of a text is time-
bound, and is constantly being revised. A comprehensive insti-
tutionalization process was required to turn Shakespeare, for
example, into a classic of English literature.

This obscurity on the subject of the nature of literature did
not stop literary theory from becoming an academic discipline.
In England, where the argument was that literature possessed
a unique power to civilize the reader, the new subject was at first
attached to language studies, since it was felt that the question
of a book's power to civilize its reader was difficult to encompass
in a system of student examinations.

> Literary study . . . became . . . a branch of philology, based
> firmly on the study of dead languages which surely needed to
> be taught and certainly could be examined in.
>
> (Kernan, 1990, p. 39)

The representatives of the new subject were not satisfied
with this compromise solution. The Victorian gentleman J. C.
Collins, who had been one of the strongest proponents of
literary theory in England, became so distressed when literature
did not become an independent discipline that he committed
suicide. After the First World War English literature not only
became a subject in its own right, but it was also perceived as
the only subject worth studying.

> In the early 1920s it was desperately unclear why English was
> worth studying at all; by the early 1930s it had become a
> question of why it was worth wasting your time on anything
> else.
>
> (Eagleton, 1989, p. 31)

The civilizing power of literature, and its role as a counter-
weight to the mechanization of life in the industrial society was
presented with renewed force by the literary theorist F. R. Leavis
in England during the 1930s. The old pastoral society, which
had not seemed too remote in the nineteenth century, had now

definitely gone. By reading serious literature it was possible for people to exist as moral and feeling individuals even in an industrialized society. Leavis thus gave a decisive answer to the question as to why people should read books.

> The answer, in a nutshell, was that it made you a better person. Few reasons could have been more persuasive than that.
>
> (Eagleton, 1989, p. 35)

The English poet T. S. Eliot proffered a similar argument. The human language, he claimed, had been in direct contact with the human senses up to the seventeenth century. Human beings experienced the world just as directly through language as through their sensory impressions. Seventeenth-century scientific rationalism created a split between the emotions and the intellect. The sensual language that brought us into direct contact with nature lives on in the literary classics, whose language is imbued with a sensual quality. The mission of modern literature, said Eliot, was to re-establish the sensual language of ancient times.

In the United States the literary scholar Richards followed in the footsteps of Leavis and Eliot. He too considered modern society to be in crisis, because science had denied the world enchantment. Literature can offer an emotional reconstruction of life by organizing human emotions in an aesthetically pleasing way, thereby providing an aesthetic survival device. Poetry can play a major role in this emotional reconstruction of society. It fulfils its function independently of the poet's intentions or the reader's experiences. A poem's meaning is public and objective. Unlike Leavis or Eliot, Richards formalized the interpretation of poetry – an approach to literary studies which became very popular in American literary theory because it endowed the discipline with greater academic status.

On the European continent, literary studies diverged from the English approach. German literary scholars found their inspiration in philosophy rather than in the study of language. The phenomenological philosophy of Husserl became a very influential source of inspiration. The early phenomenologists saw human consciousness and its mental representations of the world as the primary object of study. Humankind is asssumed to see the world through his own representations of it. Instead

of studying the way language is used, the German scholars focus on how humanity experiences the world. Human language is secondary to human thought in this mental construction of the world. Language only gives names to the mental experiences which are of primary importance. Literary phenomenologists look for a writer's representations of the world, which can be disclosed with the help of various forms of textual interpretation. The textual interpretation should be conducted as unconditionally as possible, since the goal is to understand the author's intention with regard to the text. This kind of textual interpretation on the author's terms can encroach on the reader's own representation of the world and reveal alternative ways of seeing it.

Phenomenological literary theory entails a strong emphasis on the author's significance. The structuralists and post-structuralists of the 1950s and 1960s argued the opposite. In 1957 the Canadian literary theorist Northrop Frye criticized Richards' formalized literary theory for not being rigorous enough. It is possible, he claimed, to conduct the study of literature in a much more rigorous manner, since literature is a system governed by objective laws. Furthermore, literature is a closed system. It is derived from other literature by re-combining existing literary texts, symbols and ideas. Literature deals only with itself, and says nothing about any extra-textual reality. If the goal of the natural sciences is to discover nature's order, the goal of literary theory is to find the order of the words. But Frye still preserves the Romantic idea of literature as society's free zone. With the structuralism of the 1960s, developed in France with the help of Russian literary theory and French linguistics, the last remnants of Romanticism were abandoned.

According to the French structuralists, words and literary texts have no meaning in themselves. Nor can texts or words acquire any meaning from their referential objects, since the relation of the words to the extra-textual world is arbitrary. They acquire meaning only in relation to other words and texts. The interesting thing to study is how a text generates meaning, not what meaning is generated. Texts deal only with themselves, generating meaning through their narrative structure. Such structures exist in Donald Duck as well as in Hamlet, and any

attempt to draw a sharp distinction between high and popular culture is therefore problematic.

According to Eagleton, structuralism resulted in the demystification of literature, which is no longer perceived as an expression of a more genuine and true existence. Rather, it is seen as an artificial construction which creates various effects with the help of sundry rhetorical devices. At the same time, structuralism entails a remystification of literature. According to the structuralists of the 1960s, books are written by the language, not by their authors. It is language which speaks through man, and not vice versa. This extreme confidence in the importance of language endows structuralism with an asocial character, since it sees language as an independent object and not as a social practice. Structuralism's asocial character is further reinforced by its lack of interest in the production and consumption of texts. Its interest is directed exclusively at the texts as such, and their relation to other texts. Extra-textual reality is disregarded or 'bracketed'.

Where structuralism emphasizes the order of the words, poststructuralism (literary theory's term for postmodernism) pays attention to their disorder. According to the poststructuralists, every word is made up of infinitesimal differences from other words. It is therefore impossible to nail down the meaning of a word in a definition. The meaning a word acquires is a haphazard product of a complex interaction between the word's relationships with other words. The meaning of words is both unstable and context-dependent. Even personal identity is unstable, since man is a product of language. The French psychoanalyst Jacques Lacan conceived the subconscious as a maelstrom of words, into which the self tries to bring an order that would render the words meaningful. But the game the subconscious plays with words is always on the verge of surfacing, threatening to destroy the self's attempts to create meaning.

> for Lacan all our discourse is . . . a slip of the tongue . . .
> Meaning is always . . . an approximation, a near-miss, a part-failure.
>
> (Eagleton, 1989, p. 169)

According to this approach, authors do not have much control over their texts. The written text lives a life of its own,

independent of the author's intentions. The interplay between the words' differences and the random output of meaning frustrates all attempts at generating a fixed and settled meaning. The text is out of control. The privileging of certain meanings lies beyond the range of language; it is determined in political power-play in which different social groups present their own interests as the true meaning and the foundation of all other meanings. The privileged meanings create a hierarchy of meanings, whereby certain meanings are more important than others, in exactly the same way as the self suppresses the subconscious. The privileged meanings suppress the free and democratic way of making meaning, which allows the existence of many meanings.

The French philosopher Jacques Derrida based his deconstruction methodology on this observation. By exposing the arbitrariness, instability and cultural dependency of social meanings, Derrida showed that society's privileged meanings are artificial fabrications without any firm grounds. The 'healthy' word betrays its own artificial character, and does not try to hide it.

Poststructuralism entailed a critique of structuralism by exposing the unstable and social character of words and meanings. According to Eagleton and Kernan this critique saved the privileged position of literature in society. Since there are no natural meanings from which to derive meaning, all creation of meaning is arbitrary. This means that all written texts are fictional.

> Philosophy, law, political theory work by metaphor just as poems do, and so are just as fictional.
>
> (Eagleton, 1989, p. 145)

Philosophy and science do not generate any superior truths. However, unlike literature, scientific writings try to hide their fictive and arbitrary character, and claim to be true. Fiction makes the reader aware of its own artificiality, which means – according to this view – that literary texts are superior to other texts.

> Literary works . . . are in a sense less deluded than other forms of discourse, because they implicitly acknowledge their own rhetorical status . . . Other forms of writing are just as

figurative and ambiguous, but pass themselves off as un-
questionable truth.

(Eagleton, 1989, p. 145)

Phenomenological literary theory underwent a similar develop-
ment. In the field of reception aesthetics, interest focuses on
the reader's role in literature. Structuralism and poststructural-
ism have made it seem less plausible that authors are in total
control of their texts. Literary texts can probably only suggest
possible readings, whereby meaning is created not only by the
author but by the reader as well. To allow the author a
privileged position after the poststructuralist deconstruction of
the literary classics does not seem reasonable to the proponents
of reception aesthetics. Even if literary texts are products of
linguistic and social conventions and privileged readings, there
is still considerable scope for the reader's own sense-making.
Texts cannot be rendered totally univocal and closed; there is
always some ambiguity and a certain degree of openness.
Reception aesthetics therefore sees meaning as being produced
during the consumption of the text. Literature is all the
readings that have ever been made, and the readers are co-
authors.

According to Kernan, the way Anglo-American literary theory
developed in the 1960s was in many respects a catastrophe for
literature. Until then, literature had been perceived as the best
that had been thought or said. Authors constituted a literary
aristocracy. Their books had been praised and interpreted by
critics to encourage the dissemination and reading of books.
Poststructuralism made all this seem dubious: authors were the
masters of the literary world, and the critics their servants.
Literary critics made privileged readings of the authors' books,
thus contributing to the suppression of the readers, the prolet-
ariat of the literary world. Literary classics were reactionary
writings, the work of dead white men, and they were used to
terrorize dissidents. The civilizing influence of literature was
now being questioned. It was being made to seem like an
ideological tool for the rulers of society rather than something
which brought out the best in man. According to this view, there
is no such thing as originality or creativity. Literature is merely
a language game, made up of re-combinations of existing
literature.

> Individuals create nothing but simply take the pieces their
> culture offers them and combine and recombine them by the
> rules of the particular cultural game they are playing.
>
> (Kernan, 1990, p. 28)

No-one is in control of the results of the language game. The
meaning of literary texts remains undetermined, contradictory
and self-dissolving. Literature is simply an expression of human-
ity's inability to create anything meaningful or permanent.

Kernan does, however, manage to see the development of
Anglo-American literary theory in a broader perspective, argu-
ing that structuralism and poststructuralism should be regarded
more as expressions of literature's changing role in society
rather than as its death. It is not literature that has vanished,
but Romanticism's notion of literature. Structuralism and post-
structuralism have provided a more realistic picture of how
artistic creativity functions. It is a question of re-combinations
of existing works of art rather than the creation of unique and
original ones. After the Second World War society moved out
of the print culture and into an electronic culture. The oral
culture of the pre-industrial age re-emerged in electronic form.
The flickering images of television screens are so incoherent
and fragmented that an oral commentator is required to give
them some coherence; the images alone can never achieve the
same precision as the printed word. Under the print culture,
the meaning of texts had become more difficult to ascertain,
since the opportunity for verbal and physical elucidation associ-
ated with the earlier oral culture had disappeared. The printed
word thus created epistemological problems that had not
existed before. The authorless television medium has created
a new epistemological problem in its turn. It has given rise to a
more superficial way of looking at reality. When readers were
transformed into viewers, faith in the written word as society's
primary source of knowledge and information declined, and
the author's control over language usage in society diminished.
Dictionaries were suddenly filled with the usage of the news
commentators instead of that of authors. Copy-writers and
politicians have become the linguistic innovators of the elec-
tronic society.

According to Kernan, structuralism and poststructuralism
signified these changes in post-war society. The idea that

literature had died was contradicted by the fact that more books than ever before were published in the 1980s. Moreover, the new direction of Anglo-American literary theory, with its focus on the creation of meaning, actually gave literary studies a much wider field of application. If it had become increasingly unclear what literature was, this must mean that anything can be literature. Literary theory no longer has to limit its business to written texts. Narrative structures available for study are to be found everywhere. Kernan also observes that even if the Romantic notion of art has been put to death in theory, it is still alive and well in practice, where it has been institutionalized. In practice, as we all know, authors still have a good deal of control over their texts, thanks to the copyright law.

SUMMARY

In this chapter I have looked at the way book publishing functions. The modern publishing industry emerged during the nineteenth century, when improved printing technology made it possible to mass produce printed matter at low cost, and literacy was more widespread. The publishing industry continued to grow in economic terms until the invasion of television in the 1950s and 1960s. Mergers became common in the publishing industry in both Europe and the United States during the 1960s, as publishers sought a more efficient way of producing books. The industry acquired an oligopolistic structure, with a small number of publishing and media companies dominating the market. Notwithstanding the mergers and the striving for efficiency, the publishing industry has remained a mixture of mass-production and handicraft. The industry's barriers to entry are still low enough to allow new publishers to enter the market fairly easily. In relative terms, however, the publishing industry is rather small, but its cultural importance is much greater than this would imply, since what publishers decide to print has a powerful influence on the general debate in a society.

The uncertainty attached to publishing stems from its very limited control over supply and demand; the demand for books, in particular, is highly unpredictable. Publishers thus have to learn various ways of handling the uncertainty about which books will prove to be popular. There are two common strat-

egies for managing this uncertainty, one cultural and one commercial. The commercial strategy is the predominant one among the big North American publishers. A limited number of titles are published, often at reduced prices and with the support of extensive advertising. In Europe, the commercial business strategy is employed mainly by book-clubs, in which a limited number of titles are heavily marketed and printed in big editions. European publishing is otherwise dominated by a cultural business strategy. The Swedish publisher Norstedts had an author-based strategy, which illustrates the way this business strategy can work. Instead of investing in a few book titles each year, Norstedts invested in a few authors in each generation, hoping that at least one of them would eventually become a success.

Editors enjoy the highest professional status in a publishing house. They are responsible for the acquisition and editing of manuscripts. The great uncertainty about the commercial potential of manuscripts can be reduced by sticking mainly to established authors and well-known personalities. A publisher's managerial control over its editors is informal, effected primarily through its own backlist, which expresses a house's identity and competence and is therefore an important instrument in the socialization process.

The problematic element in the marketing and distributing of books is to get the products to their targets groups. Since every book title is unique, mass-marketing techniques are difficult to apply. Word of mouth – that is, when people start talking about a book and recommending it to each other – is often regarded as the most efficient means of marketing.

The chapter concludes with a brief overview of the history and development of literary theory, with the emphasis on the changing roles of literature in society. In the next chapter I shall examine the workings of record production, which can exemplify a mixed cultural and commerical business strategy.

So you want to be a rock-'n'-roll star

The German philosopher Adorno obviously had no wish to become a rock'-n'-roll star; he was no friend of popular music.

> The music and the lyrics tend to exhibit . . . the language of a child. Predominant features include a never-ending repetition of a certain musical formula, like a child repeating the same demand over and over again ("I want to be happy"); the limitation of the melody to very few notes the way a small child speaks before it masters the sound of all letters; intentional faults in the harmony recalling the child's grammatical errors; and a certain sugary timbre, like musical candy.
>
> (Adorno, 1941, p. 294, our translation)

Popular music may be an aesthetically trivial phenomenon, but it is by no means economically trivial. In 1989 the international record industry grossed $22 billion. In 1987 the industry produced 2,390 billion records and cassettes. Around 7,000 singles and 5,000 LPs were released each year during the 1980s. Of total record production, rock and pop music account for 74 per cent, country music for 8 per cent, jazz for 5 per cent, classical music for 4 per cent, gospel for 3 per cent and other music for 6 per cent, according to an American study undertaken in the 1980s (Burnett, 1990).

Popular music has become the dominant musical expression of our time. It can be heard everywhere. The average Western brain spends 25 per cent of its time registering and decoding popular music (Burnett 1990).

Nor is it altogether certain that popular music is as aesthetically trivial as it is sometimes made out to be by its critics. Maybe its musical form is often more simple than that of jazz

or classical music, but the phenomenon of popular music cannot be understood exclusively in terms of musical qualities: what we are talking about is industrialized music. The underlying technical and commercial ideas have to be taken into account as well. It is also important to remember that popular music is mainly music for the young, which means that its social role in young people's lives cannot be overlooked. In light of all this, it could even be claimed that popular music is a more complex musical phenomenon than classical music, since the production and consumption of classical music are more straightforward.

In this chapter I describe some of the fundamental characteristics of record production, in terms of the technical, economic, musical and social factors that affect it. Because of the dominating position of popular music, I shall pay particular attention to this part of the industry.

Popular music has attracted a lot of attention through its fans, and numerous rock star biographies have been written. But the activities of the record industry behind it all, and the aesthetics of popular music, have elicited much less notice on the part of the general public. On the academic side, however, some substantial work has been done in this field of research.

Frith (1987; 1988) and Frith and Horne (1987) have studied popular music as industrialized art with reference to sociological theory and commodity aesthetics. Burnett (1990) reports a longitudinal study of the development of the international record industry since the 1940s. This author also discusses the aesthetic development of popular music, on the grounds that the industrial development is hard to separate from the aesthetic aspect.

Apart from these major references, the following description is also based on Wilson (1987) and Langer (1988), among others. Neither Wilson nor Langer are in fact academic works, but are practical manuals for aspiring rock musicians. The title of Wilson's book, for instance, is *How to make it in the Rock Business*, and Langer opens his book with the comment: 'I suspect that some of you who have bought this book are dreaming of becoming an international superstar some day' (p. 9). But both Langer's and Wilson's books contain a good deal of factual information about record production.

I start with a brief history of the record industry, followed by

a description of the organization of record companies and a few comments on the way they function. In conclusion, I discuss the aesthetics of popular music. In connection with this discussion I make some comparisons between the production of pop records and the production of best-selling books, since there are some interesting similarities between the two.

HISTORY

In 1878 Thomas Edison abandoned his work on the invention of a phonograph which could engrave sound on tin foil. When Alexander Graham Bell, who had taken the liberty of continuing to work on Edison's phonograph, asked the inventor if he was interested in developing his idea further, Edison declined the offer on the grounds that he was now engaged on another invention – the electric light. Bell therefore went on with Edison's phonograph on his own. He used wax instead of foil cylinders, since these allowed more replays of the recorded sounds. While Edison was still interested in the phonograph, he had thought about possible uses for his invention.

> Edison listed a host of practical applications for his new recording device, which included letter writing and dictation, phonographic books for the blind, speech lessons, the "Family Record," music box toys, clocks "announcing" the time, preservation of the pronunciation of spoken language, education through repetition, connection to the telephone for permanent records.
>
> (Eliot, 1990, p. 14)

That the phonograph could also be used for the mechanical reproduction of music was mentioned in a mere subordinate clause. To begin with the invention was sold as a dictaphone, without much success (Frith, 1988). The phonograph had more success at fairs and carnivals, where people could listen to engraved music for the price of a small coin.

One problem about the wax cylinders was that they could not be copied. Each cylinder was unique and individually made. Artists therefore had to record their music hundreds of times to satisfy the growing demand for recorded music. This problem was solved in the 1890s when the German inventor Emile Berliner invented the gramophone record and the gramo-

phone, thereby giving birth to the record industry. Together with the American record producer Fred Gainsberg, who opened the first commercial recording studio in 1897, Berliner spread the new invention round the world. During the early years of the gramophone the most popular music was opera and military marches. The music had been regarded mainly as a way of demonstrating the hardware.

> We can compare the early history of the record industry with the recent history of video: video manufacturers were also confused about what video-buyers would use their machines for. Software was seen at first only as a means of advertising hardware.
>
> (Frith, 1988, p. 14)

This industrial logic changed during the 1920s, when the novelty of the gramophone had worn off and interest turned to recorded music. The possibility of recording classical music and building a music library at home was used as an inducement: playing the gramophone was not quite respectable at the time, so selling the new invention to the affluent middle classes – who could afford to own a gramophone – by evoking classical music, was a way of making it culturally legitimate.

Up to the 1920s popular music had been used mainly as a means of drawing attention to the new medium, but this sort of music was not regarded as being part of a truly cultivated home. It had its origins in the old nineteenth-century music-hall songs, which were certainly not enough to satisfy the demand for musical entertainment now being generated by the gramophone. During the 1920s the music industry therefore started to mass-produce popular music at Tin Pan Alley in New York – music that was commercial in the sense that it was music on the audience's terms, as opposed to classical music, which is 'genuine' in the sense that it is music on the musician's terms.

The mass-production of music led to the application of copyright laws. It had been rare for artists or composers to receive any royalties, but from the 1920s onwards royalties became an important source of income for them both. The Sengstack Family, who held the copyright for the song *Happy Birthday to You*, received $1 million in royalties every year for 50 years until they sold the remaining 22 years of copyright to Warner Communications in 1988 for $28 million (Eliot, 1989).

Music publishers who had previously been mainly engaged in selling sheet-music switched direction to the management of copyrights.

At present, record royalties are 10–15 per cent of a record's selling price, and they represent one of the most important clauses in the record contract (Wilson). The Beatles, for example, entered into a four-year royalty agreement with EMI at the beginning of their career. According to this agreement the group and its manager Brian Epstein received 1 cent per record sold, which entailed $10,000 in royalty revenues for one million records sold. After the first four years – if the Beatles lasted that long – the royalty would be increased to 2 cents per record sold (Eliot, 1989). At the start of their career the Beatles managed to make an even less favourable agreement with the music publisher Dick James' Northern Songs. To give the music publisher half the profits was common procedure in the early 1960s. But it was certainly not common procedure to give them control over the copyrights, as in the Beatles' arrangement with Northern Songs, which was allowed to own 55 per cent of the capital stock. According to Eliot, these agreements made in 1962 were a contributing cause of the break-up of the Beatles in 1970. By then the group had sold 330 million records.

> In blissful ignorance, the Beatles eagerly gave away what was, in effect, their future. Almost all the financial turmoil the Beatles experienced during the next twenty-five years began the day they signed with Dick James.
>
> (Eliot, 1989, p. 127)

The major technological innovation of the 1920s was the microphone. Earlier music had been recorded by funnel. The invention of the microphone made possible the electrical registration of music, which considerably enhanced the quality of the sound. The new recording technique meant that the singer had to sing close to the microphone to be heard, thus creating a more intimate song style than before. This in turn led to the aesthetic innovation known as crooning.

> (Bing) Crosby was . . . forced to sing exceptionally close to the mike, a technique that altered his style and delivery . . . he was forced to a more intimate phrasing, to curl into the mike and whisper into the ears of his listeners . . . The result

was as shocking to older listeners as it was popular with younger women. By 1935, Crosby was radio's most popular performer, his appeal so strong that Hollywood paid him a million dollars a year to make movies.

(Eliot, 1989, pp. 11–12)

At first the record industry perceived the new technology as a threat, since it was felt that earlier recordings with their inferior sound might not sell. The new technology was kept a secret to begin with, while microphone recordings where sneaked on to the market so as not to upset the sales of the old records. The advent of sound film enjoyed a more positive reception from the industry, since it was perceived as a major new market for music.

The 1930s was a difficult time for the record industry. The Depression caused a drop in record sales in the United States from 104 million to 6 million records a year. The new mass medium, the radio, provided a substitute for the records the listeners could no longer afford to buy. But soon it also proved an excellent marketing channel for records. American radio stations were seen as a business venture almost from the start, after some initial confusion about what the new medium could be used for. However, it was impossible to broadcast nothing but commercials. Something else was needed. Playing music, and in particular popular music, became their way of attracting listeners. And playing a record was less expensive than renting an orchestra. The huge demand for musical entertainment from the radio stations even led to a battle between the record industry and the broadcasting companies about how much the broadcasters should pay in royalties to the performers and copyright-holders. It was not until the 1940s that a royalties agreement was reached between the two industries. For a few years at the end of the 1930s this lengthy conflict even led the record companies to forbid the playing of records on the radio. In the absence of popular music during this period the radio stations turned to other musical forms such as jazz and folk music, which proved to be commercially viable.

The 1930s saw the emergence of the current oligopolistic structure of the record industry, with a few large record companies dominating the market (Frith, 1987; Burnett, 1990). As a result of the dramatic drop in record consumption during

the Depression many small record companies went bankrupt
and others were bought up by the larger companies. By the late
1980s the record industry was dominated by five transnational
companies: Sony Records (Japan), Thorn-EMI (England), Poly-
gram (Holland/Germany), Warner Communications (USA)
and RCA (Germany).

One way of surviving that was tried in the shrinking market
of the 1930s was by price competition, in the belief that records
might be price-elastic, and consumers might therefore prefer
the record with the lowest price. It was soon discovered,
however, that record sales depended on the artist not the price,
and big economies of scale were to be won by having the right
artist on the records. One major artist yields far better returns
than a stable of minor artists. The remaining record companies
therefore started to develop artists like Bing Crosby, who had
the potential to reach a wide and undifferentiated audience.
The business concept was 'music for the whole family'. As a
result, companies began to concentrate on the production of
popular music as early as the 1930s, at least in the United States.
Classsical music may be more 'cultivated', but it was hard to
hold out against artists like Bing Crosby, who sold half a billion
records during his lifetime (Eliot 1989). In Europe, on the
other hand, this concentration on production of popular music
did not occur until the 1960s.

After the Second World War a new social phenomenon
appeared, the teenager – too old to be a child and too young
to be an adult. This new social group longed for new heroes
unknown to their parents, as a way of establishing an identity
of their own. During the War the young Frank Sinatra had given
a first indication of what was to come.

> During those years one unmistakably sensual voice oozed
> from radios kept constantly on for reports from the front.
> The voice was younger, more adventurous and sexier than the
> familiar groan of the aging patriarch of pop, Bing Crosby.
>
> (Eliot, 1989, p. 28)

Sinatra, not only more youthful but more intimately intense
than his predecessor Bing Crosby, had an immediate appeal to
female audiences.

The difference between Crosby and Frank Sinatra was the way the younger crooner laid it on the line, with an agitation in his voice America's eight million manless women could immediately relate to. Unlike Crosby, Sinatra became their fantasy boyfriend rather than their huggable papa.

(Eliot, 1989, p. 28)

Sinatra really had been the voice of youth – a bitter truth that he discovered as he lost his youthful looks in the early 1950s.

Sinatra fell as meteorically as he'd risen, his decline co-inciding with the disappearance of his youthful looks behind a crackling face and prematurely balding dome . . . By 1952 Frank Sinatra was unable to get a deal with any major label.

(Eliot, 1989, p. 30)

America's teenagers used to gather at hamburger joints and ice-cream parlours. Prominent in most of these places was the jukebox. Jukebox music was black music, such as rhythm and blues, particularly popular among teenagers in the South. But it was almost impossible for black music to become generally popular, since it was performed by black musicians with whom white middle-class youth found it difficult to identify. It took a white man capable of singing the blues to give black music a general appeal; that man was Elvis Presley. In his first year as a recording artist with RCA in 1956 Presley sold 10 million records. A new business concept, already signalled by Frank Sinatra, had seen the light of day.

The earlier business concept had been 'music for the whole family', which perhaps not surprisingly produced popular music in the 1930s and 1940s bland enough to suit everyone's taste and dull enough not to offend anyone. In this unexciting musical world Elvis Presley's rock-'n'-roll music conquered the teenagers of the 1950s. Elvis's music was different instead of indifferent, and he played on difference instead of likeness in his looks. With his haircut, his stagey dress and his wiggling hips he was like no-one else. By listening to his music and copying his appearance and his rolling movements, males in his audience could make themselves different too. For the girls Elvis provided a more daring object for sexual and romantic fantasies than the ageing Frank Sinatra. By deviating from the adults' values and their norms for good behaviour rock musicians

offered the young a prepackaged rebellion and a way of creating an identity of their own.

The dissemination of the new music was helped along by the great technical innovation of the 1950s, the vinyl record which improved the quality of the sound and had a longer life than the old 78s. The technology was further improved in the 1950s by high-fidelity and stereophonic recording, which produced a more natural sound. The transistor radio – the Walkman of the 1950s – made music a much more portable commodity than it had been before.

The somewhat conservative record industry of the 1950s chose not to exploit the new business concept to the full. Instead, it sought to supress it by turning Elvis and his imitators (such as Cliff Richard and Tommy Steele) into mainstream entertainers.

> The rise of teenage music involved . . . a variety of new money-making opportunities, but it did not affect the underlying structure of the music business: by the end of the 1950s, the exploitation of the youth market meant simply an old form – the standard pop song – with a new content – teenage angst.
>
> (Frith, 1988, p. 97)

It was not until the Beatles and the British pop revolution of the 1960s that the record industry discovered the commercial potential of the new business concept and decided to take full advantage of it. The new concept did shake up the structure of the industry a good deal during the 1960s, but by the 1970s the oligopolistic structure had been re-established. Once again, the music became homogenized and the record companies concentrated on developing supergroups. The difference was that the companies were now investing in teenage idols rather than family entertainers, since teenagers had become the most important group of record consumers. But, as the companies saw it, the best thing was for all young people to share the same idols. The punk music of the late 1970s was a reaction against the supergroups which the record companies sent touring round the world. Soon, however, the punk movement too became part of the record industry, which immediatly started to send out super-punky groups like the Sex Pistols and the Clash to tour the world as well. A more forceful reaction against the industrial standardization of music came in 1979, when the

industry's growth, unbroken since the 1950s, came to a halt. But by 1982 sales were back to the 1979 level and were starting to grow again. The industry explained this as a result of the invention of the compact disc or CD and the music video, even though the latter was perceived mainly as a new marketing channel. CD recording improved the sound so much that a demand arose for CD versions of the old vinyl recordings. The possibilities of digital tape-recording created by CD technology were perceived by the record industry as a threat, since 'every blank tape sold means one less album or cassette sold' (Burnett, 1990, p. 92). The DAT (Digital Audio Tape) cassette which appeared in the 1980s provoked the same negative reaction in the industry as the tape cassette of the 1960s. Although the industry made its own studies of the relation between tape-recording and record sales, and found that people who taped music were very active music consumers who bought more records than those who did not tape music, the industry's battle cry – none the less – remained 'Home taping is killing music' (Burnett, 1990, p. 91).

Because of its negative attitude towards home taping, the record industry stalled the commercial use of the DAT technique for many years. This blockade was all the easier to impose because of the horizontal and vertical integration that occurred in the record companies during the 1970s and the 1980s. It had become increasingly common for hardware and software to be produced by the same company. In 1987 the Japanese electronics company Sony, for example, bought the American record company CBS, which at the time was the largest record company in the world with an annual turnover of $1.6 billion.

Another explanation of the record industry's revived growth in the 1980s is that is was not until then that the new business concept of the 1950s, which played on difference instead of likeness, achieved its final breakthrough. In the 1940s the economist Schumpeter had argued that oligopolistic markets encouraged product innovation, since large companies could finance research and development more easily than small ones. Most research in this area indicates, on the contrary, that it is the other way around (Burnett, 1990). Oligopolistic firms try to uphold the *status quo* by limiting product development to harmless products that offend no-one. The result is a huge number of near-homogeneous products and a number of

unexploited market segments. After a while, these market segments become large enough to allow for profitable commercial exploitation, and new and more innovative firms are created to exploit the neglected segments. When these new firms' business has proved itself commercially viable and their market shares are suitably impressive, the large firms take over the smaller firms and the whole cycle then starts up again.

> Once a bandwagon is under way the majors are happy to climb aboard – and elbow their way to the front – but they are rarely in the driver's seat.
>
> (Eisenberg, 1988, p. 19)

According to this theory the record industry does not create new needs. Instead, it suppresses or neglects new needs until it is commercially impossible to ignore the market signals any longer.

> punk rock, for example, was developed as a musical style by musicians and audiences operating outside the usual record business relationships; it was taken over and exploited by record companies only when its market potential seemed assured.
>
> (Frith, 1987, p. 62)

This cycle theory constitutes the standard explanation of the way oligopolistic markets function. It is also the theory that has been used to explain the workings and development of the record industry. The degree of concentration has been measured in terms of different record companies' shares of hit records over a certain period of time. A high degree of concentration implies that a few record companies produce the majority of the hit records during the period in question. The degree of diversification is measured by the number of different hit records in the charts during a certain period. A high degree of diversification implies a large number of different hits in the charts during the period in question.

Burnett conducted a longitudinal study of the record industry's development between 1948 and 1989 on a basis of this theory. The theory produced correct predictions up to 1980. During the 1980s and early 1950s the degree of concentration was high and the degree of diversification low. In this period the charts consisted of a few hits produced by a few record

companies. In the mid-1950s, when the disregarded teenage segment had become big enough and rock music had arrived, a change occurred. The degree of diversification increased and the degree of concentration fell. This development reached its peak in the mid-1960s, when many different record companies were producing a variety of hits. After this, the situation went into reverse, with concentration increasing and diversification becoming less. This development culminated in the late 1970s. Once again a few record companies were producing a small number of hit records every year. The 1980s saw a complete break in the trend: concentration and diversification increased simultaneously, and continued to do so. Throughout the decade a few record companies were producing a wide variety of different hits each year.

This development may have occurred because the record industry had adapted more fully to the new business concept based on a high degree of product diversification, moving away from the old concept geared to a high degree of product homogeneity, thus coming closer to the behaviour of a traditional oligopolistic market.

ORGANIZATION

Record production faces just as much uncertainty in its market as publishing. And the way the companies do business is equally subject to various attempts to reduce uncertainty.

> The paradox of the massively successful rock business in the 1970s was that all its strategies – the incorporation of the independents, the expansion into the world market, the development of multimedia sales techniques, the professionalization of its personnel, the routinization of its sounds – were developed because of the problems of overproduction, sloppy musicians, unpredictable audiences.
>
> (Frith, 1987, p. 150)

Burnett (1990) traces the uncertainty to the loose coupling between the production and consumption of popular music. Record companies are primarily businesses geared to making profits, interested mainly in the production of commercially viable music – even though they often fail in this because of the high degree of market uncertainty.

record companies are businesses, first and foremost. They are not there just for the love of it. What is more, for every successful group they handle there are likely to be ten costly failures.

(Wilson, 1987, p. 47)

A pop record's life is rarely more than 60–180 days (Frith, 1987). Only a few of the thousands of records released every year achieve the longed-for platinum status, selling over one million copies. The record companies therefore suffer from constant overproduction, due to the enormous uncertainty about which records, of all those released, will become hits. According to Burnett only three in every thousand records released are ever played on the radio. Many records attract no listeners at all. But those that do find their way on to the radio, on the other hand, are played all the more.

once a station is down to its minimum of legally and commercially necessary talk, only particular records can turn listeners off – on comes a bad record and punch goes the button. This was the reason for the ever-narrowing chart-based playlist – people are less likely to dislike one of the Top 40 than they are one of the Top 100. This was the reason for the rapid standardization of FM radio – people are less likely to dislike a rock superstar than a rock risk-taker.

(Frith, 1987, p. 123)

This pronounced commercial orientation in the record industry differs from the book publishers' view of their business. The more explicit commercial orientation of the record companies puts much greater emphasis on marketing than is usually the case in the publishing industry. But the production processes are similar, since music is just as capricious a commodity as literature. Its commercial success is decided by two pretty unpredictable factors: sudden changes in current musical taste and musical innovation on the part of the artists.

A & R (Artist and Repertoire) is at the core of a record company's activities. The A & R department is responsible for finding and developing new artists. Where publishers are inundated with unsolicited manuscripts, record companies are inundated with unsolicited demo tapes. And just as in the

publishing world, the greater part of all the uncommissioned material is rejected.

> A record compay receives around ten tapes a week, and I am afraid that at the most 1 per cent of a whole year's harvest lead to a meeting, and in the best case to a recording.
>
> (Langer, 1988, p. 9. Our translation.)

The high rejection rate is said to depend on inadequate musical quality and the lack of a commercial profile.

> You need to work yourselves out as a total package – music, style, appearance, what part of the musical spectrum you are aiming for – before starting to sell yourselves . . . As one record company man puts it: 'The best bands have strategies, the worst just have talent.'
>
> (Wilson, 1987, pp. 31–2)

If a demo tape is to be noticed, its musical message must stand out immediately – preferably during the first 30 seconds if the A & R people are even going to go on listening to it. The music must not be over-arranged, or a good melody may be swamped by the arrangement. A potential hit song must have a strong refrain, a lyric that leads convincingly into the refrain and something that breaks the melodic pattern and makes the song both like and unlike others in the same genre. However much the A & R people may be looking for originality, they are looking even more eagerly for music that fits what is currently 'in' (Langer, 1988).

Even if aspiring musicians follow all this advice, the odds against making it as a new artist are still almost infinite. In England around 30,000 new artists try to make it every year (Wilson, 1987). What the aspiring musician needs, apart from talent and determination, are the right contacts and recommendations.

> One point all record companies agree upon is that they never – or very, very rarely – sign groups from an unsolicited tape . . . if the group does not have a recommendation it is not worth a recommendation: in other words, it is not good enough or is at too early a stage of its career. To have a recommendation means you are competent, serious, know what you are doing and are therefore worth looking at.
>
> (Wilson, p. 55)

The Beatles are an example of a group which learnt the importance of having the right connections. When the legend-ary record producer George Martin signed them with EMI in 1962, it may have depended more on the fact that their manager Brian Epstein's father owned a chain of record stores in northern England that were an important EMI distribution channel, than on the Beatles' musical qualities.

> Epstein's retail record outlet was crucial to distribution throughout Great Britain and carried a lot of weight with labels. For all the legend about the 'chemistry' between Martin and the Beatles, he may have been forced to sign the group regardless of whatever musical abilities they demon-strated during the audition.
>
> (Eliot, 1989, p. 132)

Managers are the record industry's equivalent of the pub-lishing world's literary agents. A manager is responsible for the business side of an artist's career, handling all contacts with the record companies, the tour organizers, the music pub-lishers, etc., with a view to achieving the best possible financial agreements. In the early stage of an artist's career a manager can also help to create an appropriate musical profile and market image for the artist. For this a manager usually receives 15–20 per cent of the artist's income (Wilson, 1987). Since the 1950s, according to Frith (1987), the work of the manager has become increasingly professionalized and is currently carried out mainly by lawyers and accountants, rather than by such colourful entrepreneurs as Elvis Presley's manager Colonel Tom Parker, with his roots in the world of the circus. Parker arranged favourable financial deals, not only for Elvis but also for himself, by taking 50 per cent of Elvis's income as his fee. The Colonel also had his own way of marketing. At the beginning of Elvis's career he made his protégé perform together with circus artists, so no-one would be in any doubt of Elvis's talent.

> Don't let anybody who has a scrap of talent step on the same stage. Go out and shark up a lot of lames and lops, clowns and clods, who'll screw up so bad they'll make your kid look like Caruso. That's how you showcase a star! . . . Soon the Colonel had Elvis surrounded with a bizarre carnival of tap

dancers, acrobats, magicians, comedy jugglers, Irish tenors, xylophone players . . .

(Goldman, 1981, p. 187)

If an artist – usually as a result of recommendations and with the help of a manager – actually succeeds in getting a record contract, it means that the record company is making an investment in that musician.

'Our attitude is not just about signing to put out singles and forgetting it if they don't work. We are not into marketing instant smash hits. I like to build a band slowly.'
(Record company executive, quoted in Wilson, 1987, p. 56)

This business practice recalls the way publishing houses invest in authors. But record companies demand a much faster return, trying to turn every artist into a pop star as quickly as possible – albeit succeeding with only a few.

The head of the Recording Industry Association of America (RIAA) in 1979 claimed that approximately 80 per cent of all records released failed to recover their costs . . . This low hit to release ratio means that record companies are highly dependent on big sellers such that a few winners pay for most of the losers.

(Burnett, 1990, p. 76)

It is more or less impossible for a record company to know in advance who will succeed, even though it often looks obvious with hindsight. It is difficult to foresee how the artists and the audience are going to develop. That a few particular artists become popular does not necessarily mean they possess more musical talent. It may just as well mean that their music happens to fit the prevailing musical fashion. Consequently, record companies also invest in imitations of the style of established artists. By taking on artists from a wide variety of musical genres, record companies try to increase the probability that some of their artists will hit the target and become a commercial success. With such an artist available, the likelihood of future sales from the same source increases dramatically. However, you can never be sure.

That was one of the lessons of the slump of 1979, when a new Kiss album was, with much fanfare, shipped platinum – that

is, a first run of more than a million units was sent out to the
store – and came back almost untouched.

(Eisenberg, 1988, pp. 18–19)

An artist's popularity can disappear abruptly after a wrong
turning, as some of the 1960s British pop groups on the teeny-
bop market discovered. Their market consists largely of 12–13-
year-old girls, and when some of the teeny-bop idols began to
produce more complex music, presenting themselves as serious
musicians, their fans immediately deserted them.

> The Tremeloes effectively committed pop hara-kiri by pro-
> claiming to the press that their previous singles were rubbish
> churned out for morons . . . Their much publicized progress-
> ive album Master, failed to attract a new audience and left
> them looking very foolish.
>
> (Rogan, 1988, p. 122)

Neither can the faithful repetition of a well-tried success
formula lead to eternal life, because of pop music's inherently
time-bound character.

> Dave Dee and Company had an incredible run of 13 con-
> secutive chart hits in under four years. It was strictly formula
> pop, but executed with a camp flair and theatricalism that
> proved alarmingly irrestistible . . . Time and changing mu-
> sical fashion finally caught up with the group in the late
> sixties and Dave Dee left for an unsuccessful solo career
> before moving into A & R.
>
> (Rogan, 1988, p. 267)

Few artists achieve such status that what they do automatically
becomes the prevailing fashion, as the Beatles managed to do
in the 1960s. Record companies thus prefer short-term con-
tracts, so as not to tie themselves for too long to the records of
unprofitable artists.

Here we see a difference in comparision with a publisher's
agreement with its authors. A publishing house does not enter
into an employment agreement with an author, nor does it
guarantee to publish a certain number of books by an author
within a certain period. One advantage of this system is that it
makes it easier for a publisher to put his money on an author,
because he can always choose not to publish the author's next

book. The arrangement is less advantageous if an author suddenly becomes very popular, since he or she has no obligation to publish a second book with the same publisher but is free to choose whichever publisher offers the most attractive financial terms. A record company which has signed a recording contract with an artist who becomes popular does not have to worry about any changes in the financial terms during the term of the contract, since the artist is obliged to record a certain number of records with the record company in exchange for a specific royalty fee. After the contract has expired a similar situation arises, however: the artist is then free to choose whichever record company offers the best financial terms.

There is a strong economic incentive to focus on hit records because of the huge scale advantages of record production, where manufacturing costs are high but distribution costs low. Once a record and a music video have been made, the cost of the mass-producing the recorded material is fairly low. Producing a record with a major artist can easily cost hundreds of thousands of dollars. To make a music video, which has become a very important marketing device, is even more expensive. One Janet Jackson video, for one of her 1986 singles, purportedly cost 250,000 pounds, yet the single had only a month's life, (Wilson, 1987, p. 113). This creates a very much tougher business climate than in the publishing world, where authors are not usually expected to write a bestseller immediately.

> Major outlay often demands virtually instant success from artists and extremely hard work once he or she starts to 'take off'; the strain and stress of being constantly on show, and on peak form, can take a heavy toll of the young and inexperienced. No wonder we often read of rock stars becoming addicted to drugs or drink, burning out or collapsing from mental and physical exhaustion.
>
> (Wilson, 1987, p. 16)

The importance of the A & R departments has declined during the 1980s (Burnett, 1990). More and more A & R has been transferred to minor record companies, who then supply the majors with fairly well-developed artists for consideration. This development can be regarded as an expression of an oligopolistic market's way of organizing product development. Minor record companies do not have the infrastructure neces-

sary for transnational marketing and do not therefore have the same interest in producing potential international stars as the majors. The minors can therefore focus their interest on innovative music, picking up new trends and potential stars for the majors to market transnationally.

A similar division of labour occurs in the American publishing industry, where the minor publishing houses take considerable responsibility for publishing at a more specialist level. The publishing industry has also shown that small companies can survive in oligopolistic markets by adopting a specialized niche strategy. Burnett claims that such specialization also occurs in the record industry, but in musical forms other than popular music. The major record companies will therefore probably continue to dominate the production of popular music. The control of the majors over record manufacture and record distribution has been steadily increasing, which can also be seen as a way of raising the industry's barriers to entry, fending off the threat of a growing supply of new artists and musical styles. The fate of a Swedish company illustrates the efficiency of distribution control. Up to 1988 Elektra, which was a major record company, distributed RCA's records in Sweden. In 1988 RCA's German parent company BMG started distributing RCA records in Sweden, after which Elektra soon went bankrupt and ceased to exist (Burnett).

The majors have also attempted to increase their control through vertical and horizontal integration. Differentation as a risk-reducing strategy has become increasingly common since the 1970s, not only by mergers between record companies and other media companies but also through mergers between software and hardware manufacturers. One marketing strategy that has become possible through the new media conglomerates consists of media tie-ins, whereby the same product is sold in different media.

> Audiences who have seen the film may buy the book, the magazine with the star on the cover, the music from the soundtrack and maybe a T-shirt. They may even rent the video or watch the film again on television or listen to the theme song on radio or music television.
>
> (Burnett, 1990, p. 23)

This marketing strategy was especially popular during the late 1970s, but following some less successful media tie-ins it is now used with greater caution, since the losses when a film, a book and a record all fail simultaneously are considerable.

The most important marketing channel for music is still the radio, although music videos are becoming increasingly important. The drawback of radio as a marketing channel is that the record companies have no direct control over it. 'Pluggers' are employed to promote record companies' artists to the radio stations' disc jockeys. Another way of influencing the radio stations' choice of records is through advertisements, where it is tacitly understood that there is a positive correlation between the number of a record company's records that are played and the amount of advertising. The radio stations cannot run their businesses entirely on the record companies' terms, however, since their mission is to play what the audience likes – and not only what the record companies like.

The emergence of the music video has made it possible to launch new artists 'live' to mass audiences.

> The difference between now and the sixties is that we live in a video age. It used to take ages before a band was big enough and well-known enough to play huge stadiums ... With videos, you can have a relatively new band playing to millions of front rooms, which has the same effect as playing round all the circuits ... A couple of hit singles and an album will give you a sell-out concert at Wembley. You couldn't do that before.
>
> (Wilson, 1987, p. 111)

However, music videos are still secondary to the record, which is the primary product. Moreover, videos are such an expensive marketing vehicle that the record companies are unwilling to make a video until they are sure that the record in question will sell.

Live tours, another marketing device, are especially important at the beginning of an artist's career (Langer, 1988; Wilson, 1987). The direct contact with an audience gives the artist an opportunity to develop performance skills, as well as some idea about the music's popular appeal. Live tours are also a way of building up a first group of fans, and of course a way of sustaining their subsequent interest. But touring live is not the

most efficient way to market records, and is a losing affair for most artists. Only major artists make any money from live tours. The record companies expect to recoup their expenditure on tours for their artists via future royalty revenues. As a result many artists run up huge debts with their record companies. It can therefore take them several years before they start to make any money of their own worth mentioning.

AESTHETICS

'[I]n the absence of aesthetic criteria, it only remains possible and useful to assess the value of works of art according to the profits they yield', the French philosopher Lyotard exclaims, despairing over the value-relativism that seems to accompany the postmodern condition (Lyotard, 1979, p. 76). His misgivings about money as the only reliable measurement of aesthetic value in our times find support in Burnett's comments about how the aesthetic qualities of popular music are best decided.

> the number of recordings released and the number making it into the hit lists can be an effective indicator of innovation and diversity of content available and the general development of the medium.
>
> (Burnett, 1990, p. 57)

Sutherland reaches a similar conclusion about the literary qualities of bestsellers: 'bestsellers are usefully approached by an examination of the apparatus which produces them (bestseller lists, the publishing industry, publicity)' (Sutherland, 1981, p. 8). Hence the 'best' book or record becomes the bestselling book or record. To judge not only the commercial qualities but also the aesthetic qualities of arts products with the help of best-seller lists, is a somewhat different – and for some perhaps even an upsetting – measuring device. Burnett gives several reasons, however, why it is difficult to judge the aesthetic qualities of popular culture in any more reliable manner.

It is hard to reach a definitive definition of popular music or popular culture. A certain consensus does exist about what folk music and folk culture are: distinctive for folk culture is that there is no single creator behind the products; the products,

usually created in pre-industrialized societies, are the output of a collective activity. To regard popular culture as 'commodified' folk culture does not make much sense, since popular culture is a product of an industrialized society which did not exist before industrialism.

Another way of trying to define popular culture is to compare it with high culture. This approach works so long as we are interested only in the final products and their aesthetic qualities while disregarding the processes of production and consumption. Adorno's view of popular music as a musical language like that of a child is an example of this kind of aesthetic reasoning, in the same way as Sutherland's analysis of the literary qualities of bestsellers. Sutherland tries to judge the aesthetic qualities of popular culture on its own terms, however, unlike Adorno who compares pop tunes with classical music. Sutherland finds that best-selling literature fulfils two functions; one economic and one social. For a book to sell in huge quantities it has to express and satisfy the needs of the general public. Bestsellers, therefore, usually have a therapeutic and calming function. Arthur Hailey's books about technological disasters, for example, attempt to make the high-tech society less frightening by showing that modern society still consists of ordinary people who all have an important, albeit small, part to play in it.

> There are no *single* centres to Hailey's multiplot novels. Society's large unit is made up of numerous but vitally important small lives, each with their small novel to be told. The therapeutic function of Hailey's fiction . . . is its reconstruction of the 'average citizen' as centrally important in the context of the institutions of modern life which, he fears, really dwarf him.
>
> (Sutherland, 1981, p. 51)

Bestsellers can also justify new social codes. In Erica Jong's novels about emancipated women, sexual freedom for women is legitimized. The 'insider' novel makes privileged information available to the general public – 'the Dell paperback, which the reader has bought from his drugstore for 1.25 dollars, is a top-secret dossier' Sutherland, 1981, p. 226) – giving us a a feeling of insight into the corridors of power. War has always been a

popular subject in best-selling literature. Most novels in this genre are based on two assumptions.

> The first is 'the secret history of the Second World War', the second 'fantasies of Nazism resurgent'. Both formulas are heavily imbued with a paranoid suspicion that the *real* course of events and state of things are very different from what the authorities and their 'official' histories would have us believe.
> (Sutherland, 1981, p. 167)

Other bestsellers deal with new technology and computers. Such novels try to domesticate technological innovations and make them seem part of everyday life.

> They domesticate the buzz words of the new technology and put them into circulation. They don't actually teach us anything . . . Such novels serve, rather, to add a new range to the common man's frame of reference, to put these scientific innovations in the same known but not fully understood terms as the jet engine, the tv set and the transistor radio.
> (Sutherland, 1981, p. 231)

The production of popular culture is governed by commercial as well as aesthetic considerations, however. In addition, the act of consumption is particularly important in popular culture, since the artistic object is a means rather than a goal. To understand popular culture more fully, the processes of production and consumption also have to be considered. This is less important in a high culture context, since here the aesthetic objects themselves are at the centre of attention and have been created mainly for aesthetic purposes. The related production and consumption modes are less complex and more personal. The production and consumption of high culture also occur within several art worlds, each one guided by its prevailing artistic conventions (Becker, 1982). An art world consists of all the actions that are required to produce the objects that an art world's inhabitants, and perhaps other people, define as art. It is not uncommon for an art world to be so small that many of its leading characters know each other personally.

The products of popular culture are industrial products, manufactured for an anonymous mass market. The production and consumption processes thus both become more complex and unpredictable. What becomes popular culture is decided

by current audience taste. This taste cannot be decided by any prevailing artistic conventions, since popular culture is not widely reviewed, and there is no canon of artistic conventions for its production.

Yet another way of trying to understand popular culture is to look upon it as a mass medium rather than as art, whereby interest becomes focused on the production and consumption processes.

Sutherland's analysis of bestsellers is an example of an attempt in this direction. But it never becomes more than an attempt, since his method consists mainly of fairly traditional analyses of literary content – admittedly accompanied by a dutiful account of sales volumes and marketing campaigns. The emphasis is still on the literary content, or lack of it.

> MacLean's outstanding popularity is hard to account for. He writes clumsily; his characters are wooden; his morality banal; his plots are virtually sexless.
>
> <div align="right">(Sutherland, 1981, p. 96)</div>

Adorno and Horkheimer (1989) were the pioneers of this approach to studying the production of culture. They saw popular culture as mass culture since it was transmitted via the mass media to a large and undifferentiated audience, creating a uniform supply of cultural commodities without much product differentiation. This argument builds on the assumption that the culture industries create the cultural needs of the common man. Cultural consumption consequently becomes a passive and alienating activity, since the consumers take no part in the production process. To listen to the latest hit tune is simply an impersonal activity, like pouring detergent into the washing machine. According to Frith and Burnett, among others, this assumption does not hold because the consumption of popular culture is more active and meaning-creating than the consumption of detergents, for example. Furthermore, the culture industries can hardly be accused of creating cultural needs since most arts products are commercial failures.

> The vast bulk of music aimed at the mass market simply never reaches it, thus, the industry is less organized around creating needs, than of responding to them. More often the industry is following rather than leading taste.
>
> <div align="right">(Burnett, 1990, p. 44)</div>

Rather, popular culture – in the sense of genuinely popular culture – is what people create in their interactions with the products of the culture industries.

> Popular culture is made by the people, not produced by the culture industry. All the culture industries can do is produce a repertoire of texts or cultural resources for the various formations of the people to use or reject in the ongoing process of producing their popular culture.
>
> (Fiske, 1989, p. 24)

What becomes popular music is decided by the frequency with which record consumers buy certain records. Since people under thirty-five account for the largest share of record consumption, popular music becomes mainly music for the young: 'sufficient purchases by the youth audience, the main consumers, define what constitutes popular music at any specific time' (Burnett, 1990, p. 52). Popular music thus becomes self-defining. Popular music is music that is popular. Music's popularity is expressed in the number of records sold. This popularity can be observed in the charts. Popular music's aesthetic qualities consist of its ability to become popular music. This ability also finds expression in the charts. Hence, the aesthetic qualities of popular music can be judged from the record sales.

Burnett refrains from attempting a musical definition of popular music, since classical artists such as Pavarotti can also produce hit records. What gets into the charts, however, is usually some form of rock music. A writer who has analysed the characterstics of this music in some depth is Frith (1987).

Frith traces the roots of rock to blues, country, folk and pop music. Rock can hardly be said to be music solely for music's sake. It is rather a means for emotional and commercial sensations: 'it is a musical means, not a musical end. Rock is made *in order to* have emotional, social, physical, commercial results; it is not music made 'for its own sake'. (Frith, 1987, p. 14)

The blues, which is one of the sources of rock, is improvised music, unlike classical music which is formalized. Because blues music was black folk music without any known composers, an original performance of the classical blues songs was important

to the blues artists. The singing technique was crucial; it was more important to perform the songs in a personal voice than to follow the melody note for note. The main impact of the blues on rock music was rhythmical. With its strong emphasis on bodily sensations, it entailed the sexualization of love.

> Whereas Western dance forms control body movements and sexuality itself with formal rhythms and innocuous tunes, black music expresses the body, hence sexuality, with a directly physical beat and an intense, emotional sound – the sound and beat are felt rather than interpreted via a set of conventions.
>
> (Frith, 1987, p. 19)

Country music has been called the white man's blues'. It is similar to the blues in its emphasis on the importance of performance and the artist's individual singing style. Its lyrics are also about everyday life. But country music is more conservative than blues. Where blues makes frequent and unrestrained sexual allusions, country music expresses disappointment at too much playing around and praises the ideals of family life: 'Even the honky-tonk music of bars and jukeboxes argued that casual sex and drink and fun were expressions of loneliness, the absence of family' (Frith, 1987, p. 25). Country music is therefore sentimental and nostalgic. Rock started as a mixture of country and blues in the 1950s. The folk music that influenced rock was political, with its origins in the United States during the 1930s, when folk singers like Woody Guthrie travelled across the American continent as vagabonds, singing protest songs. Protest music reappeared in America in the 1960s, with artists such as Bob Dylan and Joan Baez. As with blues and country music, the human voice was here the most important musical instrument; technical skills came second. It was the folk singer's voice that carried the political message, in adherence to the motto 'Sing the truth as simply as you can' (Frith, 1987, p. 28). Given the political ambitions of this music, the lyrics which carried the political message were of prime importance. This political folk music influenced the lyrics of rock, making them more complex than before.

These three musical forms – country, rock and folk – are all generally regarded as 'authentic' music, in the sense that they

express the needs and feelings of the artist and the people. In the same vein, popular music is considered 'artificial' because it is an industry product, expressing the record companies' need to make money. Popular music influenced rock in the late 1950s by turning rock into popular music for teenagers; during the 1960s the influence was in the opposite direction, and rock affected popular music by making it more aggressive and less romantic. If maturity had been the ideal before in society, the new ideal became eternal youth for everyone.

> The 1960s argument . . . was that youth was preferable to age and that no one need ever grow old. What was at issue was not chronology but ideology. If youth was the most desirable social condition and to be young meant to be free from the narrow routines of maturity, to be sexually vigorous and emotionally unrestrained, then anyone who lived and thought right, regardless of age, could be 'young'.
>
> (Frith, 1987, pp. 33–4)

This music for the eternally young is the music that makes it to the charts, and it is the dominating musical form of our time.

SUMMARY

In this chapter I have described record production. Because of its dominating position in the musical world, the emphasis has been on the production of popular music. The beginnings of the record industry appeared in 1887, when Thomas Edison invented the phonograph, which could engrave sound on tin foil. The invention was further developed by Alexander Graham Bell, who used wax instead of foil cylinders. One drawback of the wax cylinders was that they could not be copied. This problem was solved in the 1890s by the German inventor Emile Berliner who invented the gramophone record and the gramophone, thus giving birth to the record industry proper. During the early years of the gramophone, the music itself was regarded mainly as a way of demonstrating the hardware. This changed during the 1920s, when the novelty of the gramophone had worn off and interest turned to the music recorded. The possibility of recording classical music and building a music library at home was exploited as a marketing device for selling the new invention. Around the same time, the mass-production

of popular music was started at Tin Pan Alley in New York as a way of satisfying the growing demand for this music. Popular music is commercial in the sense that it is music on the audience's terms; classical music, on the other hand, is genuine in the sense that it is music on the musician's terms. The major technological innovation of the 1920s was the microphone, which made possible the electrical registration of music. The 1930s were a difficult time for the record industry and the Depression caused a drop in record sales. The new mass medium, the radio, became a substitute for the records the listeners could no longer afford to buy, but soon proved to be an excellent marketing channel for records as well. During the 1930s the present oligopolistic structure of the industry first emerged, with a few large record companies dominating the market. At the same time, it became evident that the demand for records was artist-sensitive. A single major artist gave a company far better returns than a stable of minor ones. The record companies that had survived the 1930s began developing artists with the potential to reach a wide and undifferentiated audience. The business concept was 'music for the whole family', and as early as the 1930s this led producers in the United States to concentrate on popular music. In Europe this concentration on the production of popular music did not occur until the 1960s.

In the 1950s popular music became increasingly orientated towards teenagers in the form of rock. The dissemination of the new music was facilitated by a technical innovation, the vinyl record, which replaced the old 78s. A new business concept playing on difference rather than similarity in musical taste attained wide acceptance in the record industry in the 1960s with the British pop revolution. This briefly upset the oligopolistic industry structure, but by the 1970s the former structure had been re-established. The record companies then tried to develop supergroups. The difference relative to the 1940s was that the record companies were now investing in teenage idols instead of family entertainers. In 1979, growth in the industry came to a temporary halt, but by 1982 sales were back to their 1979 level and growth revived, thanks to the invention of the compact disc and the music video.

Record production faces the same high degree of market uncertainty as publishing. A & R (Artist and Repertoire) is at

the core of a record company's activities. The A & R de-
partment is responsible for finding and developing new artists.
Where publishers are inundated with unsolicited manuscripts,
record companies are inundated with unsolicited demo tapes,
of which the majority are rejected. If a demo tape is to lead to
a recording, it must be backed up by recommendations and it
must have sufficient musical quality and a viable commercial
profile. Once an artist has succeeded in getting a recording
contract, it means that the record company has decided to make
an investment in that particular musician. Record companies
demand a much faster return than publishers, however, trying
to transform every artist into a pop star as quickly as possible –
although they succeed with only a few. This makes for a much
tougher business climate than in the publishing world, where
authors are not usually expected to write bestsellers im-
mediately. The importance of the A & R departments declined
in the course of the 1980s. More and more A & R has been
transferred to minor record companies, who then supply the
majors with fairly well-developed artists for their consideration.
The main marketing channel for music is still the radio,
although music videos are becoming increasingly important.
The chapter concluded with a brief survey of various ways of
judging the aesthetic qualities of popular music. In the next
chapter film production will be discussed as an example of the
functioning of a predominantly commercial business strategy.

Chapter 6

Hurrah for Hollywood

It has been said that to write a book you need a pen, but to make a film you need an army. Someone who discovered the truth of this the hard way was Steven Bach, executive producer at United Artists from 1978 to 1981.

United Artists was founded in 1919 by the legendary film director D. W. Griffith together with three film stars – Charlie Chaplin, Mary Pickford and Douglas Fairbanks (Bach, 1985). Together, the four partners planned to produce three films a year and to finance and distribute films made by other film-makers. In its early days United Artists was torn by numerous battles between the four founders, and turnover among the executive staff was high. By the beginning of the 1950s, the company was on the verge of bankruptcy. It was sold to two lawyers specializing in the entertainment industry, who promptly restructured it. The new United Artists was to limit its business to financing the films of independent film producers, a strategy that proved successful in both financial and artistic terms. In 1967 the two lawyers sold United Artists to the industrial conglomerate TransAmerica, which was looking for some glamour to add to its company portfolio. The two former owners stayed on as managing directors. During the 1970s they grew frustrated as TransAmerica increased its financial control over operations, and they finally left the company in 1978. This was a catastrophe for United Artists, since their credibility as a film company was built on the trust which Hollywood's film-makers had come to feel for the former owners. In 1978 a new management, including Steve Bach as executive producer, faced the task of re-establishing the film community's confidence in the company. TransAmerica gave management an

annual production budget of $100 million, and one of Bach's
first jobs was to create a new network for United Artists in
Hollywood, which would generate film manuscripts and film
ideas for the company to work on. When the new executive
producer discovered that the best film ideas and manuscripts
were being offered to other film companies, he realized just
how far United Artists' stock had fallen in the Hollywood
community. In the spring of 1978 United Artists was contacted
by the then relatively unknown film director Michael Cimino.
Cimino had already made a few television commercials and
directed a Clint Eastwood film which had received positive
reviews. At the time, he was in the process of editing a film about
the Vietnam War called *The Deer Hunter*, in which Robert de
Niro and Meryl Streep had leading roles. The head of pro-
duction at United Artists hinted to Cimino that they were
interested in financing his next film. In August 1978 Cimino's
producer, Joann Carelli, invited United's management to a
private screening of *The Deer Hunter*. Although the film was
rather long at three hours and four minutes, and although at
$15 million instead of $7.5 million it had exceeded its pro-
duction budget by 100 per cent, the United Artists people were
much impressed by what they saw. After this screening, their
interest in collaborating with Cimino was all the keener. In
September 1978 Bach met Cimino and Joann Carelli at the
Beverly Hills Hotel in Hollywood and was shown the manuscript
of a film called *The Johnson County War*.

The Johnson County War dealt with the massacre of a group of
people who had occupied some land in Wyoming in the early
1890s. The perpetrators of this deed were professional killers
hired by the landowners with the permission of the Governor
of Wyoming. The manuscript met with doubtful reception from
the United Artists management. Westerns were no longer a
popular genre, and the long massacre sequences at the end
struck them as very depressing. Kris Kristofferson and Christo-
pher Walken had been suggested for the male leads, and
production costs were estimated at $7.8 million. Major films at
United Artists – one or two were made each year – cost around
$10 million to produce at this time, while the production
budget for an ordinary film was $5 million. After some discus-
sion, Cimino's film manuscript was approved for production.

Shooting was to begin on 2 April 1979. The film was to be

edited in the autumn and released in time for Christmas. For the shooting, Cimino chose Glacier National Park in Montana. He tried to muffle the film's Western image by changing the title to *Heaven's Gate* and introducing a prologue at Harvard in 1870. An epilogue in Rhode Island was also added. Early in 1979 Cimino told United Artists that he wanted the French actress Isabelle Huppert as his female lead. United's management would have preferred a more familiar name such as Jane Fonda or Diane Keaton, since Isabelle Huppert was not known to American audiences and nor did she seem to have much charisma. However, the popular actresses were either busy or uninterested, which strengthened Cimino's bargaining position considerably. He managed to get Steve Bach and his fellow producer David Field, who was also involved in the production of *Heaven's Gate*, to fly to Paris to see the talents of Isabelle Huppert for themselves. Neither Bach nor his colleague were impressed by her acting skills. But when Michael Cimino responded to their lack of enthusiasm by threatening to take his manuscript to Warner Brothers instead, they decided to yield to his demands. After all, the real star of the film was supposed to be the director himself.

> We weren't betting that this and that actor or actress would add a million or two to the box-office. We were betting that Cimino would deliver a blockbuster with 'Art' written all over it.
>
> (Bach, 1985, p. 209)

United Artists had to make further concessions to Cimino in the early months of 1979. A personal weekly expense account of $2,000 had to be granted and a clause added about additional funding if there was to be any chance of having the film ready for Christmas release. United's bargaining position was hardly improved when Cimino's *Deer Hunter* received five of the Oscars in March 1979. A snowstorm in Montana delayed shooting for two weeks, which meant that the two weeks' margin, United had allowed for disappeared and Cimino's additional funding clause became effective before shooting had even started. The construction of the scenery in Montana proved much more expensive than estimated, and a realistic budget for the film seemed now to be around $15 million.

On 16 April the shooting of *Heaven's Gate* began; six days later

Cimino was already five days behind schedule. He had produced one-and-a-half minutes of showable film at a cost of $900,000. Bach's colleague David Field was dispatched to the location to sort things out, which proved impossible since Cimino refused to talk to him.

> . . . when shooting ended, I walked over to intercept Michael at his trailer, and he walked right by me . . . without saying one word . . . and I sat on a cold rock for an hour and a half . . . He finally came out of the trailer, looked right through me, got into a production car, and one of the drivers took him back to Kalispell.
>
> (Bach, 1985, p. 254)

After 12 days in production the film was 10 days behind schedule. By the end of May a Christmas opening was becoming increasingly less likely, as Cimino was becoming more and more of a perfectionist instead of speeding up production. By 1 June the costs for *Heaven's Gate* had reached $10 million, and 107 of 133 manuscript pages remained to be shot. If nothing was done, and the production continued at the same slow pace, the final cost would be someting in the region of $40–50 million. In the summer of 1979 David Field resigned from United Artists and Bach became solely responsible for Cimino's film. He tried to sell the project to other film companies but with no success. He even considered firing Cimino but found no director who was willing to replace him. In August, Bach managed to arrange a meeting with Cimino and Carelli, at which Cimino informed him that he intended to make a four-hour film that would cost $25 million. Bach informed Cimino in his turn that the film was to be no longer than two-and-a-half hours, and production was to be speeded up immediately. If Cimino was not prepared to obey, United Artists would sue him for breach of contract. Cimino did comply and increased the production tempo. By September 1979, when the shooting in Montana was finished, Cimino had 220 hours of film to cut down to three. On 1 October the cost of *Heaven's Gate* was reported as $27 million. The prologue and epilogue still had to be made. Since Harvard would not give permission for any shooting there, Cimino suggested that United Artists should build a copy of Harvard in Florida for the shooting of the prologue. In the end, this part of the film was shot in Oxford, England, at a cost of $3 million.

The film's opening date was postponed to Christmas 1980. On 26 June 1980, United's management was allowed to see the first footage of *Heaven's Gate*. To begin with Bach and his colleagues were greatly impressed, but their initial enthusiasm was rapidly replaced by a growing sense of panic as the stream of vivid images and scenes never seemed to end. After the screening, management was particularly worried about the film's length (five hours and 25 minutes), and the lack of any plot to pull all the disparate pictures and sounds together into a coherent story. This narrative problem was especially disturbing in the film's final 90-minute massacre scene.

In October, Cimino – who had at least admitted that the film was 15 minutes too long – had cut the length down to three hours and 39 minutes. He was unwilling to cut it further, as he said this would destroy the artistic unity which the film now possessed. Any public pre-screening, to get some idea about the film's commercial potential, was deemed by Cimino to be both unnecessary and unworthy. On 18 November 1980 *Heaven's Gate* opened in New York.

> The picture began . . . and so did the silence. The battle sequence was a third its original length, but felt just as long. Nothing was working.
>
> (Bach, 1985, p. 396)

The first-night audience and the film critics were fascinated by the spectacular fiasco that the film represented. How was it possible to create such a total failure as *Heaven's Gate*? The American media, which had been covering the production story since 1979, wondered about United Artists' chances of survival after *Heaven's Gate*. Notwithstanding the $36 million loss on this film the company still managed to show a profit of $22 million in 1980, thanks to the successes of their other films that year. But their owners, TransAmerica, did not accept what had happened. Michael Cimino was stripped of all future responsibility for the film. In the spring of 1981 most of the United Artists management (including Steve Bach) was fired, after which the company was sold to MGM.

Heaven's Gate, which had been pulled out of the cinemas after its disastrous opening, was given a second chance in April 1981. The film was now two hours and 30 minutes long. It grossed $1.3 million at 810 cinemas during its re-opening weekend. The

critics declared the new version an improvement, in the sense that the film could now be classed as a normal failure instead of a total disaster. *Heaven's Gate* disappeared quickly from the cinema screens, at a final cost of $44 million. Joann Carelli had the following to say:

> Michael was a little crazy up there in Montana . . . He won those . . . Academy Awards and really believed they meant something. He was definitely out of control.
>
> (Bach, 1985, p. 441)

Bach's description of the production of *Heaven's Gate* tells us a lot about the working of commercial film production: we see the difficulty of sticking to budgets, the high production costs, the need to get hold of stars and to find a coherent plot to shape the images into a visual narrative; we also see the importance of access to the network of film professionals and to a talent able to make films which have both commercial and artistic value. United Artists' lack of access to talent was Cimino's trump card in his dealings with Bach and the company. United Artists had lost its former excellent access to Hollywood's talent market at the time Cimino came on the scene. He was thought to be one of the few who possessed both commercial and artistic potential. He was also one of the few who were willing to work with United Artists in 1978. Once production began to get out of hand, he managed to keep it going by playing on his own presumed ability to deliver epic blockbuster films. His bargaining position was further strengthened when United Artists could find no-one to replace him. Nor is the total fiasco of *Heaven's Gate* anything abnormal. During the 1980s high-budget films became the vogue in Hollywood. In 1990 multi-million-dollar films were so common that it created little stir when Sidney Pollock's $50-million film *Havanna* had to be withdrawn after playing for a mere two weeks.

In this chapter I shall be looking at the way commercial film-making functions. For various reasons, the focus will be on Hollywood and American film production. Hollywood has dominated the world supply of films since the 1920s, artistically as well as commercially. Since the 1980s, the trend has been for increasingly few films accounting for an increasingly large share of drama revenues. And these films have usually been high-budget films from Hollywood. In aesthetic terms, classical

Hollywood realism, with its straightforward simple plots and its visual language, has experienced a renaissance during the 1980s, becoming once again the dominating visual genre after the formal experiments of the 1960s and 1970s (Kent, 1991). Hollywood is particularly interesting in the commercial context, since right from the start the American film industry has been geared towards making films for the whole world. European film production is still much less international (Sorlin, 1991).

Another reason for focusing on American film production is that the Hollywood film industry has been the subject of a fair amount of research, albeit of a fragmentary kind. But although film production has far more in common with industrial manufacturing than the production of either books or records, most of this research has in fact focused on the aesthetic analysis of the films as films (Kerr, 1986; Jowett and Linton, 1989). As an industry, Hollywood remains less systematically researched than either the record or publishing industries. There is no equivalent to Coser, Kadushin and Powell's (1982) study of the American publishing industry or to Frith's (1987) or Burnett's (1990) investigations of the international record industry. Since the 1980s, however, interest in Hollywood as an industry has been growing, perhaps because of escalating production costs and the spectacular incomes that film stars now earn: in 1989–90, for instance, Sylvester Stallone made $63 million, Arnold Schwarzenegger $55 million and Jack Nicholson $50 million. Since the 1980s several books on the Hollywood industry have appeared, including Mordden (1989; 1990) on developments in Hollywood 1910–70, Barnouw (1990) on the American television industry in a book which also touches on Hollywood's relations with the television medium, Kent (1991) on Hollywood in the 1980s, and various industry biographies. I have drawn on all of these in describing the workings of commercial film production below.

HISTORY

The technique for motion pictures was invented by Thomas Edison in the 1880s as a way of providing a visual accompaniment to his earlier invention of the phonograph. Jewish immigrants explored the commercial possibilities of the new technique and installed peep-shows at carnivals (Gabler, 1989).

The invention attracted a lot of attention with films such as *Fun at the Chinese Laundry*. One of the most popular films showed a horse eating hay, while its sequel – which also became a huge success – consisted of a pillow fight between the film-maker's two daughters (Goldman, 1990). Since these very early films were only about one minute long, the absence of plot did not matter too much. When film projectors began to be used, and the moving images were shown on a screen, the standard length increased to 10 minutes. The films began to offer visual narratives and rudimentary plots. By 1908 there were already 8,000 cinemas in the USA boasting 14 million visitors (Beaupré, 1977). The owners of the patent on the new technique felt that this rapidly growing film industry was altogether too chaotic, too speculative and too entrepreneurial. In 1909, under Thomas Edison's guidance, the Motion Picture Patent Company (MPPC) was established. Its mission was to see that the film industry was managed as rationally as any other business. MPPC was a patent monopoly which sought to control all aspects of the new industry by stipulating very specific licensing conditions. Only MPPC's raw film and film projectors could be used, the films had to be of a certain length and the exhibition saloons had to meet specific standards. To oversee fulfilment of these conditions MPPC employed controllers who were no strangers to physical violence and quite prepared to use it if any unlicensed film activity were detected. MPPC also sought to extend its control to film distribution, by systematically buying up film distribution companies.

At the time when MPPC was formed, the American film industry was concentrated in New York and Chicago, and the film entrepreneurs did not appreciate the new organization's attempts to assume control over an industry which they had created. After trying both Cuba and Florida as shooting locations, they fled to Southern California, where they hoped to be able to continue their unlicensed activities undisturbed. California's advantages as a film location had been discovered in 1907 by Colonel Selig, a member of MPPC. For a production of *The Count of Monte Cristo*, Selig needed the kind of sunny beach scenes which Chicago could not cater for, so he turned instead to the beaches of Santa Monica just outside Los Angeles. In 1909 the Chicago weather again created shooting problems for Selig, and he returned once more to the more warm and stable

climate of Southern California. This time he was so pleased with conditions there that he established a permanent film studio in Los Angeles. The first film studio in Hollywood, which at this time was a suburb of Los Angeles with 5,000 inhibitants, was founded in what had once been a brothel (Ford, 1990).

In 1915, before MPPC had managed to embrace California in its tentacles, the organization was recognized as a blatant monopoly and was dissolved by an anti-trust law. MPPC's monopoly regime was succeeded by an oligopolistic order of things, manifest in the Hollywood studio system of film production, which rested on two new phenomena: the full-length film and the film star.

The full-length film format was introduced by the director D. W. Griffith in 1915 with *The Birth of a Nation*. Griffith had already made more than 400 short films. Initially, his new and very expensive experiment ($200,000 in production costs instead of the usual $1,000) aroused considerable suspicion. But the scepticism soon vanished when Griffith's long film grossed $22 million, proving that higher admission could be charged for long films and that such films had a much longer life than shorts (Wasko, 1978). In 1917 Griffith tried to repeat this success with his film *Intolerance*, which had a production budget of $445,000. It did not work. *Intolerance* never covered its production costs, a financial failure which strengthened the already powerful links between the Hollywood film industry and the financial community of Wall Street.

Full-length films were much more expensive to produce than short films, and they required external capital. Since the long-film format seemed to offer a huge profit potential, the Wall Street bankers became interested in financing film productions, although Griffith's second long film also clearly demonstrated that film financing was a high-risk affair: not only could you make more money on a long film, you could also lose more. Wall Street therefore began taking an interest in the artistic aspects of film production, as Griffith soon discovered. After the failure of *Intolerance*, Griffith became increasingly dependent on Wall Street in an escalating frenzy of borrowing that could be broken only by a new success. This Griffith never achieved. When his film productions continued to show losses, the financiers took over responsibility for the final editing of the films. Griffith never recovered from *Intolerance* and went broke

in the 1930s. This dependency on Wall Street helped to trans-
form the film industry into a legitimite branch of business at an
early stage in its evolution.

The star system, which was very popular with audiences but
less so with film producers, was created by the cinema owner Carl
G. Laemmle. Laemmle noticed that films with an actress known
as the Biograph girl were attracting much larger audiences than
any others, and promptly decided to become a film producer.
He founded Universal Studios and started to hunt for the
popular Biograph girl. This entailed some problems, since film
acting still had such low status that film actors preferred not to
perform under their own names. Actors who took part in films
did so mainly because they could not find any other acting work,
but they wanted to keep this unworthy activity a secret. Audiences
thus knew the film actors only by the characters they played.

> Actors, mostly "legitimate" ones, were ashamed of this new
> medium. They snuck over to New Jersey and worked, but only
> for the bread – the last thing they wanted was their name
> attached to anything they did.
>
> (Goldman, 1990, p. 5)

Laemmle eventually found his Biograph girl in Chigago, where
she worked as a film actress for a fee of $25 a week. Her name
was Florence Lawrence. Laemmle had no problem in per-
suading the Biograph girl to work for him when he offered her
a weekly salary of $1,000. To get Florence Lawrence known
under her own name, Laemmle started a rumour that the
'Biograph girl' had died in a car accident, and in this way the
star system with its star salaries was born. Charlie Chaplin and
Mary Pickford, whose original salaries had been $5 a week, soon
managed to raise this to $10,000 a week. Charlie Chaplin even
received a $150,000 signing bonus on top of this. Since the film
stars soon achieved a strong bargaining position in Hollywood,
they were never exploited in the same way as many musicians
were by the record companies. During the 1950s it was quite
usual to cheat black musicians, for example, by giving them a
Cadillac or a modest sum in cash instead of a record contract
(Dannen, 1990). Or a musician's manager or record producer
might insist on being named as co-writer of his hit songs. This
sort of financial exploitation did not happen to film stars, but
female stars could find themselves being taken advantage of

sexually. The star system had made film acting a very attractive profession, which meant that a surplus of eager candidates soon appeared and the risk of sexual exploitation grew. The aspiring film actresses were fequently 12- or 13-year-olds, because they were the only ones able to stand the very bright light which the early raw film demanded in order to achieve a satisfactory picture quality.

> Any woman with even the slightest blemish or faintest age lines would photograph like an aged crone. The result was a flood of twelve- and thirteen-year-olds playing mature womanly roles as wives, mistresses and even vamps.
>
> (Ford, 1990, p. 27)

It was not until the 1930s that less light-sensitive film appeared and it became possible to use more adult actresses. The tradition of exploiting female actresses sexually originated in the West End of London, where the women often had to offer sexual favours if they wanted a role or a rise in salary. The first film entrepreneurs, who were rarely much older than the actresses they employed, transferred this tradition to the film industry. Fatty Arbuckle, one of the most popular comedians of the silent film era, gave a three-day-long party at a hotel in San Francisco· in 1919, to celebrate a million-dollar contract with Paramount Pictures.

> 'Party' was synonymous with 'orgy' in Fatty's vocabulary so few of the stars, starlets and extras who received invitations could have had any illusions as to the expected order of events . . . No one was expecting polite conversation and cucumber sandwiches . . . A passer-by had looked through a hotel window and seen a naked Fatty leading a conga-line of ten equally naked girls with Zukor and other Paramount executives cheering them on.
>
> (Ford, 1990, pp. 52–5)

During the 1930s, when film stars became more firmly attached to particular film companies as a result of the studio system, this sexual exploitation became institutionalized. An implicit part of the contractual obligations of the female actresses was that they should offer sexual favours to the film company's staff. It was not until the 1960s, when the studio system had disappeared, that this praxis was abandoned.

By 1920 films had become a major industry in the USA: Hollywood's population was now 150,000, the original Jewish immigrants had become film moguls with their own film companies, and the cinemas were attracting 35 million visitors a week. Only 15 years had passed since the film industry, regarded at the time as a passing fad, had seen the light of day in old factory premises in New York.

> There was simply no reason to assume that what they were doing was permanent, like farming or plumbing . . . Movies . . . were a questionable entertainment for the working class, inferior by intention and execution to even the shoddiest touring edition of the most uncouth play.
>
> (Mordden, 1989, p. 4)

The industry had also undergone a major aesthetic evolution since its humble beginnings. The early silent films had been made for poor immigrant families, many of them portraying the living conditions of the immigrants in a realistic way. Silent films also proved to be an efficient socialization device for such people, since they required no knowledge of the English language (Ewen and Ewen, 1982).

With the arrival of the star system and the full-length feature film cinema-going became an accepted form of entertainment in society as a whole, and the film companies became more interested in making films for the middle class than for poor immigrants. During the First World War a flood of vamp films was let loose, standing out in sharp contrast to the earlier, realistic films about the meagre conditions of immigrant life. After the war the vamp films disappeared, to be followed by upper-class comedies, historical dramas and other films based on the literary classics. During the 1920s cinema-going became an important form of family entertainment in the USA. Picture houses were built all over the country, replacing the pre-war amusement parks and theatres.

Notwithstanding the rapid expansion of the industry, film companies were becoming dissatisfied with the high fees the stars demanded, and when the talkies arrived in 1929 they saw their chance to renegotiate the standard contractual conditions, since many of the silent stars were unable to adapt to the new technology. The bargaining position of the companies also drew strength from the Depression of the 1930s, which

drove many unemployed stage actors to move to Hollywood. The golden age of Hollywood could begin. The typical film studio in Hollywood at this time has been described as

> a *place* governed by a *budget* set by a *mogul* who believes he can market certain kinds of *stars* who are presented by a *staff of experts* who hold certain *social, artistic,* and *political* apercus in common.
>
> (Mordden, 1989, p. 16)

A studio's basic capital consisted of a set of contractually employed film stars. The studio leaders were the film moguls, the pioneers of the film industry who enjoyed almost total control over Hollywood's film community during the studio era. They decided what films would be produced, how much they could cost, which film stars would be signed up and used in the films, who the directors would be, etc. The film moguls tried to achieve a production base of bread-and-butter films. The function of these B films was to generate the basic revenues, and to provide the financial means for producing the more prestigious A films. A films were much more expensive to make, but were able to generate considerably more artistic and commercial capital. Moreover, to be taken seriously as a film producer in Hollywood in the 1930s, it was necessary to show a regular output of A films.

During the 1920s the domestic and foreign demand for Hollywood films increased dramatically. A huge export market for long films developed. To be able to take full advantage of the rising demand for American films, it was necessary to standardize Hollywood's film production, and the B films became the vehicle of this standardization. They proved to be a very efficient way of making manageable the requirements that creativity demanded. Aesthetic innovation was delegated to A films, where new film concepts and genres were tried out. Once a certain type of film had proved commercially viable, the underlying success formula could be used in the mass production of B films. Most B films thus represented cheap imitations of successful A films. Since no film stars were used in the B films, these were far less expensive to make. In 1935 an average B film cost $40,000 and took five days to make. An A film cost $200–600,000 and production took four weeks. The B films were not only less expensive; they also showed far less aesthetic quality.

a cheap B movie is so cheap that nothing is cheaper, and the cheapest B movies are the worst movies. There is nothing worse than the worst, and there is no such thing as a C movie. B says all you need.

(Mordden, 1989, p. 314)

The new type of less light-sensitive film made it easier to standardize film production. Films could now be made indoors, without any troublesome exterior shots, which meant in turn that several films could be in production at the same time.

Due to its vertical integration, the American film industry had no great difficulty in finding a market for its B films: the film companies controlled the production, distribution and showing of theatrical films in the United States. Even in Europe, where American films accounted for 30–40 per cent of the total supply, the American film industry enjoyed considerable power over film distribution. Since Hollywood had almost complete control over film production, film companies could also insist on block purchasing. If cinema owners wanted access to A films they also had to exhibit B films. In the USA these films were shown mainly as a prelude to an A film. In the 1920s the picture houses had offered live entertainment as a prelude to the films, but in the 1930s this entertainment was replaced by B films.

If a film was ever to open it had to have stars, since whatever the qualities of a film it was the stars who attracted the first audience.

A star is someone who opens a movie . . . A star may not guarantee you a profit . . . but they will absolutely be a hedge against disaster. A star ensures that, even if the movie is a stiff, the movie will open. One of the ways producers measure the appeal of a star is the amount of business a picture does on its first weekend.

(Goldman, 1990, p. 12)

But for a film to be more than a short-term success, it was not enough to have famous names. Someone also had to exploit the talents of the various stars efficiently, and know how to transform a film into a coherent whole. The film directors and their professional skills were thus also important factors in the studio system. Moreover, film directors lasted much longer than film stars. They were able to produce successful films for decades,

while the public appeal of a star was a more fragile and short-lived affair.

Apart from the stars, the moguls and the directors, the film studios also employed a huge staff including cameramen, sound technicians, film editors, make-up artists, set designers, script-writers, PR teams, and so on. As a result of the activities of all these people, a studio could build up a certain studio style which became an expression of its ability to produce a certain kind of picture. The major film studios, which all had their unique studio styles, were Paramount Pictures, Metro-Goldwyn-Mayer (MGM), Warner Brothers, Fox, RKO and Universal Studios (Mordden, 1989).

Paramount was the film directors' studio. Its business concept was that the production of successful films required not only star actors but also star directors. A stable of film stars was not enough, and such people were anyway often very troublesome and demanding. It was therefore important to have strong film directors who could handle the stars. Paramount thus nurtured high-powered film directors such as Ernst Lubitsch, Cecil B. DeMille and Josef von Sternberg. The studio had invested heavily in cinemas chains as far back as the 1920s and had managed to acquire the most attractive locations in the city centres, all of which made it possible for Paramount to produce its A films for sophisticated big-city audiences. As a result, the studio became responsible for the main aesthetic innovations of the studio era, which the other studios then imitated or reacted against in more or less innovative ways. Instead of high-budget films, Paramount invested in visual elegance and sophisticated direction.

> Let other studios go for prestige of big casts, spectacle, or road-show specials. Paramount made its point through eleg-ance, imagination, beauty, the vivacity of the visual.
>
> (Mordden, 1989, p. 33)

As a setting for the film stars Paramount had its disadvantages, since the films possessed a value of their own and were not intended to function mainly as vehicles for the stars. The studio therefore tended to treat its stars as regular actors, who were not allowed to become larger than the roles they played. The film genre for which Paramount became best known consisted

of sophisticated parlour comedies in upper-class settings, with erotic undercurrents.

MGM, headed by Louis B. Mayer, was the studio of the stars, the producers and the musicals. From the high-budget films of the 1920s Mayer had learnt the necessity of retaining firm managerial control over film production. Eric von Stroheim's seven-hour film *Greed* (1924) had been a horrifying example of what might otherwise happen. Film production, just like any other industrial activity, required a rational division of labour and production control.

> At MGM, filmmaking was an assembly line of departments, each answerable to a producer, each producer answerable to the head of production, and the head answerable to Mayer . . . The directors would direct, the writers write, the actors act – all separate, all supervised.
>
> (Mordden, 1989, p. 93)

MGM became especially well known for high-budget musicals which took full advantage of the artistic possibilities of the film medium.

Warner Brothers was the low-budget studio, specializing in radical and cynical gangster films with actors such as James Cagney and Humphrey Bogart. The films were made quickly and cheaply, and the ideas for films were gathered from newspaper cuttings. The films often dealt with current social and political issues.

Fox's film production was characterized by nostalgia for the uncomplicated rural life. Fox's stars looked like the common man and woman, wearing ordinary clothes and preferring life in the country to a big-city existence.

RKO had no experience of the silent film era, nor did it have any strong film mogul to personify the studio. Since, apart from being a newcomer, RKO also had a soft spot for extremely innovative A films which rarely showed any profit, the studio survived on its B film production and on film distribution. In *King Kong* (1933), a film about a giant gorilla's adventures in New York, RKO was the first studio to use special effects. They were also responsible for the renewal of the film musical with the dancing of Fred Astaire and Ginger Rogers as well as for Orson Welles' film classic *Citizen Kane* (1941), which was a success in the big cities, but nowhere else.

Universal was the studio which saw no need at all for any innovation. Laemmle would have preferred the short films of the silent era to remain the predominant film form. Only reluctantly did he imitate the increasingly sophisticated films of the other studios. Because Universal had made no major investment in cinemas, this defensive strategy worked well, since their pictures were generally shown on the outskirts of the big cities to fairly unsophisticated audiences. Universal became best known for horror movies, such as *The Hunchback of Notre Dame* (1923) and *The Phantom of the Opera* (1925) in the 1920s and films like *Dracula* (1931) with Bela Lugosi and *Frankenstein* (1931) with Boris Karloff during the 1930s.

After the Second World War two developments occurred which were eventually to be the undoing of the studio system. Television broadcasting, which had been interrupted by the War, was resumed and in 1948 film companies were forbidden to own any cinemas.

The anti-trust law entailed an immediate cut in production volumes, since the film companies could no longer count on the certain distribution and showing of the 400–500 films made each year. Not to possess any studio facilities or cinemas became an asset, something which especially benefited United Artists, who had never indulged in any such investment. As early as the beginning of the 1950s United transformed itself into a finance and distribution company for independent film producers, thus establishing a pattern for the way the old film studios would be run once they had adapted fully to the new circumstances in the 1960s (Kent, 1991).

If the 1930s had been the decade of the feature film, the 1950s became the decade of television. The technology on which television was based was the wireless telegraph, which had been invented by the Italian Marconi in the 1890s and which gave birth to the radio in the 1920s. During the 1930s the technique made it possible to transfer pictures by wireless. A prime mover in this development was the American broadcasting company RCA, also founded by Marconi. By 1939 television technology had become so reliable that radio companies dared to broadcast television programmes to a public audience during the World Fair in New York (Barnouw, 1990). After the war, the American radio companies resumed their television operations, which had been halted during the war

years. During the pioneering period, which lasted until 1952 because of a licensing ban imposed in 1948, radio broadcasting was financing the television activities.

> An NBC research department memorandum of June 18, 1946, foresaw an 8,000,000 dollars loss from television operations over a four-year period. It felt that radio could and should be made to finance it.
>
> (Barnouw, 1990, p. 103)

In 1953, the licensing ban was lifted and the general dissemination of the new medium immediately took off. By 1956–7 over 85 per cent of American households owned a television set. The new medium had taken over the role of the cinemas as the most popular source of family entertainment. In 1946 American cinemas had attracted four billion visitors; in 1971 the number was down to 820 million (Kent, 1991).

To begin with, television drama was a highly appreciated programme form in the United States. In contrast to the spectacular plots and high tempo of TV series, TV drama moved at a much slower pace; the focus was on everyday problems and the psychological development of characters. The sponsors never really liked this kind of television; after all, wasn't it supposed to be possible to solve everyday problems instantly, with 'a new pill, deodorant, toothpaste, shampoo, shaving lotion, hairtonic, car, girdle, coffee, muffin recipe, or floor wax' (Barnouw, 1990, p. 163).

The psychological interpretations of everyday problems in a good TV play made it seem less plausible that a new floor wax polish could ever solve real marital problems. The characters were too ordinary to be enrolled in campaigns for upgrading American buying habits, which was what the sponsors were striving for.

> People were being urged to 'move up to Chrysler.' . . . But the 'marvelous world of the ordinary' seemed to challenge everything that advertising stood for.
>
> (Barnouw, 1990, p. 163)

And so American television plays disappeared from the TV screens, in a move which was to prove beneficial to the film industry. In the mid-1950s television was still provoking a good deal of anger in Hollywood. The lucrative B film market had

disappeared, since – as Samuel Goldwyn put it, 'Why should people go out and see bad pictures when they can stay at home and see them for nothing?' (Bach, 1985, p. 34).

The film companies had thus lost their basic source of financing and were reduced to making A films. These now carried a much higher risk, however, as they no longer provided a foundation for the mass-production of B films. Up to 1955 Hollywood tried to cope with the competition from television by making their films as different as possible from TV. In 1952 the film industry had acquired much greater freedom when motion pictures were classified as a mass medium with the same freedom as the press. During the 1950s this new-found freedom was mainly exploited in the shape of more explicit sexual allusions. The film companies also experimented with larger screens and made longer and more expensive films; films were now generally also made in colour, but their content and plots were much the same as before.

In 1954 Walt Disney made an agreement for the production of a TV series with the television company ABC. Jack Warner at Warner Brothers was much impressed by the financial terms Disney had received and made a production deal with ABC the following year. Warner would produce three TV series, receiving $75,000 for each episode. One of the series was a western which became such a huge success that it started a flood of similar series. Jack Warner's and Walt Disney's success on television led other film companies to follow their example. At the same time, the film companies discovered that television provided a perfect outlet for old films. In 1956 Warner Brothers received $21 million for the television rights to a package of old Warner Brothers films. Fox got $30 million in a similar deal and Paramount $50 million.

Thus, the film companies regained their lucrative B market and basic financial security in the shape of TV series. Film people who had emigrated to the New York television industry in the late 1940s now returned to Hollywood. In 1957 hundreds of TV series were in production. Most were very simple in format, with a strong emphasis on action rather than dialogue or character development. Action films had big advantages when it came to export: dubbing costs were minimal and audiences could understand physical action even if they had no specific knowledge of American culture.

> While some comedy series . . . were international successes,
> series emphasizing action rather than dialogue were far more
> translatable. Climactic gun battles or fist fights, following a
> chase up a fire escape or down a canyon . . . conveyed their
> meaning readily in any city or hamlet on the globe.
>
> (Barnouw, 1990, p. 231)

It was hard for the importing countries to stand out against the
invasion of the American TV series. Domestic TV production in
small countries was not competitive, because it was not possible
to spread production costs over a world market.

The European film industry had lived in the shadow of the
American industry and the two world wars (Ellis, 1989; Sorlin,
1991). After the First World War the European cinema screens
were already being invaded by films from Hollywood which
enjoyed the support of a huge marketing and distribution
apparatus. During the war the film production in the warring
European countries had come to a standstill, while Hollywood
was busy building up an industrial infrastructure for film
production, with vertically integrated oligopolistic companies.
The European film industry never caught up and was obliged
to resort to the production of specifically European and do-
mestic films. In fact, domestic subjects became the European
film-makers' special market niche, since the American films
usually portrayed an American view of the world. The result was
that European films became so country-specific as to have very
little export potential.

Since television was not in general use in Europe until the
1960s, cinema-going remained popular for longer in Europe
than in the USA. 1956 was the year that broke all records, with
three billion Europeans visiting the cinema. It was also during
the 1950s that European films began to attract more inter-
national attention. Italy was the first country to achieve a wider
market for its films, while the French film directors of the New
Wave gave European film-making its international reputation.

In the mid-1950s, two aspiring film directors, François
Truffaut and Jean-Luc Godard, were working as film critics on
the Paris film magazine *Cahiers du cinema*. In this magazine
Truffaut presented his *auteur* theory of film-making. Until that
time films had been regarded mainly as entertainment and few
people worried about whether or not they were art (Jowett and

Linton, 1989). According to Truffaut's *auteur* theory, films had
authors in the same way as books. A film's author was its
director. However, not all directors were authors, since many of
them made their films on commission. But others, such as John
Ford and Alfred Hitchcock, succeeded in taking control over
their film productions and creating a film style so uniquely their
own that it was possible to regard them as authors. And it was
this kind of director that Truffaut and Godard both wanted to
become. The *auteur* theory roused the cultural critics to take an
interest in films, which now could be accepted as an artistic
medium. In the 1960s this new perception also launched an
avalanche of academic studies of the film.

Apart from assigning the central role in film production to
the film director, Truffaut and Godard also aimed to renew the
artistic form of the films themselves. In the 1960s Truffaut and
Godard were able to realize their dreams. The New Wave's
directors aspired to the same high technical quality in their
films as Hollywood had already achieved. As to the development
of new ways of telling a story, these consisted of conscious
deviations from the classical realism of Hollywood. Federico
Fellini built his films on an associative rather than a linear logic,
paying less attention to clear causal links. The director who
sought most consistently to break with the Hollywood film
tradition, in form as well as in content, was Jean-Luc Godard,
who abandoned the illusion of reality which films often seek to
create by letting the actors turn their attention to the audience
direct, making it clear that what happens on the screen is only
make-believe. The narrative of Godard's films was fragmentary;
it was not always clear what was important and what was not in
the context of the story. Brutal and abrupt cuts also helped to
underline the artificial character of the films. This editing
technique constrasted sharply with the smooth editing tradition
of American films, where cuts were so inevitably motivated by
the sequence of events that they remained invisible. Jean-Luc
Godard also gave his films a politically radical content. He
broke with the psychological realism of the Hollywood films, in
which the characters' actions were governed by psychological
motives; instead, the actions of his characters were an outcome
of the prevailing conditions of power in society. His characters
were socially determined subjects rather than psychologically
free individuals. New Wave films never achieved any major

success in Europe, but met with a more positive response in the United States. Their subsequent commercial exploitation was thus the work of American rather than European film-makers.

The level of tolerance for what could be shown on film had been very low in the USA during the 1950s, due to the cold war. The communist persecutions of the McCarthy era also affected Hollywood, and films came to be regarded as a vital propaganda device in the battle against communism. According to McCarthy, however, the American films had been used instead by communist sympathizers for their own propaganda (Barnouw, 1990), and it was therefore important to identify all film-makers with communist sympathies in order to end such subversive goings-on. During the 1950s many film-makers were blacklisted as part of the communist hunt. In TV series no American in a position of economic power could be portrayed as a villain, since this might be perceived as a criticism of the US economic system. The Hollywood film community was pressed by the American government to take a more active part in the battle against communism by making propaganda films, but the film-makers were reluctant to comply. Hollywood's mission was to produce commercially viable entertainments, not political propaganda. None the less, film-makers took care not to experiment with new genres and formats, since the danger was that this would be perceived as communist propaganda. It was less risky to make romantic comedies with Doris Day and Rock Hudson – films in which 'everybody dates and nobody dies' as Mordden put it (1990, p. 98).

During these repressive years in America, European films had started to attract growing interest in the USA. European films were more varied, and it had become increasingly evident in the States that, since film was no longer the dominating entertainment medium, films could be aimed at more heterogeneous audiences. No film had to please everyone any more. A first sign of this market segmentation came with a tentative exploitation of the youth market, since television had made cinema-going an activity undertaken primarily by young people. Marlon Brando in *The Wild One* (1954) and James Dean in *Rebel without a Cause* (1955) portrayed rebellion against the values of the older generation. In the 1950s, however, the protests of the young were perceived as unwarranted, and the young rebels as either juvenile delinquents (Marlon Brando) or psychologically

disturbed youngsters (James Dean). The rock music that provided the soundtracks reinforced the message. 'Whenever the bad kids appear, the sound track erupts in rock So We Know They're Bad' (Mordden, 1990, p. 127).

In the early 1960s a more positive view of young people was adopted in innumerable beach-party films. The young only wanted to have a good time, ran the message, not to start a revolution. But by the late 1960s the young had definitely developed an interest in revolution, epitomized in the film *Wild in the Streets* (1968) for instance, which features a 20-year-old president.

> Elected, Jones outlaws everyone over thirty. Oldsters are to be herded into concentration camps where water coolers filled with . . . LSD, keep them pacified.
>
> (Mordden, 1990, p. 160)

In *Easy Rider* (1969) it was made quite clear that it was the older rather than the younger generation that posed a threat to the American tradition of individual freedom.

> 'They're gonna talk to you, and talk to you, and talk to you about individual freedom,' Nicholson warns the other two not long before he is killed. 'But they see a free individual, it's gonna scare 'em . . . It makes 'em dangerous.'
>
> (Mordden, 1990, p. 234)

The content of American films thus underwent a radical change in the 1960s. They became politically radical and more realistic. Subjects that had previously been taboo, such as political corruption, prostitution, homosexuality, abortion, extra-marital affairs, child abuse and racism, were now common. Happy endings and positive role models were no longer necessary. It was possible to comment on current issues without being accused of subversive activities. This evolution was further promoted by the disappearance of film censorship in 1968 and its replacement by a new film-rating system. A film could be given a G (for all ages), PG (parental guidance recommended), R (parental guidance necessary for persons under the age of 18) or an X (only for persons above 18) rating. If a company wanted to change a film's rating it first had to remove offending scenes. In practice, self-censorship was still in operation, since an X rating meant that the cinemas chains could not exhibit the film.

The formal experiments of the European avant-garde were taken up in a popular form by the American film producers: the plot could be politically radical and fragmentary, but it must be possible for everyone to understand what the film was about. *The Graduate* (1967) with Dustin Hoffman in the male lead was a popular avant-garde film success.

> Everybody saw The Graduate . . . The critics declared a festival . . . Everyone understood The Graduate and everyone wanted to talk about it . . . The Graduate was the climactic generation-war film of the 1960s, the one in which the parents are totally corrupt and the kids are spotless.
>
> (Mordden, 1990, p. 180)

Easy Rider (1969) provided a telling proof that Hollywood had managed to exploit the commercial potential of the New Wave. For a production cost of $350,000, the film generated $60 million in revenues.

The new heroes, all according to the *auteur* theory, were the film directors. Critics spent a lot of time identifying and describing film authors. Even the traditional film star role changed. In the classical Hollywood film the film stars glowed with their own personality rather than projecting a character image. Unlike stage actors, they had been encouraged to become larger than their roles, which made character acting impossible for a film star. The New Wave film stars were more like regular actors, and were able to project character. As Clark Gable explained: 'At one time if I was given line to speak that wasn't in character I'd say Clark Gable wouldn't say that. Clark Gable doesn't act that way. But now it's different. Now I'd play anything. Dope fiends, drunks, cowards'.

> (King, 1986, p. 175)

Films continued to be made in the new way until 1975, when *Jaws* surfaced on the cinema screens. *Jaws*, directed by Steven Spielberg, was made from a best-selling novel. It was a 'high-concept' film (Kent, 1991), in the sense that its plot could be summarized in one phrase: a shark attacks a beach resort. This helped to market the film. Instead of being shown first in the major cities, *Jaws* was released all over the USA at the same time, backed up by a nation-wide advertising campaign (Jowett and Linton, 1989). In aesthetic terms the film represented a return

to classical Hollywood film-making. The film had a straight, simple plot and an uncomplicated male hero. Its target group was the whole family. The film's aesthetic innovation was its elaborate and spectacular special effects, and it was a tremendous commercial success. George Lucas' *Star Wars* was released in 1977. This film, too, was a high-budget adventure film for the whole famility, with plenty of special effects. *Star Wars* demonstrated the possibility of generating more revenues from toys and other merchandise than from box-office receipts. With *Star Wars* the development begun in the 1960s in Hollywood came to an end, and the blockbusters of the 1980s took over. The heroes of the new era were to be the film producers.

Blockbusters are extremely expensive A films full of extravagant special effects, and so heavily marketed that the marketing budget is sometimes bigger than the budget for production. By the late 1970s the Hollywood film studios were well prepared for producing such films. The old film moguls were dead. Their companies had been bought up during the 1960s by large corporations, which meant that American film companies had access to huge financial resources. They could survive the $50- or $100-million loss that a failed blockbuster movie might involve. The companies were led by traditional businessmen more interested in money than culture. Blockbuster movies had shown that it was possible to generate big revenues very fast in film production. In the blockbusting 1980s, film stars became film stars again. Their fees escalated so ferociously that by the end of the decade it was felt to be less risky to make a $50-million movie than to make one costing $10 million.

> 'It's less scary to make a 50-million dollar film than a 10-million dollar film. For 50 million dollars you can afford big stars and special effects and you know you'll get some money back . . . With a 10-million dollar film with no stars, you run the risk of losing it all.'
>
> (Kent, 1991, p. 73)

In financial terms the blockbuster strategy proved successful: in the 1980s, media products became the second largest American export commodity. The American dominance of the international film market was stronger than ever. US film exports doubled between 1985 and 1990, when they amounted to $11.6 billion. Total turnover for the American film industry

the same year was $21 billion (Kent, 1991). The film industry further received a boost from the growth of the video and cable television markets. A film could now be shown first at the cinema and then sold to network television, and in addition to all this it could be released on video and sold to cable television companies. In the early 1990s the video revenues of American film companies had surpassed their box-office takings. The cinemas were beginning to function as a marketing vehicle for new and more profitable auxiliary markets. In the American business press Hollywood was portrayed as the new hope for the American economy.

> Hollywood has become the last boomtown in America . . . Entertainment is the last major American commodity that can't be produced elsewhere. Demand is so great for film, popular music and TV that Hollywood can charge pretty much whatever it wants when foreign buyers come knocking. Hollywood is where the action is.
>
> (Dana, 1991, p. 82)

A similar euphoria pervaded the US record industry. American record and film companies had become very attractive to investors. In 1987 Sony bought CBS Records for $2 billion, and in 1989 they bought Columbia Pictures for $3.4 billion. Sony's motive for these purchases was to ensure access to attractive software before undertaking any major hardware development.

> The expensive failure of Betamax taught Morita a valuable lesson. The public will only buy an item of hardware . . . if there is a sufficient library of software . . . to play on the new technology.
>
> (Kent, 1991, p. 66)

Other Japanese hardware manufacturers followed Sony's example. In 1990 the hardware company Matsushita bought Universal Studios and its parent company, the entertainment conglomerate MCA, for $6.1 billion.

For the European film industry the 1980s brought a much more cruel fate. Cinema attendances had declined drastically since the film boom of the 1950s. A great may films were still being produced, but more than 60 per cent of Europe's annual production of around 350 films was unprofitable. In Europe,

film was no longer a popular culture; instead it had become a state-subsidized cultural offering for a minority audience (Sorlin, 1991).

ORGANIZATION

Unlike record producers and book publishers, film companies cannot release a large number of products on to the market, hoping that some of them will be hits. Because of the considerably higher production costs for film, (in 1990 films costing $15–20 million to produce were considered inexpensive in the USA) every film must cover its costs. Major American Hollywood movies ($50 million or more in production costs) are expected to gross $100–200 million within a couple of months. How, then, are such films made? According to Goldman nobody knows.

> NOBODY KNOWS ANYTHING
> Not one person in the entire motion picture field knows for a certainty what's going to work. Every time out it's a guess – and, if you're lucky, an educated one.
>
> (Goldman, 1990, p. 39)

The film industry suffers from the same high market uncertainty as publishing and the record business. Most films flop, and there are no certain hits. Goldman offers several examples of how hard it is to predict which films will be successful. In the 1980s Columbia pictures turned down Steven Spielberg's film *E.T.*, after spending a million dollars to develop the idea. Its decision was based on a survey which suggested that *E.T.* would be of only limited interest to general audiences. Some years earlier Universal Studios – who took *E.T.* after Columbia rejected it – had declined an offer to produce George Lucas' *Star Wars*.

> why did Universal . . . pass on *Star Wars*, a decision that just may cost them, when all the sequels and spinoffs and toy money and book money and video-game money are totaled, over a billion dollars? Because nobody, *nobody* – not now, not ever – knows the least goddam thing about what is or isn't going to work at the box-office.
>
> (Goldman, 1990, p. 41)

To manage this uncertainty film companies employ a pre-dominantly commercial business strategy. Hollywood only releases around a couple of hundred new films a year, as opposed to the thousands of records and hundreds of thousands of books with which the record and publishing industries swamp the market with every year. The film industry thus has a far stronger hold on the supply. Film companies also take a great many risk-reducing steps during the production process, so as to be able to cut their losses or take full advantage of the few films which show commercial potential. In the following pages I shall describe film production in some detail, but limiting myself to the way the American film industry (Hollywood) has functioned over roughly the last 15 years.

Unlike European film production, which has always been rather provincial in character, the American film industry has been geared to making films for the whole world right from the start. At the beginning of the 1990s the industry was dominated by seven companies, namely, Columbia Pictures, Twentieth-Century Fox, Metro-Goldwyn-Mayer/United Artists, Universal, Warner Brothers, Paramount and Walt Disney (Castro, 1990). All these companies had their origins in the old Hollywood. Columbia was owned by Sony, Universal by Matsushita, Fox by the Australian media mogul Rupert Murdoch and MGM/UA by the Italian financier Giancarlo Parretti (subsequently taken over by Credit Lyonnais). Warner Brothers, Paramount and Walt Disney had American owners. These former film studios were now organized as finance and distribution companies. It was less common for film companies to initiate film productions themselves. Instead, these were usually initiated by independent film producers who sold film concepts to the companies.

A film producer is responsible for the budget and administration of a film. Producers may be former film executives, agents, film directors or film stars. The first thing a film producer needs is an idea for a film – ideas such as can be found in books, magazines, films, experience of everyday life, etc. Producers usually work on several film ideas at a time, since ideas tend to have a high mortality rate. Once a producer has settled on an idea and acquired the rights to it, the next step is to transform the idea into a film script, usually with the help of a scriptwriter, and to sell the script to a film company.

Each of the seven major Hollywood companies were making

around 15 films a year at the beginning of the 1990s (Kent, 1991). About 100 scripts, chosen from among the 4,000 each company received annually, were continually under development. To handle them all, professional writers were hired as script-readers. They would write a report about each script's qualities and recommend it for approval, rejection or further consideration. The cover page of a report, where the script content is summarized, is particularly important: this is what a film executive – looking primarily for high-concept scripts – would read first. If the plot cannot be summarized in two sentences the executive might stop reading. If a script has media tie-in possibilities the chances of approval increase, and if a film star has already shown some interest in a script, the chances rise dramatically (Goldman, 1990; Kent, 1991).

Batman (1989) is an example of such an ideal film. It was a high-concept movie (Batman fights his arch-enemy, the Joker). It had Jack Nicholson cast as the villain. The movie could be released as a book, a cartoon and a record. It had obvious potential as a toy-selling device.

Once a script has been approved by a film studio, the next step is the casting. For a script to become a film, the producer has to interest some stars in the script as well as a film director of a good reputation. During the studio era this was not a problem, since stars and directors were both employed by the film studios (Mordden, 1989). When the studio system disappeared during the 1950s, it was replaced by an open talent market in which agents acted as talent brokers.

> 'The studios need the talent and the talent needs the studios and everybody sort of pretends they don't need each other, and that's kind of where the agent comes in.'
> (Jeremy Zimmer, artists' agent, quoted in Kent, 1991, p. 211)

Because the demand for talent in Hollywood in the 1980s was greater than the supply, there was a seller's market, where film stars and the directors could pick and choose between offers. And, since many of the stars had become multi-millionaires, they could be quite choosy and it was therefore vitally important to have good relations with the talent network, i.e., the agents.

Once the stars and the director have been contracted, a major script rewrite takes place. A film script is not a film in itself, but merely the starting-point for a film. It is not enough for a script

to have the potential to catch an audience of a couple of thousand; it must be reworked to attract the attention of millions. Since appeal on such a scale must exploit the stars to the full, an important part of the script editing consists of adjusting the script to the stars.

Despite the continual demand for good scripts, the script-writers occupy a very low position in the film-making hierarchy. They tend to be treated like tailors, expected to cut the scripts to fit the stars, the directors and the film executives without letting the seams show too much. Several scriptwriters are usually involved in the final editing of a script; nor is it rare for the original writer to be fired at an early stage in the editing process. According to Goldman (1990), who has been working as a scriptwriter in Hollywood since the 1960s, the consolation for him and his like is the money. Goldman received $80,000 for his first film script, which was substantially more than the $2,500 he had made on his most recent book. As Kent acknow-ledges: 'They ruin your stories. They trample on your pride. They massacre your ideas. And what do you get for it? A fortune' (Kent, 1991, p. 115).

Once a script has been cast and adopted by the stars, the next step is to get the go-ahead signal from the company boss. At this stage it is crucial that the film is clearly anchored in a successful cinematic genre, and that it constitutes an interesting variation within the genre. Original or off-beat scripts tended to arouse suspicion among film executives in the Hollywood of the 1980s. Such films meant taking a step into the unknown. That off-beat scripts had proved capable of generating extremely successful films only increased the film executives' fears (Goldman, 1990): for the executives an approval of an off-beat script meant admitting that they knew absolutely nothing about what made a film successful – which would open up a terrifying abyss.

The survival span of a film executive in Hollywood has been growing ever shorter (Kent, 1991). An executive is expected to deliver a hit immediately. At the same time, he is forced to speculate on future audience taste, since it takes about 18 months to produce a film. The film executive is thus never better than his next film.

'You only need two or three expensive movies that don't do well within a given year, and your legitimacy is very suspect.

Eventually you are going to lose because the odds are running against you.'

<div align="right">(Studio executive, quoted in Kent, 1991, p. 52)</div>

Upon approval by the chief, production and time budgets are established. Up to 1986 tax deduction arrangements made it possible to attract outside investors into film production in the USA (Vogel, 1990). Once this source of finance had disappeared it became the common practice to offer the stars a share in the profits of a film against a reduction in their fees, which for a blockbuster movie in the 1990s could easily amount to $15–20 million. If the stars agreed to accept lower fees in exchange for a share in profits, there would be a substantial reduction in production costs. This system was fairly well received by the stars. Jack Nicholson made an agreement along such lines for *Batman* (1989) and ended up a multimillionaire. Over and above a guaranteed fee of $7 million, Nicholson received 15 per cent of the film's gross profits.

Once the chief has given his go-ahead, shooting starts. At this stage the film director takes over responsibility for the production. Apart from the artistic responsibility, the director is also expected to see that production and time budgets are kept. His job is hard and intensive: 'In Attenborough's case, it wasn't just twenty-four months; it was twenty-four months, seven days a week, for an average of eighteen hours per day', Goldman tells us (1990; p. 288), describing work on a *A Bridge Too Far* (1977).

When the film has been shot and edited, extensive marketing activities are launched. The producer's function at this stage is to ensure that the film gets enough marketing support. Since the marketing of a film is almost as expensive as its production, the company may decide to curtail the advertising somewhat, if there are any doubts about a film's commercial potential. Previews and audience surveys are undertaken, but the real market test tends to be on the opening night, when the film's true commercial potential is revealed. In the USA major film premieres are held during the summer or Christmas season; since the main cinema audience is under 30 years old, there is an advantage in exploiting the school holiday period.

Although American films often target a young audience, they certainly consider the interests of other potential audiences too. The goal is to attract as many different audiences as

possible. Christmas openings are particularly important be-
cause a Christmas film can enjoy a new life in March when the
Oscars are announced. In the late 1980s an Oscar for the best
film was estimated to be worth $10–30 million in extra revenues
(Jowett and Linton, 1989).

A blockbuster campaign can run to $20–30 million in market-
ing costs (at the beginning of the 1990s), and encompasses a
huge range of activities. The film is released nation-wide,
supported by a massive advertising campaign. Thousands of
copies of the film must be available. The box-office revenues
taken during the first weekend decide the future of the film: if
attendence figures are low, the film company halts its promo-
tion activities; if the film is a box-office success the promotion
campaign continues. In the long run, however, this is not
enough. For a film to become a lasting success, it has to be
genuinely popular, the sort of film that people recommend
each other to go and see.

Due to increasing production and marketing costs, film
company profits have not reached the same astronomical heights
as the film stars' fees. In 1990 the production cost of an ordinary
Hollywood film rose to $15–20 million. With outgoings for
overheads, interest and marketing on top of this, such a film had
to generate $50 or 60 million in revenues to cover its costs. Few
films achieved that. Most of the revenues of a successful film had
to be used to cover the losses on those that were less successful.
But if the blockbuster mentality of the 1980s failed to create
blockbuster profits, it did succeed in raising the barriers of entry
so high that by the end of the decade Hollywood dominated film
production almost unchallenged.

AESTHETICS

In the infancy of the film the question arose as to whether such
a 'realistic' medium could be art. Did it not perhaps have more
in common with instruments such as the microscope, thus
lending itself to scientific rather than artistic exploration? The
art psychologist Rudolf Arnheim argued in the 1930s that film
was an artistic medium because of its unique ability to create an
illusion of reality. It was this illusion, and never reality itself,
which the pictures portrayed. And no earlier medium had been
able to create illusions of reality as vividly as film. Art photo-

graphy had encountered a similar reaction, and the advocates of the art had pointed out that photographs never portrayed raw reality, but an edited version of it. The photographer always had to choose the subject, the lighting, the shooting distance, the angle, and so on (Becker, 1986).

This early debate about the aesthetic status of the film medium never caught the public interest. The prevailing view was that film was entertainment. It also had a use in teaching and the transmission of news, since film provided a more direct experience of the world than still pictures or the printed word. The recognition that film could evoke different perceptions of reality depending on the way it was edited led to its adoption for purposes of political propaganda. In the very early days of film it was even thought that the moving images entered all viewers' minds direct and unchanged. Not until the 1930s was it pointed out that socio-cultural factors affected their reception by different individuals (Jowett and Linton, 1989).

It was with such sociological, as opposed to aesthetic, premisses in mind that Adorno and Horkheimer embarked on their famous study of the Hollywood film industry during the 1940s (Adorno and Horkheimer, 1989). The authors saw Hollywood as a dream factory which manufactured day-dreams for the American people in the same way that the car industry in Detroit made cars for them. Nor was there any great difference between the two activities: films were just as standardized and as hard to tell apart as cars.

> That the difference between the Chrysler range and General Motors products is basically illusory strikes every child . . . The same applies to the Warner Brothers and Metro Goldwyn Mayer productions . . . for automobiles there are such differences as the number of cylinders, cubic capacity, details of patented gadgets; and for films there are the number of starts, the extravagant use of technology, labor, and equipment, and the introduction of the latest psychological formulas.
>
> (Adorno and Horkheimer, 1989, pp. 123–4)

This theory of film production has not gone unchallenged (Storey, 1993). Adorno and Horkheimer have been accused of cultural elitism because of their extreme hatred of popular culture, which they regarded as a kind of stylized barbarism.

Moreover, their theory can be discarded as irrelevant, since the system of film production on which it is based ceased to exist in 1948. Nor, during the studio era, was Hollywood film production as stereotyped as Adorno and Horkheimer described. It was more in the nature of a handicraft than an industry (Ellis, 1989). As Kent claimed, 'if we made cars the way they make movies, we would all be pedestrians' (1991, p. 34). Furthermore, film production could not possibly have been standardized to the extent that Adorno and Horkheimer claimed, since A films at least could not resemble each other too closely. And even if the films themselves were fairly standardized, this did not necessarily mean that their reception was equally uniform (Fiske, 1989). The cinema-goers of the 1940s were a very active audience (Ellis, 1989; Sorlin, 1991). Going to the cinema was a social and meaning-generating activity. People went to the pictures in groups, took an active part in what was happening on the screen, and discussed the qualities of the film both during and after the show.

Despite all the criticism, however, Adorno and Horkheimer were in many ways pioneers. They are still fairly unusual in having tried to understand how technical and economic factors, as well as aesthetic considerations, can influence film production. Their fear of the new mass media probably owed more to their experience of Nazi Germany than to visits to American cinemas. And even if Hollywood film production was not totally standardized and uniform during the 1930s and 1940s, it has to be admitted that the film moguls had tried systematically to standardize it in order to make possible the mass-production of films. This was particularly evident in the area of B films, where successful film concepts taken over from A films were mass-exploited. Kerr (1979–80), for example, describes how the very limited production budgets of the B gangster films of the Forties contributed to the dark sense of doom that pervaded them. The model was the cynical gangster film with stars such as James Cagney or Humphrey Bogart. But without the necessary financial and artistic resources, and suffering from severe budget restraints, the B versions often had to be shot at night when A films were not using the sets. And since there was no money for elaborate sets of their own, the poor light was an advantage, because everything looked better in the dark. The shooting of crowd scenes or the use of special effects were both

financially impossible, so left-over footage from other films was used, which made it impossible to adopt the smooth editing technique of the A films. All this gave the B gangster film a fragmentary and incoherent character, which the film critics interpreted as an anti-realistic aesthetic. The constant darkness and the gloomy atmosphere inadvertently created were perceived as a critique of modern civilization.

No system of streamlined B-film production ever developed in Hollywood. The production of such films in the studio era remained rather an *ad hoc* affair, since the film-makers had to make do with whatever they could find in the studio. It was left to the television medium to take full advantage of the possibilities of standardization which Adorno and Horkheimer had pointed out. In television production greater standardization was possible due to the TV series format.

The production of a TV series suffers from the same high level of market uncertainty as the production of a film. During the 1980s American television companies were receiving around 3,000 new ideas every year (Gitlin, 1985). Of the 25 new TV series that were chosen and which appeared each year, only five survived more than one season. The scale advantages of television production arise when a successful TV series is actually achieved. Such series will have a reliable narrative structure and popular main characters. And although the viewers know that the main characters will always cope with the problems that arise, suspense is maintained because the don't know how they will do it. By varying the arrangement of the basic elements in a series, a sustained sense of surprise can be created. If the different episodes begin to resemble each other too closely, new characters can be introduced to create new problems and developments. A successful TV series can also generate spin-offs, whereby some of the characters appear in a series of their own. The successful elements of a series can also be recombined into a new not-too-obvious imitation of the original success formula. The television companies also gradually discovered that the hazardous process of product development could be delegated to the more innovative film industry (Ellis, 1989). As early as the 1950s Hollywood films were already functioning as prototypes for the production of new TV series. If the manufacture of a TV series could be described as industrial long-line

production, then film was still a handicraft engaged in the making of unique products.

Adorno and Horkheimer's sociological approach never gained wide acceptance in film aesthetics, partly because of the impact of Truffaut's *auteur* theory. Since, according to Truffaut's theory, films had authors, films could also be seen as texts. It therefore became possible to study films with the help of literary theory. In *auteur* theory terms, film-making was a creative activity not a mechanical production process. The film was the director's artistic medium (Kerr, 1986). The industrial environment in which films were made was no more than an obstacle that had to be overcome. The great film creators were artists who had managed to realize their artistic visions despite the industrial aspects of film-making. Ingmar Bergman and Roger Corman are two film directors who can illustrate this alleged tension between art and commerce.

Ingmar Bergman saw the artistic value of his films as being of prime importance (Bergman, 1989; 1990). He suffered in the 1950s when he had to direct light entertainment films to get enough money for his more artistic projects, and his relief was great when his film *Persona* (1965) finally brought him enough respect to allow him to concentrate on artistic films henceforth.

> At some time or other, I said that *Persona* saved my life – that is no exaggeration. If I had not found the strength to make that film, I would probably have been all washed up. One significant point: for the first time I did not care in the least whether the result would be a commercial success. The gospel according to which one must be comprehensible at all costs, one that had been dinned into me ever since I worked as the lowliest manuscript slave at Svensk Filmindustri, could finally go to hell (which is where it belongs!).
>
> (Bergman, 1990, pp. 64–5)

The B-film director Roger Corman was interested mainly in a film's commercial value, as suggested by the title of his autobiography *How I Made a Hundred Movies in Hollywood and Never Lost a Dime* (1990). He was always upset if he failed to keep to his production budget or if any of his films lost money. He was especially pleased with *Little Shop of Horrors* (1959), which had been made in two days with money left over from another production that had gone more quickly than expected. *Cock-*

fighter (1978), on the other hand, proved to be a troublemaker. It was about cockfighting in Georgia, and Corman thought it would be a surefire success but it wasn't. However, Corman was no quitter. He gave the film a new name, made a trailer that had nothing to do with it, and re-released it.

> we're going to call the picture *Born to Kill* and we're going to make a new trailer and we're going to put all these new scenes into the trailer and make it look like a picture with trucks and girls and tits and guns and all these things that really aren't in the movie. And we'll try to save the picture.
>
> (Corman, 1990, p. 202)

When he experimented with LSD in 1967 it was not God he saw, but a new art form with distribution advantages.

> you didn't need books or film or music to communicate it; anyone who wanted to experience it would simply lie face down on the ground anywhere in the world . . . and the work of art would be transmitted through the earth from the mind of its creator directly into the mind of the audience . . . To this day, I'd like to think this could work . . . I think of all the costs you could cut in production and distribution alone.
>
> (Corman, 1990, p. 146)

But Bergman and Corman were both well aware that film was not solely art or solely commerce. It was ordinary businessmen who financed Bergman's production of cultural capital.

> I have always found it difficult to feel resentment when industry comes rushing towards culture, check in hand. My whole cinematic career has been sponsored by private capital. I have never been able to live on my beautiful eyes alone!
>
> (Bergman, 1990, pp. 285–6)

Although Bergman's films had a limited audience, they still generated substantial revenues, since unlike other more popular but more provincial Swedish films they commanded a huge export market.

In the 1970s Corman had switched from film directing to film production. He now churned out B films on a much greater scale than he had done before, but he wanted to be perceived as more than a simple trash-film producer. He therefore decided to supplement his B film production by importing

foreign art films. Among others he imported Ingmar Bergman's films and showed them at drive-ins.

> When I . . . met Bergman . . . he mentioned that he thought it was great that we put his film in the drive-ins. "Nobody even thought of that before", he said. "'I've always wanted my pictures to get the widest possible audience."
>
> (Corman, 1990, p. 190)

Corman also created cultural capital by acting as mentor to up-and-coming directors and film stars such as Francis Coppola, Martin Scorcese, Peter Bogdanovich, Jack Nicholson and Robert de Niro. Making a B film for Corman was a way for them to learn the skills they would need.

After the first wave of enthusiam, the *auteur* theory began to seem a bit too romantic, given that a film was the product of several hundred people's work (Goldman, 1990). The subsequent dislocation of the film directors from the central position began as part of a movement known as *auteur-*structuralism. Attention became focused on artistic form rather than content. It was more interesting to study the way different directors generated meaning in their films than to consider some unique world-view that their films might be said to express. The question arose as to whether or not a director really did create the meaning of a film. If not even literary authors were able to control their texts, it seemed even less plausible that a single individual would be able to control a vast collective product such as a film. This heralded the demise of the author in the world of films and, as elsewhere, structuralist analysis became the order of the day. No-one could be said to control a film text. A film gathered its meaning from the relation between its various images and the pictures in other films. There was no world outside the film. Marxist structuralism provided some contact with the extra-textual world: here interest focused on how far films could be seen as reflections of prevailing social conditions. But this focus said nothing about a film's relations with the film industry which produced it. Film had become art, and art had nothing to do with commerce. Film studies became an academic discipline in the 1960s, and film students began to study classical Hollywood realism in textual film analyses. This development was encouraged by the structuralist view that it was impossible to draw

any clear dividing-line between popular and high culture. Meaning-generating structures were to be found everywhere. You could just as well study a cocktail party as a play by Shakespeare or the latest Hollywood movie. The subsequent wave of poststructuralism, which stressed the disorder rather than the order of the images, was later to justify the film critics' interest in the action-orientated blockbuster movies of the 1980s. Postmodern aesthetics here underlined the emotional and visual elements in art. Since blockbuster movies were geared to a very high degree of physical action and special visual effects, they aroused a good deal of interest among poststructuralist film critics.

Classical Hollywood realism has several recognizable attributes. The film's events are anchored in time and space in a logical chain of events with clear causal links (Bordwell and Thompson, 1986). The audience is given privileged information in the sense that the spectators are allowed to know more about prevailing causalities than the textual characters. Even films in which things happen that could not happen in reality (e.g., Superman can fly) can qualify as realistic films, provided clear causal connections are established (Superman can fly because he is from another planet). Characteristic of realistic films is thus that they create a universe of their own with its own natural laws, rather than that they reproduce any kind of extra-textual reality. The films concentrate on events that advance the story. Cutting and editing are motivated by the chain of events. The artificial character of the film is thereby concealed, to enhance the illusion of reality. Single individuals are the film's action agents. These people's actions have psychological causes. An unfulfilled desire for something is an important force which drives the main characters. A film often starts with some disturbance in an otherwise harmonious state of equilibrium. The textual characters may fall in love or be unjustly attacked. The film then portrays how they restore the equilibrium by getting married or taking revenge. The ending of such films is final, in the sense that no doubt remains about whether or not the textual characters have accomplished their mission.

According to Ellis (1989) the dominance of this visual narrative technique in film-making is the result of a social learning process. Because American films began to dominate film production as far back as the 1920s, cinema-goers came to see 'films' as meaning 'Hollywood films'. Films that diverge too

far from Hollywood's realistic narrative technique are not therefore perceived as proper films. Since American films were often also blatantly lavish, cinema-goers learnt that proper films were expensive films.

Another reason for Hollywood's dominance may have been that the large American home market offers an almost unbeatable competitive advantage. Thanks to the huge home market, American films can be made at much greater cost than European films. They can also bear much higher marketing costs. Furthermore, the American film industry can invest far more in special effects and in film stars with world-wide appeal. And the United States has yet another competitive advantage in its much longer experience of the mass production and distribution of culture.

During the nineteenth century, when our present industrialized society was emerging, the production of culture in Europe was governed by the notion of culture inherited from the Romantics, whereby art was seen as an alternative societal ideology, which emphasized the creative rather than the repetitive aspect of human existence. By contemplating works of art, man would be able to survive as a feeling and moral being, even in industrialism's mechanized society (Eagleton, 1989). Inspired by this notion of the mission of art, many leading artistic creators in Europe began to look down upon common pleasures such as amusement parks and vaudeville theatres. This Romantic notion of culture never gained a strong foothold in the United States (Twitchell, 1992). While the production of culture in Europe was governed by a Romantic ambition to educate people and make them more civilized with the help of the arts, the production of culture in America was governed by an ambition to make money from it. While amusement parks were frowned upon in Europe, they were industrialized and mass-produced on the other side of the Atlantic.

As a result, the USA became the home of specialists in the production of popular culture as far back as the nineteenth century, while producers of culture in Europe were geared more to the production of high culture. Since popular culture entails the mass-production and distribution of culture, this also meant that the Americans were able to take advantage of the technological innovations of industrialism. Combined with the popular, easily understood, action-packed and spectacular

nature of American arts products, this proved to be an un-beatable force. By the turn of the century the Americans were already well prepared to spread their industrialized carnival culture all over the world.

To break the American dominance in the field of arts production today would be a very hard task. In 1993 Universal Studios invested almost $200 million in Steven Spielberg's dinosaur movie *Jurassic Park* (1993). The production budget was around $60 million, and the marketing budget as high again. If the movie became a box-office success, Universal Studios planned to build a Jurassic Park for more than $60 million in the company's amusement park in Orlando, Florida (Broeske, 1993).

Despite the almost total market dominance of American films, Ellis (1989) still believes there is also room for other types of film. Fiske (1989; 1990) does not. Fiske claims that a cultural product is transformed into popular culture by the consumer, not by the producer. For a film to become popular it must represent an open text. Charactistic of open texts is that they are ambiguous and offer the reader a variety of possible interpretations, whereas closed texts want the reader to make the 'right' interpretation. In high culture the creative labour resides primarily with the producer, so that texts produced within this culture tend to be fairly closed. In open texts the creative labour occurs in the course of consumption, when consumers create meanings of their own.

However, it is not sufficient for a film to have an open text in order to be popular. It must also be easy to understand. Modernist poetry also has an open text, but it is difficult to understand because understanding calls for considerable know-ledge of poetry and other literature. Because Hollywood films are both open and easily understood, they stand a much better chance of becoming popular culture than modernist poetry.

Their openness is necessary because they are produced for heterogeneous audiences. If a blockbuster movie is to attract several million people it cannot be too narrow, since this would exclude many potential audiences. And even if the main audience of the Hollywood film is white middle-class youth, it is still necessary to make the film attractive to other audiences as well. This is achieved by the ambiguous character of the film. Sylvester Stallone's films about the Vietnam veteran Rambo can

be interpreted either as assenting to American imperialism (Rambo's disappointment over the loss of the Vietnam War) or as a revolt of the suppressed against their opressors (Rambo's rage against his superior officer who does not understand his disappointment). Ronald Reagan chose to make the first interpretation, while the Aboriginals in Australia preferred the second (Fiske, 1990). MTV provides another example of the way ambiguous products of popular culture manage to attract different audience categories. MTV has aroused a lot of interest, not only among teenagers but also among postmodern feminists.

> MTV is a useful area within which to debate competing claims about postmodernism . . . Madonna's successful 'Material Girl' . . . stands in a strange intertextual relationship to Howard Hawk's film, *Gentlemen Prefer Blondes* . . . Madonna may be said to represent a postmodern feminist stance by combining seductiveness with a gutsy kind of independence.
>
> (Kaplan, 1989, pp. 35–7)

Fiske's view of popular culture and popular films can be seen as the film critics' surrender to Hollywood. Aesthetics is not only a question of aesthetic sense-making. It can also function as a retrospective legitimization of new art forms once these have reached enough audiences (Becker, 1982).

SUMMARY

In this chapter I have tried to describe the functioning of commercial film production. The description has focused mainly on the American film industry. The technique for showing moving pictures was invented by Thomas Edison in the 1880s. Jewish immigrants discovered the commercial potential of the new invention. Originally, the American film industry was concentrated in New York and Chigago. In 1909 an attempt to create a film monopoly was made by Thomas Edison. The film entrepreneurs did not appreciate Edison's attempts to take control over an industry which they had themselves created, and they fled West to Hollywood. Edison's monopoly organization was dissolved by an anti-trust law in 1915. An oligopolistic order then came into being among the film entrepreneurs in Hollywood, as manifest in the studio system. A film studio consisted of a film

mogul, film stars, film directors and other personnel. The film stars were important to the marketing of the films, since the stars were the ones to attract the first audience. But for a film to be more than a short-term success it also required someone who could exploit the talents of the film stars efficiently. The professional skills of the film directors were therefore also an important feature of the studio system.

In 1948 the studio system was dissolved by an anti-trust law which made it illegal for a film company to own cinemas. The American film companies could no longer count on the guaranteed distribution and exhibition of the 400–500 films they were producing each year. The situation was aggravated by the arrival of television. In the 1950s television took over the role of the cinemas as the most popular medium for family entertainment. The American film industry was severely hit by this development, since its most important source of revenue – the B films – now disappeared. Until this time aesthetic innovation had been delegated to the A films, in which new film concepts had been tried out. When a certain type of film had proved commercially viable, the underlying success formula was then used in the mass-production of B films, which represented cheap imitations of successful A films. The American film companies were reduced to producing A films exclusively, which now represented a much higher risk as they were no longer the basis for the mass production of B films. In the mid-1950s the film companies started to cooperate with the new TV medium, and regained their lucrative B-film market by producing series for television. During the 1960s American film production became more varied and heterogeneous under the influence of the New Wave in Europe. In 1975 this trend was broken by *Jaws*, which was based on a best-selling novel and was full of spectacular special effects. The film became a huge commercial success and opened the way for the blockbuster movies of the 1980s. Blockbusters are extremely expensive A films which are marketed so heavily that the marketing budget is sometimes even bigger than the budget for production. The blockbuster mentality managed to raise the barriers of entry so high that by the end of the decade Hollywood had come to dominate commercial film production almost entirely. By then, the American film companies were organized as finance and

distribution companies. Films were usually initiated by independent film producers who sold ideas to the film companies. The chapter concluded with a brief discussion of the history and development of film studies.

Chapter 7

Just making believe

So far this book has been mainly concerned with the production of art. In the present chapter I will be discussing the consumption of art, and the effects of this on the activities of arts-related businesses. The analysis starts with an examination of story-telling as a way of creating knowledge about the world; and the production of art by the culture industries is here interpreted as industrialized story-telling. The way in which the stories produced by these industries are used in human sense-making is illustrated by examples from two sources of story-telling: American television series and popular management literature. I conclude by discussing some implications for strategy-making in arts-related businesses and suggest some lines of exploration that could be useful in this context.

HOMO NARRANS

The idea that there is an aboriginal world to discover somewhere 'out there' has fewer advocates among scholars today. Human beings are thus obliged to create their own worlds, and the worlds they create are necessarily based on earlier world creations (see, among others, Bruner, 1986; Anderson, 1990). Each human being constructs his or her world (theoretically there are as many worlds as there are human beings) from his or her intentions, and from experiences occurring in contact with fellow human beings. Ultimately, it is the transfer of meanings between individuals that creates human culture and gives meaning to existence. No world can be said to be more 'true' than any other world. Nevertheless, different versions of the world may be more or less firmly anchored in earlier

human experiences of the way the world functions (Bruner, 1983; 1986). Nature sets the limits on what humans can do. But it is human culture that governs human action.

> The engine in the car does not not "cause" us to drive to the supermarket for the week's shopping, any more than our biological reproductive system "causes" us with very high odds to marry somebody from our own social class.
>
> (Bruner, 1990, p. 21)

If there is no original or 'true' reality against which the validity of different world-views can be tested, then it seems reasonable instead to test the usefulness of the different views (Bruner, 1990). Instead of asking whether a certain view of the world is true, it makes more sense to ask what belief in that world-view would entail, what implications it would have for action, and whether or not these are desirable.

Although many attempts to establish absolute and 'true' world-views have been made throughout history, the probability of success in such a venture according to Anderson (1990) has declined considerably since the industrial revolution; the world, he claims, consists of our stories about it. Before the dawn of the industrialized society, people were not as aware as we are today of the existence of the multiplicity of world stories differing from their own. This sort of knowledge came – or became more widely spread – with the greater social and physical mobility that accompanied industrialsm. The improbability of the existence of a 'single truth' has become even more evident during the twentieth century: modern information technology makes it increasingly difficult to put a lid on undesirable stories and the fabrication of absolute truths is well-nigh impossible. There are simply too many stories for any one of them to stand out as the true story of the world. The story to end all stories will probably never appear, since the human brain is not a mirror of nature portraying the world as it is, but an active processor of our sense impressions or images of the world. This does not mean that there is no extra-textual reality, only that we cannot see it direct and in the raw. Science can be said to represent an attempt to test the correspondence between our stories and this storyless reality. But even these tests cannot be said to constitute definitive experiments whereby the

story to end all stories will become manifest, since many different stories can fit one and the same reality.

Scientific sense-making is effected through the depiction of scientific theories which order the world on a basis of scientific concepts. Everyday sense-making, on the other hand, does not usually seek the help of scientific theories (Benson and Hughes, 1983). Rather, people tell each other stories about the world and about the reasons why people undertake certain actions in it (Fisher, 1989; Bruner, 1990). Everyday sense-making thus makes the world into a narrative structure. Events happening in everyday life are ordered in a sequence to suggest a coherent course of events. Single individuals are the agents of action in the stories. Human story-telling is particularly likely to occur when something unexpected happens and a state of equilibrium is thereby disrupted. The surrounding world and/or the person involved then tends to invent a story to make the disturbance seem understandable. By establishing a coherent chain of happenings, the unexpected event is endowed with meaning and becomes comprehensible. The happenings of everyday life are thus ordered in a pattern that resembles the narrative structure of a classic Hollywood film. And, just as in a Hollywood film, it is the story's narrative credibility that is important, rather than its correspondence to reality.

Compared with scientific theories the stories of everyday life represent texts of a much more open and ambiguous kind. This equivocal quality is necessary, since the credibility of the stories rests on their social relevance to the audience; people must be able to recognize their own lives in them. By remaining equivocal and open to multiple interpretations, everyday stories provide opportunities for a multitude of listeners to see themselves reflected in them. It is also important, if identification is to occur, that the agents of action are human beings. It must also be clear that the story is being told by a human, and not by some kind of superhuman sense-making being:

> It is easier to live with alternative versions of a story than with alternative premises in a "scientific" account . . . We *know* from our own experience in telling consequential stories about *ourselves* that there is an ineluctably "human" side to making sense. And we are prepared to accept another version as "only human".
>
> (Bruner, 1990, p. 55)

Over the ages human societies have accumulated a vast stock of stories. This storehouse has come to function, not only as a device for everyday sense-making but also as a way of making social conflicts manageable. Thanks to their ambiguity, the stories become socially negotiable and thus able to help solve social conflicts (Bruner, 1990). Mankind's stock of stories is constantly being topped up, largely by the culture industries. The activities of the culture industries can thus be seen as industrialized story-telling for everyday sense-making.

Below I shall examine the way stories told by the products of the culture industries are used in everyday sense-making. My argument owes much to Fiske (1989; 1990). The concept of culture is used here mainly in its anthropological sense, implying certain ways of living which express certain ideas about the appearance, functioning and meaning of the world.

'TOP MODEL MARRIES LEPER'

According to Fiske there is no such thing as 'raw' reality. What is perceived as real is rather the outcome of cultural coding.

> There may be an objective . . . reality out there, but there is no universal, objective way of perceiving and making sense of it. What passes for reality in any culture is the product of that culture's codes, so "reality" is always already encoded, it is never "raw".
>
> (Fiske, 1990, pp. 4–5)

A code is a rule-governed system of signs whose rules and conventions are shared by the members of a culture. Cultural codes are used to generate and circulate meanings in a culture. They relate the different cultural products to each other in a network of social meanings about the signification of various phenomena. The reality we encounter is therefore already culturally encoded and filled with social meaning. The culture industries are specialists in this sort of encoding, since they use the codes of a culture in a deliberate manner to create specific social realities. However, the fabrication of reality by these industries is not absolute; it merely suggests possible ways of experiencing the world. The reality constructs that actually emerge will depend on the way the consumers interpret the cultural products.

Berger and Luckman (1966) studied social sense-making in detail and found that, in their view, the whole of human society is a social construction produced by human action and thought. Human action and thought are institutionalized in the shape of social institutions which define how social issues such as education, health care, commerce, foreign policy, child care, etc. are to be handled. Social institutions acquire coherence and legitimacy from prevailing social meanings, which explain the existence and necessity of the institutions. Social institutions often try to justify their own existence on the grounds that they are the expression of a natural and rational order. Human beings are socialized into existing social meanings and institutions, and tend to experience them as objective, in the sense that they are taken for granted and perceived as originating in nature rather than in man. The activities of the culture industries can be seen as a part of these processes whereby people are socialized and the prevailing social meanings find their justification.

Fiske is particularly interested in the encoding of social reality in this perspective in American television series. The reality transmitted by this medium is encoded on three levels. Raw reality consists of the TV actors' physical appearance – their clothing, make-up and movements – and the physical environment. This raw reality is constructed from the social coding of everyday reality where, for example, a certain environment carries a specific social meaning. The representation of reality in the TV shows is achieved by imposing a narrative and dramatic structure on this raw reality, whereby certain features of everyday life are highlighted and endowed with a special significance. Camera angles, editing, lighting and soundtrack provide important technical codes here, while story, *mis-en-scène*, characterization, action and dialogue are important dramatic codes. At the ideological reality level, American TV series express prevailing American social values which explain and justify existing social conditions in American society. For instance, they portray the white middle class as American society's natural power-holders, the market economy as the natural economic system and a liberal democracy as the natural political system. In the world of the American TV series it is natural to be a materialistic individualist, trying to make as much money as possible. It is also a fact of nature that men

know better than women and children, and that white middle-aged men know best of all. At this ideological level of reality television casting is particularly important, since the various actors are going to embody prevailing social ideologies.

The narrative structure of American television series is classical Hollywood realism. Just like Hollywood films, American TV series aim at creating a strong sense of reality, even though they are not mirrors of nature, any more than the human brain is. Since the TV series are encoded from everyday reality, and the coding is hidden in accordance with the conventions of classical realism, the series tend to confirm existing social meanings. Prevailing social conditions are portrayed as natural and are not questioned. However, since the American series aim to attract large audiences, and the only way to accomplish this is to attract *different* audiences, as there is no homogeneous mass audience to appeal to in contemporary society, the series cannot be as closed or as one-sided as political propaganda would be, since this would exclude many potential audiences. Consequently, out of commercial necessity, American TV series constitute open and ambiguous texts with a view to attracting as many audiences as possible.

Since it is mainly the products of high culture that are studied in schools and reviewed in the media, there are no privileged or society-sanctioned readings of the products of popular culture. The sense-making evoked by a TV series therefore occurs mainly on the audience's terms. When a series is being used by a large enough number of people in their everyday sense-making, it becomes popular culture. Such popularity does not mean that all viewers have discovered the same meaning in the series or that it has managed to capture something with universal appeal. The popularity of a TV series is rather an expression of the fact that many viewers have found it socially relevant and useful to their own production of meanings.

The meaning of a series is thus not embedded in the series as such, but in the viewers' interaction with the series – even though American TV serials often try to make some meanings more plausible than others. According to Fiske, most Hollywood products are based on an individualist ideology, in which conflicting types of character are welded into a harmonious whole. The American action series *The A-Team* can illustrate this.

The A-Team consists of four Vietnam veterans who have run into trouble with the law. They live on their own and have no families; they make a living by helping people in need, but insist on being paid. They are not in the charity business. The people in need have to locate the A-Team for themselves if they want their help. The A-team is organized as a commando group, and the members' relations with each other are only a means for realizing the group goal. Each episode describes how the team carries out an aid mission. The A-Team is organized according to a strict hierarchical order. Its leader is Hannibal, a white middle-aged man whose emotions are under perfect control. Next in order is Face, a man in early middle age and one possessing social skills. Face's weakness is that he likes women, which sometimes diverts his interest from the A-Team's missions. Face and Hannibal constitute the brain of the A-Team. The commando group proper consists of Mr T and Murdock. Mr T, who became particularly popular with American children during the 1980s, is played by a black body-builder. He is the muscles of the A-Team. Mr T has his emotional life under far less control than Face and Hannibal. He is prone to terrible outbursts of temper and therefore cannot be trusted with any important tasks. Mr T's self-control is none the less far superior to that of the fourth group member, Murdock. He is so wild that he has to be restrained in a mental institution between missions.

In the A-Team these four conflicting types of character are united in a harmonious and functioning whole, the group, which in each episode can concentrate exclusively on proving its manliness in never-ending trials of virility, since the A-Team members have nothing else to worry about. The masculine character of the team is further strengthened by the narrative structure of the show, which is just as action-orientated as the A-Team itself. Each episode ends in an action-filled climax, confirming that the mission has been accomplished. And the story up to then is limited to the moments of physical action for which the A-Team lives. Everything else is a waste of time. There are no parallel plots. Each episode concentrates on how the mission is fulfilled. The main function of the editing is to keep the action moving up to the moment of achievement. The whole narrative structure is thus ineluctibly goal-orientated.

American television series are not modernist or progressive

texts, in the sense of making references to their own artificial character or criticizing the prevailing social order. Instead, contemporary society and the series itself are both depicted as natural. According to Fiske, however, they tend towards modernism through the activities of their audiences, and towards progressiveness through their equivocal character and their excess of meaning. Since it is the audience, not the producers, who transform a television series into popular culture, audiences see the popular TV series as 'their' culture. The audience's interest is not limited to the series as such, but encompasses its production as well. Television actors, producers and screenwriters are interviewed in the popular press and on TV, providing information about themselves, the characters and the history and future of the series. Journalists write about the production of the series. So, even if the primary text (the series itself) does not demonstrate its own artificial character, the secondary texts (newspaper articles, fan magazines, etc.) do. Since the audiences thus actively gather information about the production of their favourite series, the programmes lose their aura of naturalness and are transformed into modernist texts. Sometimes the audience even manages effectively to become co-producer of a television series, since ratings may influence the fate of the role characters.

For various reasons popular characters in these series sometimes have to be written out of the action. In *Dallas*, for instance, the head of the family, Jock Ewing, had to be lifted out of the series at an early stage because the actor portraying him was dying of cancer. The authors had Jock Ewing disappear under mysterious circumstances during a business trip to South America, thereby making it possible for him to reappear in the series if the audience response should prove too negative. This option never had to be taken up. Things were different in another case, namely, in *Dynasty*, with its story of a wealthy family in Denver. One of the main actors in the series left after one season, because he was playing a gay character and was afraid that this might damage his image. Both *Dynasty* and this particular character had by then become very popular, so again the character disappeared under mysterious circumstances, this time in an oil-field accident in Southeast Asia, but reappeared in the series with a new actor playing the part. The fact that the character no longer looked the same was explained by his

having been severely burnt in the accident, and having under-
gone extensive plastic surgery. A more fantastic explanation
had to be found when Bobby Ewing reappeared in *Dallas* after
dying in a car accident, under no mysterious circumstances at
all. Bobby had been properly buried and mourned in the series,
but the *Dallas* producers had reckoned without the very strong
audience reaction to his departure. The explanation of his
ressurection was that his ex-wife Pamela had only dreamt he was
dead, and all the episodes since his 'death' had only occurred
in the world of Pamela's dream.

The 'progressive' potential in American TV shows is most
evident in certain soap operas which describe what it means to
be a woman in the USA. Soap operas are serials rather than
series. They are broadcast four or five days a week, and are the
opposite of the masculine action series in both content and
narrative structure. The soap operas have no beginning or end
but seem to be taking place in the course of an eternal middle
act. They have a plethora of main characters and parallel plots.
The main characters are positioned not in hierarchical rela-
tionships but in social networks. Time is real and concentrated
to everyday events. The cutting is abrupt, with a view to
transporting viewers from one sub-plot to another.

This editing technique is also a function of women's viewing
habits. American housewives, who constitute the soaps' main
audience, watch TV while also doing household chores. Their
viewing is therefore frequently disturbed and fragmented.
Since the soaps continually jump from one subplot to another,
fragmentary viewing is little problem. Men are usually able to
watch television with fewer interruptions, something which is
reflected in the closed and coherent narrative style of the
masculine series, which calls for concentrated viewing.

The soap operas are full of intimate conversations about
relationships. The social interaction itself is more important
than its results. The male characters are sensitive hunks. There
is no equilibrium to restore. Any equilibrium that arises is
temporary and unstable. A character may get married, but since
a soap's reality is marked by continual extra-marital affairs and
devastating divorces, it is clear that the marriage won't last. A
heroine's children are just as unstable as her marriages, tending
to become drug addicts, have abortions, give birth to unwanted
babies, turn out to be gay or lesbian, or run away from home.

The villains are women who go in for wrecking homes by seducing other women's men. The seductress characters never quite succeed, as their devious doings are constantly being exposed. On the other hand, they never fail either, since they are allowed to embark on further forays. In *The A-Team* the criminal activities of the villains are brought to a definite end in each episode. But since the team's sole function is to fight crime it needs a permanent supply of new criminals to keep the show going. Thus, paradoxically, the A-Team ends up being just as inefficient at stopping crime as the soap heroines are at stopping predatory females.

The 'progressive' element of these shows resides in their excess of meaning, which is especially evident in the soaps. Fiske quotes the fate of Anna in *Days of Our Lives* as an example of this. After a five-year absence Anna reappears in the show. She has

> been kidnapped and held captive in a boat where she had been drugged, probably forced into prostitution, starved nearly to death and whipped so that her back is still scarred. She has multiple sclerosis and is offering . . . her husband . . . a divorce so that he will be free to marry . . . the woman he fell in love with during her absence.
>
> (Fiske, 1990, p. 193)

Anna's suffering is not all revealed at once but comes to light gradually. Fiske sees this prolonged revelation as a way of making viewers aware of the power men have over women, and perhaps of making them wonder whether such power is acceptable.

Television serials can also provide social consolation. In Australia a soap opera about a female prison became very popular with Australian schoolchildren. They identified the prison with school, the guards with their teachers and the prisoners with themselves. This helped to make the experience of school more bearable to these children: although going to school was bad enough, it was not as bad as going to prison. Even sensational newspaper headlines can fulfil a similar consolatory function. The headline 'TOP MODEL MARRIES LEPER' tells us that even top models can have difficulty finding a suitable marriage partner. 'WOMAN GIVES BIRTH TO POODLES' suggests that not all children are born perfect. A

male action series like *The A-Team* acquires a certain amount of 'progressive' content from its over-explicit masculinity. The trials of manhood in *The A-Team* are so exaggerated that the male viewer may wonder not only how he can possibly live up to this role model, but also whether it is reasonable to expect him to. Popular management literature provides another example of the way cultural texts, which set out to praise existing social conditions, actually – albeit inadvertently – end up criticizing them instead. Molloy's international bestseller *Dress for Success* (1988), which tells men climbing the career ladder how they should dress, is an example of this.

THE EMPEROR'S NEW CLOTHES

Popular science is often perhaps associated with the simplified presentation of the findings of scientific research. But the popular literature of management has more in common with popular fiction than it has with serious management science. Popular management literature no more intends to popularize academic management theories than Jackie Collins aims to present Guy de Maupassant's moral tales in a simplified way in her novels about sinful women in Hollywood. Management books are written to sell, not to support the production of scientific knowledge.

A great many popular management books are written by management consultants, which means that the aim of the books is to promote their authors' consulting practices. If one of their books becomes a bestseller, they will be able to put up their fees. We need look no further than the former McKinsey consultants Thomas Peters and Robert Waterman for confirmation of this: their best-selling book *In Search of Excellence* (1982) made them superconsultants on the international stage.

There is little point in evaluating popular management literature on a basis of its scientific qualities, since such books are anyway an expression of commercial rather than scientific ambitions. Reviewers who seek to judge the books solely according to scientific criteria tend to be disappointed. Bate (1991), for example, came to dismiss all popular business texts as a form of quackery, due to their tendency to offer universal cures for all managerial ills. Sutherland (1981) points out, however, that this quality is inherent in bestsellers, which usually have a

therapeutic and calming function. Just as high-tech thrillers can work as a way of making sense of new technology, popular management literature helps to make sense of modern business life. Unlike popular fiction, however, management books must have a scientific aura, so they can be perceived as scientific literature rather than some kind of science fiction for managers. Molloy is thus very careful to stress that his book rests on firm scientific grounds and is not just another book about good manners.

> Let research choose your clothing. My research is unique in concept, scope and results. It has been conducted over a period of twenty-six years and includes the opinions and subconscious reactions of over sixty thousand executives.
>
> (Molloy, 1988, p. 2)

Molloy anchors his book to the behavioural sciences. People's response to different kinds of clothing is conditioned by their environment, which means we can manipulate the environment by way of the clothes we wear. Under the heading 'WHY IMAGE CONSULTANTS ARE DANGEROUS' Molloy launches an attack on the false prophets who have tried to steal his knowledge. They have failed utterly, since Molloy has kept most of his research findings secret. The only rivals to survive are ex-models, which he says proves that his theory is true:

> They succeeded, not because they knew what they were talking about, but because they *looked* like they knew what they were talking about.
>
> (Molloy, 1988, p. 4)

Molloy portrays himself as a man of the people, eager to help others who lack an established social and educational background to achieve a successful business career. Since his target group does not consist of millionaires, Molloy emphasizes that the clothes necessary to social advancement can be found at sales.

The first chapter of the book establishes its 'scientific' character. Molloy carefully describes the experimental activities on which his advice is based. In great detail he describes how he came to the conclusion that a beige raincoat is associated with the upper middle class and a black raincoat with the lower middle class. Molloy started this experiment in New York, where

he investigated the way people responded to men dressed in beige or black raincoats. He then repeated the experiment in Chigago, Los Angeles, Dallas, Atlanta and six smaller towns, and presented the hypothesis reported above. The hypothesis was then tested on 1,362 people, of whom 1,118 did associate beige raincoats with members of the upper middle class. Hence, according to Molloy, it is possible to control the world through one's clothes. Once he has thus established the book's scientific character Molloy concentrates on describing the clothing of the upper middle class down to the last detail.

The aim of Molloy's elaborate description of his experiment is probably not to claim his book as a contribution to behavioural science. Rather, the idea of the detailed description is probably to reassure the reader that all Molloy's advice has been subjected to rigorous scrutiny.

The description also gives Molloy firm ground to stand on. If clothing is a function of the environment, then different environments must have different ideas as to what constitutes appropriate clothing. One way of creating some certainty in such a relativistic world is to find clothes that are independent of the environment and always correct. A beige raincoat seems to be such a garment. Molloy's dress advice is based to a large extent on the assumption that the garments he recommends are environmentally non-specific and always successful.

Molloy's social aspirations, combined with the fact that his 'social ladder' geared to environment-independent clothing does not altogether work, actually gives his book a certain critical content: when, for instance, he starts to describe how his 'dress for success' works in practice, he is forced to admit that the ability to associate a beige raincoat with the upper middle class is not located in the genes; a New Yorker's dress code proves incorrect in the South and the Southerner's code looks funny in New York, while in Southern California the dress codes are so ambiguous that you have to improvise your clothing on the spot.

> If you visit a company and find yourself the only man there with a suit, take off your jacket and tie and open your collar as if that is the way you normally do business. This will diffuse any antagonism.
>
> (Molloy, 1988, p. 183)

Instead of breaking through the class barriers, Molloy finds himself becoming a master of disguise, someone who never quite manages to bluff those around him about his social background. Pursued by critical college professors he runs round the sales, all dressed up so the salesmen will treat him with some respect, continually changing clothes to suit the environment (he hopes). But no matter how he dresses he remains a clown. And you don't do business with clowns.

SUMMARY AND SOME IMPLICATIONS FOR STRATEGY-MAKING IN ARTS-RELATED BUSINESSES

In this chapter I have looked at art consumption and its effects on the activities of arts-related businesses in light of the role of art consumption in everyday sense-making. Many scholars are now claiming that there is probably no aboriginal world 'out there' to discover, and that we are therefore compelled to create our own worlds. Scientific sense-making is effected through the depiction of scientific theories which order the world. Everyday sense-making, however, does not usually seek the help of scientific theories. Instead, people tell each other stories about the way the world functions. Everyday sense-making thus makes the world into a narrative structure. Compared with scientific theories, the stories of everyday life represent open and ambiguous texts. This equivocal quality is necessary, since the credibility of the stories rests on the listeners being able to see their own lives reflected in them. How the stories narrated by the products of the culture industries are used in everyday sense-making has been described above in an analysis of the narrative structure of American television series and in the works of popular management literature.

This brings us to the end of our examination of the activities of arts-producing organizations. The aim has been to give the reader a theoretical and empirical perspective on the management of arts-related businesses, which is multirational in the sense that the activities of such businesses are governed by a commercial as well as a cultural/artistic rationality. To understand the workings of such organizations it is therefore necessary to turn to aesthetic as well as economic theories. The focus has been on the industrialized production of art in Western

societies. Such cultural production is characterized by the mass-production and distribution of artistic commodities in industry-like settings. I have looked chiefly at the activities of publishing houses and record and film companies as examples of this kind of cultural production. Particular attention has been devoted to the production of popular culture, which dominates the activities of both the record and the film companies today. The book opened with a description of the emergence and development of aesthetic theory in Western society. The theories outlined in that chapter have then been used to show how the aesthetic development in each cultural form (literature, music and film) is linked to the particular industry's economic and technological development. After this, I examined the commercial considerations that characterize the business of arts-producing organizations.

A prominent feature of arts-related businesses is a high level of uncertainty in the market response to individual arts products. Because of this uncertainty, the business strategies of arts-producing organizations tend to be 'emergent' rather than deliberate, the outcome of interactions with the environment rather than of internally generated business plans. It is therefore important for arts-related businesses to learn from their interaction with the environment; otherwise the risk is great that the strategy-as-realized will diverge in an undesirable way from the strategy-as-intended. This is not to say that arts-related businesses are totally in the hands of an unpredictable environment. Two prevailing business strategies for managing the market uncertainty of arts production have been identified here. They are multirational in the sense that they allow for the commercial as well as the cultural considerations that characterize the business of an arts-related organization. A commercial business strategy implies art on the market's terms. It focuses on controlling the supply, whereby a limited amount of arts products are put on the market supported by forceful marketing, and these products are expected to yield a rapid return on the money invested. A cultural business strategy implies art on the artist's terms, and it takes a longer view. It reduces the uncertainty by developing artists, hoping that some of them will eventually become commercially successful.

The application of the business strategies in the production of books, records and films has been described. Publishing

houses exhibit a predominantly cultural business strategy, while film companies pursue a commercial business strategy and record companies a mixture of the two. That film and record companies are inclined to choose a more commercially orientated business strategy than publishers can be explained by the far greater investment required for the production of films and records.

The emergent rather than deliberate character of the strategies, and the necessity to learn from interactions with the environment, were both particularly evident in the record and film industries. During the early years of the record industry the music itself was mainly regarded as a means for demonstrating the hardware. When the novelty of the gramophone had worn off, the possibility of building up a classical music library at home was tried as a marketing device. In the 1930s it was discovered that family-orientated popular music singers like Bing Crosby were capable of selling millions of records. The record companies therefore started to concentrate on popular music instead. In the 1950s popular music became increasingly orientated towards teenagers in the shape of rock. This business concept, which attained wide acceptance in the 1960s and which still prevails today, played on difference rather than similarity in musical taste.

Turning to the film business, we have found that the American film industry began by showing short films at carnivals. The invention of the full-length film format and the star system led to the creation of the Hollywood studio system in the 1920s. In 1948 this system was dissolved by an anti-trust law which made it illegal for film companies to own cinemas, and by the arrival of television. In the mid-1950s the American film companies had accommodated themselves to the new situation. They started to cooperate with the new TV medium by producing series for television. During the 1960s American film production became more varied and heterogeneous under the influence of the New Wave in Europe. In 1975 this trend was broken by Steven Spielberg's film *Jaws*, which opened the way for the blockbuster strategy of today. These strategic developments in the record and film industries were an outcome of interactions with the environment rather than internally generated business plans.

In the first six chapters of the book the emphasis was on the production of art, while in the present chapter we have looked

at the way the consumption of art influences its production. I shall close by suggesting some lines of exploration which could build further on the arguments developed above.

It is my hope that the strategic framework for the functioning of arts-related businesses presented here could be combined with conventional organization and management theory in further research into the problems and opportunities of such businesses. I have pointed out that it is important for arts-related businesses to learn from their interaction with the environment, since the control which they can exert over their environments is often limited. A fruitful path for future research to follow could thus be to investigate the learning component, or learning possibilities, of the cultural or the commercial business strategy.

In theoretical terms, a commercial business strategy could be expected to be more strongly geared towards learning than a cultural business strategy. Essentially, a cultural business strategy implies culture on the artist's terms. The audience is expected to learn to appreciate the cultural products offered and to understand the artist's cultural intentions in producing them. Under these circumstances, a possible commercial failure can be perceived as the fault of an unsympathetic audience, rather than the fault of the product itself. A company working according to a cultural business strategy therefore runs the risk of pursuing a business line that does not adequately reflect the prevailing taste of the audience.

The risk of such a situation arising under a commercial business strategy is probably much less, since the commercial strategy implies culture on the audience's terms. Commercial failures will then be blamed on the product rather than the audience, which in turn means that continuous adjustments can be made with audience preferences in mind. After all, an organization working to a commercial business strategy is anyway prone to designing its products according to the current taste of its customers. The risk that any major reorientation in a commercial business strategy will be needed is therefore small, since adjustments are being made all the time. Major changes are much more likely to be needed under a cultural business strategy, since here the incentive to adjust the business to the audience's taste is weaker. Strategic development under

such a system thus probably tends to occur in leaps rather than in small steps.

Onsér-Franzén (1992), for example, in a study of municipally governed cultural activities, shows that the frequent failure of such activities to attract audiences may depend on an underlying normative notion of culture, i.e., it is a question of culture on the producer's terms. This producer-orientated notion of art meant that the cultural activities studied by Onsér-Franzén stemmed more from some ideal of a 'desirable' audience taste than from the taste the audience actually represented, about which the local politicians knew very little and which they generally wanted to 'improve'. Her results are to some extent contradicted by the results of a study of the Swedish film industry (Björkegren, 1994). One of the companies studied had adopted a predominantly cultural business strategy, in the sense that it was interested primarily in producing, distributing and exhibiting films with an artistic rather than a commercial value. However, since the film company operated mainly in a commercial market rather than a state-subsidized cultural political market, it proved hard to ignore the audience's taste. The company thus had to show commercial films as well, to make the artistic films economically possible. This change of direction came about as part of a major strategic reorientation after the company had run into severe financial difficulties. In other words, its strategic development had progressed in a leap rather than in small steps.

These two studies suggest that an aptness to learn on the part of the adherents of a cultural business strategy may not depend solely on the normative view of culture production that is inherent in this strategy; it can also depend on the prevailing market conditions. Indeed, the studies even support the idea that a cultural business strategy may actually be less geared towards learning than a commercial one, but that this attribute of the cultural business strategy ('knowing better') is mitigated by the workings of the commercial market. It seems to be hard in such a market to ignore the audience's taste altogether, whatever business strategy is being used. This whole question of organizational learning in arts-related businesses calls for further exploration.

The empirical scope of research in this and other arts-business-related areas could also usefully be extended to in-

clude, for example, the fashion and advertising industries. Advertising and fashion, just as much as the pop business, are in the business of selling lifestyles. The fashion designer Ralph Lauren's business provides a good example of this. When Lauren registered his trademark Polo, in 1967, his idea was to associate it with a timeless upper-class ambience.

> Weber's [Lauren's photographer] photographs for Lauren depict picnics in the Hamptons, tennis parties, and scented, gracious homes. The cast of characters . . . are seen slipping in and out of glossy black limousines from the 1940s, boarding liners, and at candlelit dinners in their dinner jackets. They are photographed in elegant rooms full of crocodile skin, mahogany, and flowers. The men wear braces and inhabit rooms full of old books . . . and . . . well-oiled cricket bats.
>
> (Sudjic, 1989, p. 79)

Ralph Lauren, who spends millions of dollars a year on advertising, has been very successful in realizing his dream. His fashion empire now grosses over $1,000 million a year. The Polo trademark has acquired such an aura that he can now sell Polo sweaters, costing a very few dollars to produce, for several hundred dollars in his Polo stores. That consumers of exclusive brand-names really do feel themselves transported into some other world is confirmed, among others, by a study of the impact of ads for Hermes fashion lines:

> "If I see someone wearing a Hermes tie, it speaks to me of a world of style and leisure, a lot of style, a lot of money, a lot of time"
>
> (real estate agent, quoted in Rosen, 1991, p. 20)

Hermes scarves are no less attractive, to judge by the following.

> "No, I don't own any Hermes scarves. Because I can't afford them. But I'd love to. Jesus Christ, it's every little girl's dream to be a princess. And the first thing that comes to mind is Grace Kelly, because she's a commoner who married a king. So it's either the Grace Kelly bag, or the Hermes scarf she wore in all those photographs, but I think it's the scarf."
>
> (Journalist, quoted in Rosen, 1991, p. 12)

Another unexplored culture industry is the relatively recent management industry, which perhaps burst into its fullest bloom during the 1980s. I am thinking of the many popular

management books that are published every year and the ever-expanding activities of management consultants. A range of fruitful approaches suggest themselves here. For instance, we could ask ourselves whether popular management books and consultants are acting as vehicles for the production of a 'popular' management culture evaluated in terms of narrative credibility and social relevance, as opposed to 'high' management culture evaluated in terms of its adherence to extra-textual reality and prevailing scientific norms and transmitted by academic management literature and business professors in university settings. In seeking answers to such a question we could extend our knowledge of the relation between art and science, about where they resemble one another and where they do not. This is a topic much discussed in academic circles at the present time. It will also be the focus of this book's epistemological excursus.

First, however, one more issue should be mentioned as meriting further investigation, namely, the effects of technological innovation on the production of culture. The use of new technology in arts-related businesses has not been a main focus here, although one or two examples have been mentioned in passing. But studies focusing chiefly on this topic are urgently required. Developments in the field of communication technology are advancing at an ever-increasing rate, and a merger between telecommunications, the computer industry and the culture industries is said to be on its way (Neuman, 1991). Since the television industry is at the heart of this development (Auletta, 1991; Björkegren, 1994a), systematic studies of television companies would be particularly interesting. Because the dissemination of technical innovations has long been a subject of research in the field of the management of innovation, studies of the implications of new technology for the production of culture could probably build on findings already achieved in this field of investigation.

Television is our largest cultural medium. It is also the prime example of the industrialized and multirational production of culture in our times, when decisions about what television programmes to make are based, not only on cultural considerations but just as much on commercial, technical *and* political grounds. The production of television has attracted much more political attention than the production of books,

records or films, on account of the far greater popularity and the all-embracing presence of the medium in our society.

Television established itself as an industry during the 1950s, when it soon became an important cultural and advertising force. The 1960s and 1970s were characterized by fairly stable industry structures. The national television markets were dominated by public monopolies or private oligopolies. The major technical innovation was colour television, but its introduction did not affect the prevailing industry structures. However, during the 1980s these were upset by the advent of the video cassette recorder (VCR) and cable and satellite television (Baughman, 1992). The VCR meant that the viewers no longer had to watch TV according to the broadcasters' programme schedules. It also became possible, when watching taped programmes, to fast-forward over the commercials. Viewers could rent films and programmes on video and refrain from watching broadcast television altogether. Cable and satellite television entailed a radical increase in the amount of channels available, which led in turn to a fragmentation of the television audience, more competition for viewers and a decline in the old public and private television broadcasters' market shares. At the same time, a political debate was taking place in the USA and in Europe about the desirability of a less regulated society, with more space for free enterprise and free competition (Curran and Seaton, 1991). In many European countries this development involved the deregulation of public television monopolies, the introduction of commercial television and a radical increase in domestic and international television channels.

The technical and commercial development of the TV medium will probably be just as turbulent during the 1990s. The deregulation of national television markets that began in the 1980s seems to be continuing in the 1990s. It is expected that digitial transmission of pictures and sound will be introduced during this decade. The number of channels available to viewers will continue to grow, since digital transmissions will radically reduce the television channels' broadcasting costs. Interactive television of various kinds is also expected to appear. Watching television will become more viewer-controlled, since viewers will be increasingly able to decide what programmes to watch and when to watch them. Pay television will spread as

digitalization makes it possible to charge the viewers on a programme basis (Congdon, 1993).

Some observers even claim that in a future digitalized television universe with thousands of channels, the channel concept will become irrelevant (Gilder, 1994). In such a universe it will be impossible to acquire an overview of the existing programme supply by channel jumping, and it will probably be necessary to install computerized menu systems to help the viewers find their way about. It is thus not unlikely that television companies will find themselves in the same situation as film companies, as far as marketing is concerned. A computerized menu system will probably be created round different programme categories such as news, films, light entertainment, music, sport, childrens' programmes, etc., and within each category there will probably be a large number of programmes to choose from. If, for example, the viewer is offered a choice between 50 news programmes, huge marketing investments will be needed to give any single news programme a distinct profile. In such a world the television medium may experience a development similar to that of the film industry, in which a small number of blockbuster movies, supported by vast multimillion dollar marketing campaigns, are responsible for the greater part of the film companies' revenues (Björkegren, 1994). In television terms this would mean that a few heavily marketed blockbuster programmes within each programme category would account for the bulk of the viewing.

In conclusion, it should be pointed out, however, that in a pioneering six-year experiment with interactive multi-channel television in Columbus, Ohio, carried out by Warner Amex Cable Communications in the 1980s, people's viewing habits were found to be fairly conservative and rigid (Barwise and Ehrenberg, 1992). Television was predominantly perceived as an entertainment medium. Interest in such interactive programmes as were available proved to be low, except for game shows in which viewers could win prizes by taking an active part. Interest in participation in political debate programmes was negligible. Nor did the opportunity to act as one's own television editor and to create a personal channel arouse much enthusiasm. Most of the viewers preferred to leave the editing to the television broadcasters. Thus, all the commercial and cultural possibilities that digitalization of the television medium

could apparently give us, may not be fully realized, since viewing habits seem fairly likely to remain much as they are, despite the dazzling advances in communication technology.

Excursus

What can organization and management theory learn from art?

As we have seen, the notion that art and science lead separate lives on each side of a sharp dividing-line enjoys increasingly little credence today (see e.g., Eagleton, 1989; Geertz, 1988; Simons, 1989). At the same time, postmodern thinking, with its interest in cultural and social change rather than the technological and economic kind, has begun to influence the field of organizational studies (Burrell, 1988; Cooper and Burrell, 1988; Berg, 1989; Cooper, 1989; and others). A related development has been a renewed interest in rhetoric in the social sciences (e.g., McCloskey, 1985; Van Maanen, 1988). In the field of organization theory Czarniawska-Joerges (1988) has described management consultants as merchants of meaning and beautiful words, while Czarniawska-Joerges, Gustafson and Björkegren (1990) compare management consultants with the ancient Greek sophists and invoke the rhetorical skills of both. Some attempts have also been made to approach organizations as texts and to analyse them as such. Cooper (1989), for example, has applied Derrida's deconstructive methodology to the field of organizations, and speaks of 'the writing of organizations' and 'the organization of writing'. Kreiner (1989, p. 12) describes working in an organization as being exposed to a 'torrent of words in a text without structure, without punctuation, without sentences'. Kreiner also observes that the enormous interest in the autobiographies of well-known industrialists, such as Iacocca (1984), suggests that what society is prepared to accept as a truthful representation of an organization does not have to be associated with any scientific method. Perhaps this is because science has no special right to the 'truth' any more, and we all have a free hand in the

organizational theory 'market'. Once again, we see that the demarcation line between what passes as art and what passes as science is becoming blurred.

In this epistemological excursus the relationship between art and science, and the possible lessons that organization and management theory can learn from art, are discussed in a linguistically postmodernist perspective. We have seen how postmodernism tries to show, by way of various forms of textual analysis, that what is perceived as 'true' is a social construction rather than the discovery of an 'aboriginal' world. In the following discussion this postmodern assumption is used as an epistemological guide in an attempt to understand the production of art and scientific knowledge. I hope to show that what is perceived as science and what is considered to be art is a product of the practices of science and art, and in this way it should be possible to throw some light on differences and similarities between these practices and their products.

I start by describing different views about what is regarded as scientific knowledge (in a description that makes no claims to be exhaustive). I merely want to give some idea of what is thought to be characteristic of scientific knowledge. I shall then compare the production of art and scientific knowledge and indicate some significant ways in which they resemble one another. The final products also reveal similarities, but they exhibit significant differences as well: the aim of art is after all to create aesthetic experiences, while science aims at creating 'true' knowledge about the world. In a final section I suggest that what art could perhaps teach us about organizations and management probably lies in the artistic form rather than the artistic content.

TRUTH

To start with, how can we know whether something constitutes scientific knowledge rather than knowledge of some other kind? Over the years many attempts have been made to determine this. The positivists of the nineteenth century declared that scientific knowledge was characterized by the use of a scientific methodology; a scientific method of enquiry was objective and quantitative. The logical empiricists of the early

twentieth century added that only directly observable phenomena could be investigated scientifically.

In the 1930s the philosopher Karl Popper argued that more important even than an objective and quantitative method of enquiry was that the research results should be falsifiable (Popper, 1986). If they were not, then we were talking metaphysics, not science. In a polemic against Popper, Kuhn (1970) suggested that what was perceived as scientific knowledge was determined by the prevailing scientific paradigms. What counted as the production of scientific knowledge occurred within the framework of the theoretical and methodological conventions of these paradigms.

These three views about the possible nature of scientific knowledge are based on a realist ontology or theory of existence. In contrast to an idealist ontology, realism assumes that the world has an existence of its own, independent of any thoughts or feelings we may have about it. Idealism, on the other hand, assumes that what exists depends on ourselves.

The positivists, whose aim is to verify theories, base their epistemology – theory of the grounds of knowledge – on a perceptual version of realism. Perceptual realism, which originated with David Hume, involves the assumption that reliable knowledge about the world can be acquired directly through our senses. Accumulated data should therefore be influenced as little as possible by theoretical assumptions. The assumption of the existence of a real world implies a striving to establish the truth of theories and hypotheses by seeking to identify concordance between the theories and reality.

Popper's falsifiability principle is based on a critical version of realism. He regards perceptual realism as a Utopia: we need assumptions about the way the world works in order to make meaningful interpretations of what we experience. If we succeeded in freeing ourselves from all our assumptions about the world, we would find it incomprehensible. If the world is to be comprehensible to us, we must ourselves create a meaning in what we see. There is no given meaning in the world, waiting for us to absorb it by way of our sense impressions. On the other hand, our assumptions about the way the world works can vary in their degree of reasonableness and functionality. In this 'constructivist' perspective the question of whether or not there is a true reality becomes less important. We can never discover

such true reality as may exist if we constantly see the world through our assumptions about it.

Attempts have been made within the positivist tradition to solve this problem through the creation of a universal scientific language, independent of the individual, but no-one has succeeded in constructing such a language. Popper's suggested solution is the falsifiability principle. Given that we can never know whether or not a true reality exists, we cannot know either when or if we have reached such truth as there may be. We can therefore probably never attain true and absolute knowledge. Our knowledge will always be variously imperfect, which leads Popper to claim that it is better to attempt to falsify than to verify theories.

In his polemic against Popper, Kuhn (1970) declares that scientific knowledge is produced in the way the positivists claim it should be. He distinguishes between normal science, where the scientist solves a problem within the existing paradigms, and revolutionary science which involves a paradigm shift. In real life scientists try not to falsify but to verify their theories. When it becomes impossible to explain away anomalies, a shift in paradigms occurs whereby the old theories are replaced by new ones which can explain the anomalies.

But regardless of whether it is a positivist, a Popperian, or a Kuhnian who is speaking, an outer reality is implied which can 'talk back' and verify or falsify the theories. The proponents of the renewed interest in rhetoric in the social sciences take another and more inter-textual view of what comes to be regarded as scientific knowledge (e.g., McCloskey, 1985; Geertz, 1988; Van Maanen, 1988). The traditional philosophy of science focuses on theoretical content and the relation between theories and their empirical reference objects. Rhetoric focuses primarily on theoretical form and the relation of theories to other theories. What comes to be regarded as scientific knowledge is seen mainly as a question of rhetorical form. The important thing about scientific texts is that they should appear credible to the reader, not that they are 'true' quite independently of whatever the reader may think. Important rhetorical means for helping to achieve credibility include the use of methods that are regarded as scientific, and references to other scientific texts. By way of such stylistic means, a text becomes grounded in the scientific discourse. The crucial thing for

anyone wanting to be perceived as a scientist is not to deviate from the existing norms about how scientific knowledge is produced.

A description of the organizational scientists' research community in the USA provides some support for this notion (Cummings and Frost, 1985). These authors suggest that scientific form may be more important than scientific content. Their book consists of a collection of articles about how to write scientific articles in the organizational sciences, but indirectly they provide us with a picture of a particular research community in the USA. In their world, the best way to generate organizational knowledge is to publish scientific articles in scientific journals. Competition is supposed to promote the development of knowledge. The high rejection rate (90 per cent or more in the high-status journals) is a good sign that the wheat is being separated from the chaff. The incentive to write scientific articles is very strong, since publication in scientific journals is necessary to academic advancement. The writing of books provides little or no academic value, since book manuscripts are accepted for publication on commercial rather than scientific grounds. For an article to have any chance of being published it must follow a specific form and run to a certain length, and it must not diverge from the prevailing theories and methods in the relevant field of research. It is less important whether the article contains anything new or ground-breaking. Senior researchers can permit themselves to deviate from the research norms a little more than their juniors. And, lastly, network-building by attending academic conferences is recommended as a way of increasing the chances for publication.

THE PRODUCTION OF TRUTH AND BEAUTY

In this rhetorical perspective the production of scientific knowledge exhibits a significant resemblance to the production of art. Cummings and Frost's book can be compared with a recent study of the Stockholm art world (Ericson, 1988). Ericson, who is an anthropologist, argues that what comes to be regarded as 'art' in the Stockholm art world emerges from a social construction process. She begins by looking at the education of aspiring visual artists. To become established as a serious painter in Sweden a degree from the Academy of Arts in

Stockholm is more or less mandatory. An important part of the artist's education, apart from learning about the prevailing art conventions, consists of a socialization process in which the student learns the work ethic and acquires the right gallery contacts. An exhibition at one of the six top galleries in Stockholm is necessary to get the leading art critics to write about the aspiring artist's paintings, hopefully acknowledging them as serious art. When the aspiring painter has gained acceptance as a legitimate artist the artistic operation becomes a nine to five business. The work ethic is a very hard one, remote from the Romantic and Bohemian ideal which the artists cherish during their student days.

Ericson also investigates the work of the art critics. The ghost of Luther tends to haunt perceptions of what is seen as serious art in Sweden: serious paintings are likely to be pure and simple, often portraying scenes from nature; it should also be obvious that the painting has required a lot of hard work.

Thus, just as organizational scientists exhibit their research findings in scientific journals for the approval of fellow scientists, so artists exhibit their paintings in art galleries for the approval of the art critics and their fellow artists. And just as fashion trends emerge in art, so also do they arise in science. Abrahamson (1988; 1989), for example, reminds us that the popularity of quality circles at the beginning of the 1980s was largely a question of fashion. The goal of the quality circle was to increase productivity, but the companies were not in fact certain that their implementation would have such an effect. On the other hand, they were afraid they would be regarded as out of step with the times if they didn't have quality circles like all the other companies seemed to. If you strayed too far from the behaviour of other firms, it might look as though you were out of touch with modern developments.

Evaluation of the quality of art is usually made on the terms dictated by high culture (Gans, 1974). An analysis of the way the scientific debate in organizational theory in the USA is conducted (Stablein, 1989) is rather similar to Gans' analysis of the functioning of the cultural debate. According to Stablein, scientific debate in the USA is concerned mainly with methodological issues. The underlying ontologies and epistemologies are not usually discussed. Since positivism is the dominating epistemology in the country, almost all management research

is judged in light of a positivist world-view. Although other epistemologies allow subjective methods of enquiry and the use of qualitative data, the results of such research are considered unscientific, since they are not based on what positivism regards as scientific methods. According to the recent debate about the practical relevance of American management research, this heavy reliance on positivism seems to have created a scientific 'hyperreality' in that country. Growing doubts have been expressed there as to whether American organization and management theory really creates any factual information about the managerial world (Webster and Starbuck, 1988; Bedeian, 1989; Byrne, 1990). Bedeian, a former president of the American Academy of Management, expresses anxiety about the fact that most of the research produced by Academy members is driven by methodology rather than theory, and therefore tends to establish already well-known facts. Webster and Starbuck say straight out that industrial psychology, which has remained extremely atheoretical due to the strong emphasis on a positivist research methodology, has contributed nothing in the way of new knowledge since the research field was established in the 1950s. Byrne questions the relevance of American management research for practitioners. We might thus wonder whose reality has been talking back – the managers' or the scientists'?

Byrne's critical investigation of the conduct of American management research suggests that it has been mainly the scientists who have been talking back at each other.

> The papers are largely written to please an inner circle of academic experts who must approve an article before it can be published. Morris Holbrook of Columbia University has called the lengthy review process "a socially approved form of intellectual sadomasochism". Delays of up to two or three years are common because reviewers often demand pages of revisions.
>
> (Byrne, 1990, p. 51)

The Dean of New York University's Graduate School of Business took a very grim view of the relevance of this research when Byrne interviewed him.

> "It's often crap", he says of academic writing in learned journals. "They say nothing in these articles, and they say it

in a pretentious way. If I wasn't the dean of this school, I'd be writing a book on the bankruptcy of American management education."

(Byrne, 1990, p. 50)

Scholarly research started at American business schools in the 1950s as a way of improving the academic legitimacy of the schools on the college campus, where they had previously been regarded mainly as vocational schools. This striving for academic legitimacy seems to have led to the creation of a scientific hyperreality, in which scientific concepts such as 'management' and 'organization' float around in academic journals and at conferences. We might then ask ourselves whether science and art are just different forms of fiction, in which aesthetic and scientific experiences are created by way of different rhetorical devices, and whether the relationship with extra-linguistic reality is of any importance. The case of the Harvard Business School – which is not considered part of the hyperreality of American management research – can perhaps shed some light on this question: 'most academics look askance at writing for the Harvard Business Review. "It's not quite whoring, but if it's given any value, it's seen as educational instead of scholarly" (Byrne, 1990, p. 52). At the same time the results of research at the Harvard Business School emerge as those which are most relevant to practitioners.

The survey found that Harvard Business School is a bastion of research, producing far more insight and relevant information for executives than many other schools that have long-held reputations for traditional scholarship.

(Byrne, 1990, p. 51)

This may depend not only on the pedagogical presentation of the research done at the Harvard school, but also on the underlying research method: to a very great extent organization and management research at the Harvard Business School is still influenced by the clinical method (see Roethlisberger, 1977).

The clinical method originated in the Human Relations movement. Its foremost representative was F. J. Roethlisberger who, together with Ernest Mayo, founded the Human Relations school and the clinical research method in the 1930s.

Roethlisberger subsequently elaborated the method in the course of his teaching at the Harvard Business School. The main feature of the clinical method is that the research object is studied in its natural environment. The researcher adapts to the situation under investigation by finding out what is important to the people involved, not by directing his attention to the data his theories say he should be looking for. The idea is that with the help of the clinical method the researcher can build on the research subject's own theories about the studied reality. This provides more relevant input into the subsequent analyses, since people's behaviour in a social context is normally controlled by their own theories and not by the accepted theories of the relevant science (see, for example, Benson and Hughes, 1983).

As a result of this clinical approach, the research conducted at the Harvard Business School thus seems to have become grounded in the world of business and management. This may explain the high regard in which of research from the Harvard Business School is held among practitioners, and their low opinion of the output of the American management research which, if we are to believe Byrne, seems to have largely lost contact with managerial practice.

Scientific hyperrealities are not apparently anything new, but to judge from Jonathan Swift's description in 1726 of Gulliver's voyage to the scientists' paradise island of Laputa, they have been with us since at least the eighteenth century. In this land, not only the scientific concepts but the whole scientific community were detached from the world, in the form of a free-floating island up in the sky. This celestial existence had practical disadvantages. The Laputans were not, for example, the best of house-builders.

> Their houses are very ill built, the walls bevel, without one right angle in any apartment, and this defect ariseth from the contempt they bear for practical geometry, which they despise as vulgar and mechanic, those instructions they give being too refined for the intellectuals of their workmen, which occasions perpetual mistakes. And although they are dexterous enough upon a piece of paper in the management of the rule, the pencil and the divider, yet in the common actions and behaviour of life, I have not seen a more clumsy,

awkward, and unhandy people, nor so slow and perplexed in their conceptions upon all other subjects, except those of mathematics and music.

(Swift, 1985, p. 205)

Nor were they always the best of scientists.

The first man I saw was of a meagre aspect, with sooty hands and face, his hair and beard long, ragged and singed in several places. His clothes, shirt, and skin were all of the same colour. He had been eight years upon a project for extracting sunbeams of cucumbers, which were to be put into vials hermetically sealed, and let out to warm the air in raw inclement summers . . . I saw another at work to calcine ice into gunpowder, who likewise showed me a treatise he had written concerning the malleability of fire, which he intended to publish. There was a most ingenious architect who had contrived a new method for building houses, by beginning at the roof and working downwards to the foundation, which he justified to me by the like practice of those two prudent insects, the bee and the spider.

(Swift, 1985, pp. 223–4)

But scientific failure did not necessarily exclude scientific respectability.

There was a man born blind, who had several apprentices in his own condition; their employment was to mix colours for painters, which their master taught them to distinguish by feeling and smelling. It was indeed my misfortune to find them at that time not very perfect in their lessons, and the professor himself happened to be generally mistaken; this artist is much encouraged and esteemed by the whole fraternity.

(Swift, 1985, pp. 224–5)

DISCUSSION

Is it then possible for business to learn anything from art? Despite Plato's view of art as consisting of phantom images, it seems certain that even business has much to learn here. If art can teach us about the feelings of other people, about people in other times and other economic systems as well as in other

cultures, it must surely have a wealth of insights to offer the business world too.

In the field of organization and management theory, Waldo (1968) and many others more recently (Guillet de Monthoux. 1988; Czarniawska-Joerges, 1989) have pointed out how much we can learn about the effect of organizations on people, from novels located in administrative settings. Novelists can take account of people's private experiences of organizational life so much more easily – and express it more strikingly – than scientists can. Scientific descriptions of organizational life are often expressed in an almost exclusively quantitative form and certainly in a narrower perspective. Waldo stresses that, compared with scientific studies of organizations, administrative novels can give a more balanced view of organizational behaviour just because of their broader approach to organizational activities and the wider context in which the activities can be set.

One obvious difference between art and science is that art is fiction, a construct not based on facts. But this does not mean that it has to be false. Scientific theories are also reconstructions of the world, although based on facts (Alvarez and Cantos, 1989). It has even been suggested (among others by Sandelands and Srivatsan, 1989) that the artist may be creating knowledge about the world that is more 'true' than the knowledge produced by the scientists, since art is based on direct sense impressions to a greater extent than science is: the scientist sees the world through a filter of abstract concepts, while the artist faces it direct. In this sense, it could be claimed that the artist sees the world as it 'is'.

However, the idea that art portrays reality more accurately than science seems to stretch the qualities of artistic representation a bit too far. The goal of art is, after all, to create aesthetic experiences, not 'true' knowledge about the world. It is the relation between the work of art and its observer that is important, not the relation of art to reality. If a novel, for example, deals with eternal questions, if its thinking is profound and its critique of current conditions in life and society are urgent and well-founded *but* it is also poorly written, it may not be perceived as an important work of art, since it is unlikely to give the reader any very profound aesthetic experience. If another novel deals with banal questions, its thinking is arti-

ficial and shallow and its critique of current conditions in life and society is trivial *but* it is well written, it may be perceived more strongly as a work of art, since it gives the reader a more profound aesthetic experience.

Thus, according to this view, what is perceived as art ultimately depends on the potential art object's capacity to evoke aesthetic experience, a capacity linked more closely to form than to content. It is a notion that has certainly not gone unchallenged, but has always been central to the aesthetic debate; where should the emphasis lie? On artistic form or artistic content? On the emotional or the intellectual impact of art? The argument started with Plato and his aesthetic based on reason, proposed in reaction to the earlier emotion-bound conception.

In Chapter 2 we saw how aesthetic philosophy has swung between these two poles throughout history, focusing sometimes on the importance of reason in art, and sometimes on that of emotion. The postmodern aesthetics of the 1980s brought a new swing towards emotion. The postmodern view of art is almost identical to that of the 1960s as propounded in Sontag (1969). Sontag reminded us that the tendency to make of art something other than art goes back to Plato's reflections on the relation of art to reality, to the whole issue of the value of art. For something to be mere art is not enough. It has to be something more. From this derives the separation of artistic form and artistic content, with content as the predominant part, and interest switches from the aesthetic experience evoked by the work of art on the level of the senses to a detached analysis of its content at the level of the intellect. Artistic intellectualism also represents a way of protecting observers from the emotional impact which a work of art might have on them. Many artists have tried to avoid this kind of intellectualization of art through a variety of experiments in form, at the expense of content. Sontag suggests that one way of letting art remain art would be to create a work whose surface is so dense and pure, and whose effect is so immediate and direct, that any analysis becomes impossible. Such creation is possible in film-making, and Sontag cites Ingmar Bergman's films as an example: the visual intensity and beauty of his films is so strong and direct that it neutralizes the sometimes pseudo-

intellectual dialogues about the perils of human existence which the films also contain.

In line with this argument, Sontag advocates that greater attention be paid to artistic form rather than to content. Bordwell and Thompson (1986) show how it is possible to analyse films without bothering about their content. By studying narrative technique, *mise-en-scène*, cinematography, sound, shooting and editing it is possible to form an opinion about a film's artistic form and the way it produces cineastic experiences. Welleck and Warren (1967) reach the same conclusion in the context of literature. It is the literary form and its ability to evoke literary experiences that matters, not the relation between the literary content and reality.

Perhaps it is thus the artistic form of a work of art rather than its content that can help to increase our knowledge of organizational behaviour. Sandelands and Buckner (1989), for example, show how job satisfaction can be affected, not only by the content of the job but also by its form. Berg (1979) uses the concept of narrative structures to study a case of organizational change, and Schultz (1989) shows how semiotics can contribute to the study of organizational culture – thus transferring to the organizational world two techniques commonly used in film analysis. Speculations on the possibility of 'writing down' organizational behaviour in a simple formula and checking the validity of the formula with the help of computer simulations to see if the forecast behaviour pattern emerges (Drazin and Sandelands, 1989) are highly reminiscent of synthesizer programming which builds on the formal properties of music. The type of thematic analysis which Zaleznik and Kets de Vries (1984) advocate for the study of leadership also originates in the world of music. The word *theme* refers to a recurrent melody in a piece of music, by which – among other things – the work in question can be identified. In the context of leadership the 'text' is interpreted, not from a musical but from a social point of view, and is expressed in words and actions rather than musical notes, recurring as topics of discussion and/or actions on the part of the studied actors. In an analysis of the Harvard Business School's case method, Alvarez and Cantos (1989) examine the cases as a particular type of narrative fiction, and showing how the use of narrative techniques can enhance the literary quality of

business cases, thus making them more enjoyable to read and more likely to invite reflection.

Thus, even if the production of truth and the production of beauty have their similarities, we should probably not over-emphasize the resemblance between the final products; nor should we demand of art that it be something more than simply art. This is not to say that a work of art cannot affect the extra-textual world, but it does mean that its influence resides more in the aesthetic qualities of the art object than in its cor-respondence to extra-textual reality. Nor does it mean that art is incapable of sometimes making significant observations about the functioning of the extra-textual world. And certainly we can learn a lot from art about the use of rhetoric. Because if works of art sometimes happen to provide factual information it is perhaps less common that scientific texts evoke an aesthetic experience.

Bibliography

Abrahamson, E. (1988) 'Fads, Fashions, Adaptions, and Imbalances'. Manuscript. New York University.

Abrahamson, E. (1989) 'Organizational Fashion'. Manuscript. New York University.

Adorno, T. (1941) 'Om populärmusik' (On Popular Music). In Burill, J. (ed.)(1987) *Kritisk teori – en introduktion* (Critical Theory – An Introduction). Göteborg: Daidalos.

Adorno, T. and Horkheimer, M. (1989) *Dialectic of Enlightenment*. New York: Verso.

Alloway, L. (1988) 'The Development of British Pop'. In Lippard, L. (ed.) (1988) *Pop Art*. New York: Thames & Hudson.

Alvarez, J. and Cantos, C. (1989) 'Narrative Fiction as a Way of Knowledge and Application to the Development of Imagination for Action.' Paper presented at the Post Modern Management: The Implications for Learning Conference. Barcelona, 18–21 September.

Anderson, W. (1990) *Reality Isn't What It Used To Be*. New York: Harper & Row.

Auletta, K. (1991) *Three Blind Mice*. New York: Oxford University Press.

Bach, S. (1985) *Final Cut*. New York: Signet Books.

Barnouw, E. (1990) *Tube of Plenty*. New York: Oxford University Press.

Barwise, P. and Ehrenberg, A. (1992) *Television and its Audience*. London: Sage.

Bate, P. (1991) 'Reading the Popular Business Texts from a Cultural Perspective'. Paper presented at the 8th International SCOS Conference, Copenhagen, 26–28 June.

Baudrillard, J. (1988) *Selected Writings*. Oxford: Polity Press.

Baughman, J. (1992) *The Republic of Mass Culture*. Baltimore: The Johns Hopkins University Press.

Beardsley, M. (1981) *Aesthetics*. Indianapolis: Hackett.

Beaupré, L. (1977) 'How to Distribute a Film. In Kerr, P. (ed.)(1986) *The Hollywood Film Industry*. London: Routledge & Kegan Paul.

Becker, H. (1982) *Art Worlds*. Princeton: University of California Press.

Becker, H. (1986) *Doing Things Together*. Evanston, Ill.: Northwestern University Press.

Bedeian, A. (1989) 'Totems and Taboos'. *The Academy of Management News*, 19(4), pp. 1–6.

Benjamin, W. (1936) 'Konstverket i den tekniska reproduktionsåldern' (The Work of Art in the Age of Mechanical Reproduction). In Burill, J. (ed.)(1987) *Kritisk teori – en introduktion* (Critical Theory – An Introduction). Göteborg: Daidalos.

Benson, D. and Hughes, J. (1983) *The Perspective of Ethnomethodology*. Hong Kong: Longman.

Berefelt, G. (1977) *Skönt* (Beautiful). Uppsala: Almqvist & Wiksell.

Berg, P-O. (1979) *Emotional Structures in Organisations*. Lund: Studentlitteratur.

Berg, P-O. (1989) 'Postmodern Management? From Facts to Fiction in Theory and Practice'. *Scandinavian Journal of Management*, 5(3), pp. 201–17.

Berger, P. and Luckman, T. (1966) *The Social Construction of Reality*. New York: Doubleday.

Bergman, I. (1989) *The Magic Lantern*. New York: Penguin.

Bergman, I. (1990) *Images*. New York: Arcade.

Björkegren, D. (1990) 'Litteraturproduktion – en fallstudie' (The production of Literature – a Case Study). Research report. Stockholm: The Economic Research Institute at Stockholm School of Economics.

Björkegren, D. (1994) *Filmens företag* (The Film Enterprise). Stockholm: Nerenius & Santérus förlag.

Björkegren, D. (1994a) 'Turbo-TV – framtidens television?' (Turbo TV – The Future of Television?). *MTC Kontakten*, jubileumstidskrift 1994, pp. 51–5.

Blecher, G. (1990) 'Bokutgivningens ekosystem i obalans' (The Publishing Industry's Eco-system in Disequilibrium). *Dagens Nyheter*, 5 November, p. B2.

Bloom, A. (1988) *The Closing of The American Mind*. New York: Touchstone.

Bockris, V. (1989) *The Life and Death of Andy Warhol*. New York: Bantam.

Bordwell, D. and Thompson, K. (1986) *Film Art*. New York: Alfred A. Knopf.

Bourdieu, P. (1975) 'Le couturier et sa griffe: contribution a une théorie de la magie.' *Actes de la recherche en sciences sociales*, I, pp. 7–36.

Bourdieu, P. (1977) 'La production de la croyance. Contribution a une economie des biens symboliques.' *Actes de la recherche en sciences sociales*, III (13), pp. 3–43.

Bourdieu, P. (1986) *Distinction – A Social Critique of the Judgement of Taste*. London: Routledge & Kegan Paul.

Briggs, J. B. (1989) *Joe Bob Briggs goes to the Drive-in*. Harmondsworth: Penguin.

Brodin, B. (1979) 'Marknadsföring och distribution i bokförlag' (Marketing and Distribution in Publishing Houses). In Ahlmark, D. and Brodin, B. (1979) *Bokbranschen i framtiden* (The Future of the Publishing Industry). Stockholm: The Economic Research Institute at the Stockholm School of Economics.

Brodin, C. (1995) 'Den svårfångade läsaren' (The Elusive Reader). Graduating thesis. Stockholm: Stockholm School of Economics.

Broeske, P. H. (1993) 'The Beastmaster.' *Entertainment Weekly*, 12 March, 161, pp. 8–9.

Bruner, J. (1983) *In Search of Mind*. Cambridge, Mass.: Harper.

Bruner, J. (1986) *Actual Minds, Possible Worlds*. Cambridge, Mass.: Harvard University Press.

Bruner, J. (1990) *Acts of Meaning*. Cambridge, Mass.: Harvard University Press.

Brunius, T. (1986) *Estetik förr och nu* (Aesthetics Now and Then). Stockholm: Liber.

Burnett, R. (1990) *Concentration and Diversity in the International Phonogram Industry*. Göteborg: The University of Gothenburg.

Burrell, G. (1988) 'Modernism, Postmodernism and Organizational Analysis 2: The Contribution of Michel Foucault'. *Organization Studies*, 9(2), pp. 221–35.

Buscombe, E. (1975) 'Notes on Columbia Pictures Corporation 1926–41'. In Kerr, P. (1986) *The Hollywood Film Industry*. London: Routledge & Kegan Paul.

Byrne, J. (1990) 'Is Research in the Ivory Tower 'Fuzzy, Irrelevant, Pretentious'? *Business Week*, 29 October, pp. 50–2.

Castro, J. (1990) 'Let Us Entertain You'. *Time International*, 10 December, 50, pp. 52–4.

Coleridge, N. (1988) *The Fashion Conspiracy*. New York: Harper & Row.

Collins, J. (1989) *Uncommon Cultures – Popular Culture and Postmodernism*. London: Routledge.

Congdon, T. (ed.) (1993) *Paying For Broadcasting: The Handbook*. London: Routledge.

Cooper, R. (1989) 'Modernism, Postmodernism and Organisational Analysis 3: The Contribution of Jacques Derrida'. *Organisation Studies*, 10(4), pp. 479–502.

Cooper, R. and Burrell, G. (1988) 'Modernism, Postmodernism and Organisational Analysis: An Introduction'. *Organisation Studies*, 9(1), pp. 91–112.

Corman, R. (1990) *How I Made a Hundred Movies in Hollywood and Never Lost a Dime*. London: Fredrick Muller.

Coser, L., Kadushin, C. and Powell, W. (1982) *Books – The Culture and Commerce of Publishing*. Chigago: The University of Chigago Press.

Cummings, L. and Frost, P. (eds) (1985) *Publishing in the Organizational Sciences*. Homewood, Ill.: Irwin.

Curran, J. and Seaton, J. (1991) *Power without Responsibility*. London: Routledge.

Czarniawska-Joerges, B. (1988) *To Coin a Phrase*. Stockholm: Institute for Study of Power and Democracy in Sweden.

Czarniawska-Joerges, B. (1989) 'Don Quijote and Capitalism in Poland'. Studies in Action and Enterprise. The Department of Business Administration. The University of Stockholm.

Czarniawska-Joerges, B., Gustafson, C. and Björkegren, D. (1990)

'Purists versus Pragmatists: On Protagoras, Economists and Management Consultants'. *Consultation*, 9(3), pp. 241–56.

Dana, W. (1991) 'The Last Boomtown in America'. *M-inc.*, February, VIII (5), pp. 82–9.

Dannen, F. (1990) *Hit Men*. New York: Random House.

Drazin, R. and Sandelands, L. (1989) 'Autogenesis and the Process of Organising.' Draft paper, Emory and Columbia Universities.

Eagleton, T. (1989) *Literary Theory*. Oxford: Blackwell.

Eagleton, T. (1990) *The Ideology of The Aesthetic*. Oxford: Blackwell.

Eco, U. (1987) *Travels in Hyperreality*. New York: Basic Books.

Eisenberg, E. (1988) *The Recording Angel*. London: Picador.

Eliot, M. (1989) *Rockonomics*. London: Omnibus Press.

Ellis, J. (1989) *Visible Fictions*. London: Routledge & Kegan Paul.

Ericson, D. (1988) *In The Stockholm Art World*. Stockholm: Stockholm Studies in Social Anthropology.

Erlandsson, Å. (ed.) (1987) *Litterära smakdomare* (Literary Taste Judges). Lund: Symposion.

Etzioni, A. (1988) *The Moral Dimension*. New York: Free Press.

Ewen, S. and Ewen, E. (1982) *Channels of Desire*. New York: McGraw-Hill.

Fisher, W. (1989) *Human Communication As Narration*. Columbia, S.C.: University of South Carolina Press.

Fiske, J. (1989) *Understanding Popular Culture*. London: Unwin Hyman.

Fiske, J. (1990) *Television Culture*. London: Routledge.

Ford, S. (1990) *The Casting Couch*. London: Grafton.

Foucault, M. (1991) *Discipline and Punish*. Harmondsworth: Penguin.

Fowles, J. (1992) *Star Struck*. Washington, D.C.: Smithsonian Institution Press.

Frith, S. (1987) *Sound Effects – Youth, Leisure, and the Politics of rock-'n'-roll*. Suffolk: Constable.

Frith, S. (1988) *Music for Pleasure*. Oxford: Polity Press.

Frith, S. and Horne, H. (1987) *Art into Pop*. New York: Methuen.

Gabler, N. (1989) *An Empire of Their Own*. New York: Anchor Books.

Gamson, J. (1994) *Claims to fame*. Berkeley, Calif.: University of California Press.

Gans, H. (1974) *Popular Culture and High Culture*. New York: Basic Books.

Geertz, C. (1988) *Works and Lives – The Anthropologist as Author*. Stanford, Conn.: Stanford University Press.

Gilder, G. (1994) *Life After Television*. New York: Norton.

Gitlin, T. (1985) *Inside Prime Time*. New York: Pantheon.

Goldman, A. (1981) *Elvis*. New York: Allen Lane.

Goldman, W. (1990) *Adventures in the Screen Trade*. Austin, Tex.: Futura.

Gross, G. (ed.) (1985) *Editors on Editing*. New York: Harper and Row.

Guillet de Monthoux, P. (1988) 'Docteur Clerambault in Zola's Paradise'. Studies in Action and Enterprise. The Department of Business Administration. The University of Stockholm.

Halldén, R. (1989) 'Grått och trist i bokskogen' (Grey and Dull in the Forest of Books). *Dagens Nyheter*, December 20, p. B4.

Haraszti, M. (1987) *The Velvet Prison – Artists under State Socialism*. Harmondsworth: Penguin.

Harvey, D. (1989) *The Condition of Postmodernity*. Oxford: Blackwell.

Heymann, D. (1990) *A Woman named Jackie*. New York: Signet.

Hutter, M. (1991) 'Art Productivity in the Information Age'. Research paper. University of Witten/Herdecke.

Iacocca, L. with Novak, W. (1984) *Iacocca – An Autobiography*. New York: Bantam.

Jowett, G. and Linton, J. (1989) *Movies as Mass Communication*. Newbury Park, Calif.: Sage.

Kaplan, A. (1989) 'Feminism/Oedipus/Postmodernism: The Case of MTV.' In Kaplan, A. (ed.) (1989) *Postmodernism and its Discontents*. New York: Verso.

Kent, N. (1991) *Naked Hollywood*. London: BBC Books.

Kernan, A. (1990) *The Death of Literature*. Bingham, New York: Yale University Press.

Kerr, P. (1979–80) 'Out of What Past? Notes on the B Film Noir.' In Kerr, P. (ed.) (1986) *The Hollywood Film Industry*. London: Routledge & Kegan Paul.

Kerr, P. (1986) 'Introduction'. In Kerr, P. (ed.) (1986) *The Hollywood Film Industry*. London: Routledge & Kegan Paul.

Kerr, P. (ed.) (1986) *The Hollywood Film Industry*. London: Routledge & Kegan Paul.

King, B. (1986) 'Stardom as an occupation'. In Kerr, P. (ed.) (1986) *The Hollywood Film Industry*. London: Routledge & Kegan Paul.

Kreiner, K. (1989) 'The Postmodern Epoch of Organisation Theory'. Paper presented at the Post Modern Management Conference, Barcelona.

Kuhn, T. (1970) *The Structure of Scientific Revolutions*. Chigago: The University of Chigago Press.

Langer, J. (1988) *Musikbranschen* (The Music Industry). Kungsbacka: Johan Langer Produktion.

Lash, S. (1990) *Sociology of Postmodernism*. London: Routledge.

Levitt, B and Nass, C. (1989) 'The Lid on the Garbage Can: Institutional Constraints on Decision Making in the Technical Core of College-Text Publishers.' *Administrative Science Quarterly*, 34, pp. 190–207.

Lippard, L. (ed.) (1988) *Pop Art*. New York: Thames & Hudson.

Lyotard, J-F. (1989) *The Postmodern Condition: A Report on Knowledge*. Manchester: Manchester University Press.

McCloskey, D. (1985) *The Rhetoric of Economics*. Hemel Hempstead: Harvester Press.

Mintzberg, H. and McHugh, A. (1985) 'Strategy Formation in an Adhocracy'. *Administrative Science Quarterly*, 30, pp. 160–97.

Mintzberg, H. and Waters, J. (1985) 'Of Strategies, Deliberate and Emergent'. *Strategic Management Journal*, 6, pp. 257–72.

Molloy, J. (1988) *New Dress for Success*. New York: Warner Books.

Mordden, E. (1989) *The Hollywood Studios*. New York: Fireside.

Mordden, E. (1990) *Medium Cool*. New York: Knopf.

Neuman, W. R. (1991) *The Future of the Mass Audience.* New York: Cambridge University Press.

Norris, C. (1987) *Derrida.* Cambridge, Mass.: Harvard University Press.

Ödeen, M. (1988) *Dramatiskt Berättande* (Dramatic Story-telling). Köthen: Carlssons.

Onsér-Franzén, J. (1992) *Kulturernas Kamp* (The Battle of the Cultures). Göteborg: Etnologiska föreingen i VästSverige.

Oumano, E. (1985) *Film Forum – Thirty-five Top Filmmakers Discuss their Craft.* New York: St. Martin's Press.

Parsons, M. (1987) *How we Understand Art.* New York: Cambridge University Press.

Perrow, C. (1986) *Complex Organizations.* New York: Random House.

Peters, T. and Waterman, R. (1982) *In Search of Excellence.* New York: Harper & Row.

Petersson, J. and Zetterqvist, K. (1994) 'CD-ROM i bokindustrin' (CD-ROM in the Publishing Industry). Graduating thesis. Stockholm: Stockholm School of Economics.

Pettigrew, A. and Whipp, R. (1991) *Managing Change for Competitive Success.* Oxford: Blackwell.

Plato (1976) *The Republic.* Harmondsworth: Penguin.

Popper, K. (1986) *Unended Quest.* Carlsbad, Calif.: Flamingo.

Porter, M. (1980) *Competitive Strategy.* New York: Macmillan.

Porter, M. (1985) *Competitive Advantage.* New York: Macmillan.

Powell, W. (1985) *Getting into Print.* Chigago: The University of Chigago Press.

Rein, I., Kotler, P. and Stoller, M. (1987) *High Visibility.* London: Heinemann.

Roethlisberger, F. (1977) *The Elusive Phenomena.* Boston, Mass.: Harvard University Press.

Rogan, J. (1988) *Starmakers and Svengalis.* Austin, Tex.: Futura.

Rönnberg, M. (1989) *Skitkul! Om sk skräpkultur* (Hilarious! About the So-called 'Trash Culture'). Uppsala: Filmförlaget.

Rosen, M. (1991) 'Scholars, Travelers and Thieves: On Concept, Method and Cunning in Organizational Ethnography.' Paper presented at the 8th International SCOS Conference, Copenhagen, June 26–8.

Ryan, B. (1992) *Making Capital from Culture.* Berlin: de Gruyter.

Sandelands, L. and Buckner, G. (1989) 'Of Art and Work: Aesthetic Experience and the Psychology of Work Feelings'. *Research in Organisational Behaviour,* 2, pp. 105–31.

Sandelands, L. and Srivatsan, V. (1989) 'Experience and Organization Studies'. Manuscript. University of Michigan.

Schultz, M. (1989) 'Postmodern Pictures of Corporate Culture'. Paper presented at the Post Modern Management Conference, Barcelona.

Sellerberg, A-M. (1987) *Avstånd och attraktion – Om modets växlingar* (Distance and Attraction – About the Changes of Fashion). Uddevalla: Carlsons.

Simons, H. (ed.) (1989) *Rhetoric in The Human Sciences.* London: Sage.

Sjöstrand, S-E. (1985) *Samhällsorganisation* (The Organization of Society). Kristianstad: Doxa.

Sontag, S. (1969) *Konst och antikonst* (Art and Anti-art). Stockholm: Pan/Norstedts.

Sorlin, P. (1991) *European Cinemas, European Societies 1939–1990.* London: Routledge.

Stablein, R. (1989) 'Structure of Debate in Organization Studies.' Paper presented at the Academy of Management, Washington, D.C., 13–16 August.

Storey, J. (1993) *Cultural Theory and Popular Culture.* London: The University of Georgia Press.

Sudjic, D. (1989) *Cult Heroes.* London: Andre Deutsch.

Sutherland, J. (1981) *Bestsellers.* London: Routledge & Kegan Paul.

Swift, J. (1985) *Gulliver's Travels.* Harmondsworth: Penguin.

Tomlinson, A. (ed.) (1990) *Consumption, Identity and Style.* London: Routledge.

Tushman, M. and Moore, W. (ed.) (1988) *Readings in the Management of Innovation.* Cambridge, Mass.: Ballinger.

Twitchell, J. B. (1992) *Carnival Culture.* New York: Columbia University Press.

Van Maanen, J. (1988) *Tales of the Field.* Chigago: The University of Chigago Press.

Vogel H. L. (1990) *Entertainment Industry Economics.* Cambridge: Cambridge University Press.

Waldo, D. (1968) *The Novelist on Organization and Administration: An Inquiry Into the Relationship Between Two Worlds.* Institute of Governmental Studies. University of California, Berkeley.

Warhol, A. (1975) *The Philosophy of Andy Warhol.* New York: Harvest/HBJ.

Wasko, J. (1978) D. W. Griffith and the Banks: a Case Study in Film Financing. In Kerr, P. (ed.) *The Hollywood Film Industry.* London: Routledge & Kegan Paul.

Webster, J. and Starbuck, W. H. (1988) 'Theory Building in Industrial and Organizational Psychology.' In Cooper, C. L. and Robertson, I. (eds) *International Review of Industrial and Organizational Psychology,* pp. 93–138.

Welleck, R. and Warren, A. (1967) *Litteraturteori* (Literary Theory). Malmö: Aldus/Bonniers.

Wilson, M. (1987) *How to Make it in the Rock Business.* London: Columbus Books.

Wolff, J. (1987) *The Social Production of Art.* Basingstoke: Macmillan.

Zaleznik, A. and Kets de Vries, M. (1984) 'Leadership as a Text. An Essay on Interpretation.' Research Report, Harvard Business School.

Index

Salade de poulet et pois chiches à la chermoula

Pour 4 personnes
Trempage 12 heures • Préparation 25 minutes • Cuisson 20 minutes

200 g de pois chiches secs
4 blancs de poulet (800 g)
1 poivron rouge moyen (200 g) en petits dés
1 poivron vert moyen (200 g) en petits dés
2 grosses tomates olivettes (180 g) en petits dés
1 petit oignon jaune (80 g) haché
2 c. à s. de jus de citron

Chermoula
2 poignées de coriandre fraîche finement ciselée
2 poignées de persil plat frais finement ciselé
2 gousses d'ail écrasées
2 c. à s. de vinaigre de vin blanc
2 c. à s. de jus de citron
1 c. à c. de paprika doux
1/2 c. à c. de cumin moulu
2 c. à s. d'huile d'olive

1 Faites tremper les pois chiches une nuit entière dans l'eau froide. Égouttez-les, rincez-les à l'eau froide puis égouttez-les à nouveau. Faites-les cuire dans de l'eau bouillante jusqu'à ce qu'ils soient tendres. Égouttez-les et passez-les sous l'eau froide. Égouttez-les une fois encore avant de les mettre dans un saladier.

2 Préparez la chermoula en mélangeant tous les ingrédients. Mettez-en la moitié dans un récipient, ajoutez les blancs de poulet, retournez-les dans ce mélange et laissez reposer quelques minutes.

3 Préchauffez un gril en fonte ou une grande poêle antiadhésive et faites cuire les blancs de poulet en les retournant plusieurs fois. Dès qu'ils sont à point, gardez-les au chaud entre deux assiettes.

4 Ajoutez sur les pois chiches le reste de chermoula, les poivrons, les tomates et l'oignon. Détaillez les blancs de poulet en tranches fines et disposez-les sur la salade. Arrosez de jus de citron avant de servir.

Salade d'oranges et radis

Pour 4 personnes
Préparation 30 minutes

6 grosses oranges (1,8 kg)
4 gros radis rouges (200 g) en tranches fines
1/2 oignon rouge (50 g) en tranches fines
180 g d'olives noires dénoyautées

Assaisonnement
1 gousse d'ail écrasée
1/2 c. à c. de paprika doux
1/2 c. à c. de cumin moulu
2 c. à s. de jus de citron
2 c. à s. d'huile d'olive
1/4 de c. à c. de sucre en poudre
2 c. à s. de persil frais ciselé
1 c. à c. d'eau de fleur d'oranger
1/2 c. à c. de cannelle moulue

1 Commencez par préparer l'assaisonnement en mélangeant tous
 les ingrédients dans un récipient.

2 Pelez les oranges à vif et coupez-les en tranches en éliminant
 les membranes blanches. Enlevez aussi les pépins.

3 Disposez les tranches d'oranges et de radis en couches dans un grand
 plat, en les faisant se chevaucher. Ajoutez les olives et l'oignon rouge.
 Versez l'assaisonnement. Servez sans mélanger.

Pratique Très utilisée en pâtisserie, l'eau de fleur d'oranger apporte aussi
 une note douce aux recettes salées. Sa saveur permet d'atténuer ici
 le goût poivré du radis. En vente dans les épiceries fines et en grandes
 surfaces.

Salade marocaine au couscous et au poulet

Pour 4 personnes
Préparation 10 minutes • Cuisson 5 minutes

1 petit poulet grillé
250 ml de bouillon de légumes
300 g de couscous
1 oignon rouge moyen (170 g) en tranches fines
75 g d'abricots secs hachés
80 g de raisins secs
1 poignée de feuilles de menthe ciselée
1 c. à s. de pignons
2 c. à c. de graines de cumin
2 c. à s. d'huile d'olive
1 c. à s. de jus de citron

1 Découpez le poulet en morceaux, enlevez la peau et désossez-le. Détaillez la viande en petits dés.

2 Portez à ébullition le bouillon puis retirez-le du feu. Versez le couscous, couvrez et laissez gonfler 5 minutes : tout le bouillon doit être absorbé. Aérez la graine à la fourchette.

3 Transférez le couscous dans un saladier et ajoutez la viande, l'oignon, les abricots, les raisins secs et la menthe. Mélangez délicatement.

4 Fouettez ensemble l'huile et le jus de citron. Faites sauter à sec dans une poêle les pignons et le cumin. Ajoutez le mélange d'huile et de jus de citron. Versez cette sauce sur le couscous, remuez délicatement et servez sans attendre.

Harira

Pour 8 personnes
Trempage 12 heures • Préparation 25 minutes • Cuisson 2 h 15

200 g de pois chiches secs
20 g de beurre
2 oignons jaunes moyens (300 g) hachés
2 branches de céleri (200 g) en petits dés
2 gousses d'ail écrasées
20 g de gingembre frais râpé
1 c. à c. de cannelle moulue
1/2 c. à c. de poivre noir moulu
1 pincée de filaments de safran
500 g de viande d'agneau en cubes
3 grosses tomates (660 g) épépinées et grossièrement concassées
2 litres d'eau chaude
100 g de lentilles brunes
2 c. à s. de farine de ménage
100 g de riz blanc à longs grains
2 grosses poignées de coriandre fraîche
2 c. à s. de jus de citron

1 Faites tremper les pois chiches toute une nuit dans l'eau froide.
 Égouttez-les, rincez-les bien puis égouttez-les de nouveau.

2 Dans une grande cocotte, laissez fondre le beurre pour y faire revenir
 l'oignon, le céleri et l'ail. Dès que l'oignon est tendre, ajoutez le
 gingembre, la cannelle, le poivre et le safran. Laissez chauffer quelques
 minutes pour libérer les arômes puis faites colorer dans ce mélange les
 morceaux de viande.

3 Ajoutez les pois chiches et les tomates. Remuez 5 minutes à feu moyen,
 jusqu'à ce que les tomates soient tendres.

4 Versez l'eau et portez à ébullition. Couvrez et laissez mijoter 45 minutes.
 Ajoutez les lentilles et continuez la cuisson à feu doux pendant 1 heure
 environ.

5 Délayez la farine dans 120 ml de liquide de cuisson tiède, versez-la
 dans la cocotte avec le riz et laissez épaissir quelques minutes à petits
 bouillons. Incorporez la coriandre et le jus de citron juste avant de servir.

Après le coucher de soleil, durant le ramadan, de nombreux musulmans
 rompent le jeûne quotidien en commençant leurs repas par la harira,
 une soupe épaisse dont la recette varie d'une famille à l'autre. Mais elle
 contient toujours des pois chiches et de l'agneau.

Soupe algérienne au poulet et aux pois chiches

Pour 4 personnes
Préparation 20 minutes • Cuisson 50 minutes

2 c. à s. d'huile d'olive
350 g de blancs de poulet
1 gros oignon jaune (200 g) haché
2 gousses d'ail écrasées
20 g de gingembre frais râpé
1 c. à s. de cumin moulu
1 c. à s. de coriandre moulue
1 c. à c. de curcuma en poudre
1/2 c. à c. de paprika doux
1 petit bâton de cannelle
35 g de farine de ménage
1 litre de bouillon de volaille
1 litre d'eau
600 g de pois chiches en boîte rincés et égouttés
800 g de tomates concassées en boîte
2 c. à s. de citron confit détaillé en dés
1 c. à s. de coriandre fraîche ciselée

1 Versez la moitié de l'huile dans une poêle chaude et faites revenir le poulet pendant 10 minutes, en le retournant à mi-cuisson. Laissez-le tiédir avant de l'effilocher grossièrement. Réservez-le.

2 Dans le reste d'huile, faites fondre l'oignon avec l'ail et le gingembre. Ajoutez les épices et mettez à chauffer quelques minutes sans cesser de remuer pour que les arômes se dégagent.

3 Saupoudrez de farine et laissez épaissir jusqu'aux premiers bouillons. Versez alors progressivement le bouillon et l'eau, en mélangeant sans cesse pour éviter les grumeaux. Baissez le feu après l'ébullition et faites épaissir la soupe pendant 20 minutes sans couvrir.

4 Ajoutez les pois chiches et les tomates. Quand le liquide recommence à bouillir, réduisez le feu et laissez mijoter encore 10 minutes.

5 Incorporez enfin le poulet et le citron confit, remuez à feu moyen pour réchauffer la viande et retirez la cocotte du feu. Ajoutez la coriandre juste avant de servir.

Boulgour au poulet

Pour 4 personnes
Préparation 15 minutes • Cuisson 15 minutes

160 g de boulgour
500 g de blancs de poulet en fines lamelles
2 gousses d'ail écrasées
180 ml de jus de citron
60 ml d'huile d'olive
250 g de tomates cerises coupées en deux
4 oignons verts en tranches épaisses
4 poignées de persil plat frais ciselé
4 poignées de menthe fraîche ciselée

1 Mettez le boulgour dans un saladier, couvrez d'eau bouillante et laissez gonfler 15 minutes. Égouttez-le et pressez-le bien dans vos mains pour éliminer le plus d'eau possible.

2 Mélangez dans un autre saladier l'ail, un quart du jus de citron et 1 cuillerée à soupe d'huile. Ajoutez la viande, remuez et laissez mariner 5 minutes.

3 Faites chauffer 1 cuillerée à soupe d'huile dans une poêle antiadhésive pour y faire sauter la viande parfaitement égouttée. Gardez-la ensuite au chaud entre deux assiettes.

4 Versez le boulgour, la tomate et l'oignon dans la poêle et réchauffez-les à feu vif. Retirez la poêle du feu pour ajouter le persil, la menthe, le reste du jus de citron et de l'huile. Mélangez délicatement avant de servir.

Salade tunisienne au thon

Pour 4 personnes
Préparation 30 minutes • Cuisson 3 minutes

2 œufs durs détaillés en dés
2 poivrons verts moyens (300 g) épépinés et coupés en dés
4 oignons verts en tranches fines
2 filets d'anchois égouttés et détaillés en dés
30 g d'olives vertes dénoyautées et hachées
2 petits piments rouges frais en tranches fines
2 c. à c. de menthe fraîche ciselée
180 g de thon en boîte égoutté et émietté
1 c. à s. de petites câpres égouttées et rincées

Assaisonnement
2 c. à s. d'huile d'olive
1 gousse d'ail écrasée
1 c. à c. de graines de coriandre
1 c. à c. de graines de cumin
1 c. à s. de jus de citron
2 c. à s. de vinaigre de vin rouge

1 Pour l'assaisonnement, faites chauffer l'huile dans une poêle pour
y faire sauter l'ail avec les graines de cumin et la coriandre. Quand
le mélange embaume, retirez la poêle du feu pour y ajouter le jus
de citron et le vinaigre.

2 Mélangez tous les ingrédients de la salade dans un grand plat creux,
versez l'assaisonnement et remuez délicatement. Vous pouvez servir
ce plat avec du pain pita grillé.

Pratique Cette salade est meilleure si on la prépare avec du thon frais
juste poêlé et détaillé en petits morceaux.

Cette salade originaire de Tunis est aussi agréable au palais qu'à l'œil.
Comme la plupart des recettes du Maghreb, elle est assez épicée mais
on peut réduire la quantité de piments (ou l'augmenter si on aime les
saveurs très relevées).

Plats végétariens

Aubergines rôties et riz parfumé

Pour 4 personnes
Préparation 10 minutes • Cuisson 30 minutes

3 aubergines moyennes (900 g)
6 c. à s. d'huile d'olive
2 gousses d'ail en tranches fines
1 c. à s. de persil plat frais finement ciselé

Riz parfumé
30 g de beurre
1 oignon jaune moyen (150 g) haché
2 gousses d'ail écrasées
3 gousses de cardamome froissées
1/2 bâtonnet de cannelle
400 g de riz basmati
250 ml de bouillon de légumes
250 ml d'eau
40 g de pignons grillés

1 Préchauffez le four à 220 °C.

2 Détaillez les aubergines en tronçons de 3 cm en jetant les extrémités. Faites-les dorer rapidement dans 4 cuillerées à soupe d'huile d'olive, dans une très grande poêle ou en procédant en plusieurs tournées. Mettez-les ensuite dans un plat allant au four, répartissez l'ail dessus et faites-les rôtir pendant 20 minutes environ.

3 Pour le riz parfumé, faites fondre le beurre dans une casserole et laissez revenir l'oignon et l'ail avec la cardamome et la cannelle. Ajoutez le riz et remuez vivement pour que les grains soient enduits de beurre. Versez alors le bouillon et l'eau, portez à ébullition, couvrez et laissez frémir 15 minutes. Retirez la casserole du feu et laissez le riz gonfler encore 5 minutes à couvert pour que tout le liquide soit absorbé. Incorporez enfin les pignons.

4 Nappez les aubergines avec l'huile restante, saupoudrez-les de persil et servez sans attendre avec le riz chaud.

Carottes à l'orange

Pour 8 personnes
Préparation 10 minutes • Cuisson 20 minutes

30 g de beurre
1 c. à s. d'huile d'olive
6 carottes moyennes (720 g) en tranches épaisses
2 c. à s. de sucre en poudre
1 c. à s. de persil plat frais finement ciselé
1 c. à s. de vinaigre balsamique

1 Mettez les carottes dans une casserole avec l'huile et le beurre, couvrez et laissez cuire plusieurs minutes à petit feu. Elles doivent être cuites mais rester un peu fermes.

2 Ajoutez alors le sucre et laissez cuire 10 minutes en remuant sans cesse, jusqu'à ce que les carottes caramélisent. Incorporez enfin le persil et le vinaigre.

Pratique Cette recette peut se préparer plusieurs heures à l'avance et se réchauffer avant de servir.

Pommes de terre aux épices

Pour 4 personnes
Préparation 5 minutes • Cuisson 25 minutes

1 kg de petites pommes de terre nouvelles
2 c. à s. d'huile d'olive
1 c. à s. de graines de moutarde noire
1 c. à c. de poivre noir fraîchement moulu
1 c. à s. de persil plat frais haché

1 Faites cuire les pommes de terre à l'eau ou à la vapeur puis égouttez-les.

2 Faites-les revenir dans l'huile chaude jusqu'à ce qu'elles dorent légèrement.

3 Ajoutez les graines de moutarde et laissez sauter 1 minute, en remuant souvent.

4 Incorporez le reste des ingrédients et mélangez délicatement.

Aubergines grillées et salade aux herbes

Pour 4 personnes
Préparation 15 minutes • Réfrigération 2 heures • Cuisson 10 minutes

3 petites tomates (270 g)
40 g de boulgour
2 grosses aubergines (1 kg)
80 ml d'huile d'olive
16 poignées de persil plat frais ciselé
4 poignées de menthe fraîche ciselée
1 oignon rouge moyen (170 g) haché
2 c. à s. de jus de citron

1 Concassez les tomates en petits dés en conservant autant de jus que possible. Mélangez-les avec le boulgour dans un saladier, couvrez et réfrigérez 2 heures pour que les graines absorbent le liquide.

2 Détaillez les aubergines en tranches fines dans la longueur, nappez-les avec la moitié de l'huile et faites-les griller 10 minutes environ sur une plaque de fonte chaude (ou au barbecue).

3 Terminez la salade en y ajoutant le persil, la menthe et l'oignon. Mélangez dans un bol le jus de citron et le reste de l'huile, versez cette sauce sur la salade, remuez et servez avec les aubergines grillées.

Légumes grillés et caviar d'aubergine

Pour 4 personnes
Préparation 20 minutes • Cuisson 50 minutes

1 gros poivron vert (350 g)
2 gros poivrons rouges (700 g)
2 gros poivrons jaunes (700 g)
3 aubergines moyennes (800 g)
2 gousses d'ail en chemise
60 ml de jus de citron
2 c. à c. de tahini
400 g de gombos nettoyés
de l'huile d'olive pour la cuisson
400 g de tomates cerises
12 pâtissons jaunes (360 g) coupés en quatre
2 grosses poignées de basilic frais
1 c. à c. de sumac

1 Préchauffez le four à 220 °C. Huilez deux grands plats.

2 Coupez les poivrons en quatre, retirez les graines et les membranes blanches. Piquez les aubergines avec une fourchette. Répartissez les poivrons dans un plat (côté peau tourné vers le haut), les aubergines et l'ail dans un autre, et laissez-les griller 30 minutes. Sortez les poivrons du four, couvrez-les d'une feuille d'aluminium et laissez-les reposer 5 minutes avant de les éplucher et de les détailler en lanières épaisses. Gardez-les au chaud.

3 Pelez les aubergines et l'ail. Hachez-les grossièrement avant d'incorporer le jus de citron et le tahini. Couvrez et réservez au chaud.

4 Étalez les gombos sur une plaque de cuisson huilée, badigeonnez-les d'huile et faites-les griller au four pendant 20 minutes environ.

5 Versez un peu d'huile dans une poêle pour y faire revenir les tomates et les pâtissons, en les couvrant à mi-cuisson.

6 Mélangez tous les légumes grillés dans un saladier, ajoutez le basilic et remuez délicatement. Répartissez-les ensuite sur les assiettes de service, ajoutez une belle cuillerée de caviar d'aubergine et saupoudrez de sumac. Servez sans attendre.

Courgettes frites
aux pignons et raisins secs

Pour 8 personnes
Préparation 15 minutes • Cuisson 15 minutes

60 ml d'huile d'olive
40 g de beurre
2 tranches de pain épaisses
2 gousses d'ail écrasées
1 c. à s. de pignons grillés grossièrement broyés
1 c. à c. de zeste de citron finement râpé
2 c. à s. de persil plat frais finement ciselé
1 c. à s. de raisins secs
24 petites courgettes avec leur fleur

1 Enlevez la croûte du pain et coupez la mie en petits cubes. Faites dorer ces cubes dans la moitié de l'huile et la moitié du beurre. Ajoutez l'ail, remuez jusqu'à ce qu'il embaume, puis incorporez les pignons, le zeste de citron, le persil et les raisins secs. Transférez ce mélange dans un saladier et couvrez.

2 Dans la même poêle, faites fondre le reste du beurre avec l'huile pour y faire sauter les courgettes. Couvrez-les durant la cuisson pour qu'elles soient bien tendres.

3 Disposez les courgettes sur un plat de service, ajoutez la garniture et dégustez sans attendre.

Pratique Vous pouvez préparer la garniture plusieurs heures à l'avance ; vous la réchaufferez rapidement avant d'en saupoudrer les courgettes. Si vous ne trouvez pas de fleurs de courgette, achetez des mini-courgettes et coupez-les en deux dans la longueur.

Boulettes de pommes de terre en sauce tomate

Pour 4 personnes
Préparation 30 minutes • Égouttage 40 minutes • Cuisson 35 minutes

4 pommes de terre moyennes (400 g)
2 c. à s. de coriandre fraîche ciselée
75 g de noix de cajou grillées et finement broyées
60 g de petits pois décongelés
de l'huile végétale
4 œufs durs coupés en deux

Caillé
1 litre de lait
2 c. à s. de jus de citron

Sauce tomate
1 c. à s. d'huile d'olive
1 gousse d'ail écrasée
30 g de gingembre frais râpé
1/2 c. à c. de piment en poudre
1 c. à c. de cumin moulu
1 c. à c. de coriandre moulue
1/2 c. à c. de graines de moutarde
800 g de tomates concassées en boîte

1 Commencez par préparer le caillé. Faites bouillir le lait, ajoutez le jus de citron hors du feu et laissez reposer 10 minutes. Transférez le mélange dans un tamis fin garni d'une étamine et laissez égoutter au moins 40 minutes au-dessus d'un saladier.

2 Pour la sauce tomate, faites revenir l'ail et le gingembre dans l'huile chaude, ajoutez les épices et les graines de moutarde, remuez 1 minute à feu vif puis versez les tomates avec leur jus. Laissez épaissir la sauce quelques minutes à feu moyen, sans la couvrir.

3 Faites cuire les pommes de terre puis égouttez-les bien.

4 Écrasez-les dans un saladier avant d'incorporer le caillé bien égoutté, la coriandre, les pignons et les petits pois. Façonnez des boulettes et faites-les frire en plusieurs tournées dans l'huile végétale chaude, dans une grande sauteuse. Égouttez-les sur du papier absorbant.

5 Mettez les boulettes dans la sauce tomate et laissez frémir 5 minutes sans couvrir. Répartissez-les avec la sauce sur les assiettes de service. Décorez chaque assiette de moitiés d'œufs durs.

Couscous au potiron

Pour 4 personnes
Préparation 10 minutes • Cuisson 20 minutes

1 c. à s. d'huile d'olive
2 gousses d'ail écrasées
1 gros oignon rouge (300 g) en tranches fines
600 g de potiron pelé et détaillé en cubes
3 c. à c. de cumin moulu
2 c. à c. de coriandre moulue
200 g de couscous
250 ml d'eau bouillante
20 g de beurre
2 c. à s. de persil plat frais ciselé

1 Préchauffez le four à 220 °C. Faites revenir dans l'huile l'ail, l'oignon
 et le potiron. Quand le mélange commence à dorer, ajoutez les épices.
 Laissez chauffer encore 2 minutes pour que les arômes se développent
 et transférez le mélange dans un grand plat. Terminez la cuisson au four
 pendant 15 minutes, jusqu'à ce que le potiron soit tendre.

2 Mettez le couscous, l'eau bouillante et le beurre dans un saladier,
 remuez, couvrez et laissez gonfler 5 minutes. Quand tout le liquide
 est absorbé, aérez la graine avec une fourchette. Ajoutez enfin le persil
 et les cubes de potiron, remuez délicatement et servez rapidement.

Salade d'épinards, boulgour et pois chiches

Pour 4 personnes
Préparation 20 minutes • Cuisson 10 minutes

1 gros poivron rouge (350 g)
160 g de boulgour
250 ml d'eau bouillante
420 g de pois chiches en boîte rincés et égouttés
1 branche de céleri (100 g) détaillée en dés
50 g de pousses d'épinards

Assaisonnement
1 c. à s. de graines de sésame
2 c. à s. de sumac
1 c. à s. de thym frais
1 c. à s. d'origan frais grossièrement ciselé
125 ml de jus de citron vert
1 c. à s. d'huile d'olive
1 gousse d'ail écrasée

1 Coupez le poivron en quatre, enlevez les graines et les membranes blanches et mettez-le à rôtir au four dans un grand plat. Quand la peau commence à noircir, sortez le poivron du four, couvrez-le d'une feuille d'aluminium et laissez-le reposer 5 minutes avant de le peler et de le couper en lanières fines.

2 Faites gonfler le boulgour 10 minutes dans l'eau bouillante, en le couvrant hermétiquement. La graine doit être tendre et le liquide complètement absorbé.

3 Préparez l'assaisonnement en mélangeant tous les ingrédients dans un récipient.

4 Mélangez dans un saladier les pousses d'épinards, le boulgour, les pois chiches, le céleri et le poivron grillé. Versez la sauce, remuez délicatement et servez sans attendre.

Tajine de potiron et pois cassés

Pour 4 personnes
Préparation 15 minutes • Cuisson 40 minutes

200 g de pois cassés
1 c. à s. d'huile d'olive
1 oignon jaune moyen (150 g) haché
2 gousses d'ail écrasées
2 c. à c. de coriandre moulue
2 c. à c. de cumin moulu
2 c. à c. de gingembre en poudre
1 c. à c. de paprika doux
1 c. à c. de poivre de la Jamaïque moulu
1 kg de potiron pelé et détaillé en cubes de 3 cm
400 g de tomates concassées en boîte
250 ml d'eau
250 ml de bouillon de légumes
2 c. à s. de miel
200 g de haricots verts coupés en petits tronçons
1 poignée de coriandre fraîche ciselée

1 Faites cuire les pois cassés dans une casserole d'eau bouillante. Quand ils sont tendres, rincez-les sous l'eau froide puis égouttez-les.

2 Dans une sauteuse, faites revenir l'oignon dans l'huile, jusqu'à ce qu'il soit tendre. Ajoutez l'ail et les épices, laissez cuire encore 2 minutes en remuant, puis incorporez le potiron. Retournez les morceaux dans le mélange d'épices pour qu'ils en soient recouverts.

3 Versez dans la sauteuse les tomates avec leur jus, l'eau et le bouillon. Portez à ébullition puis laissez mijoter 20 minutes. Quand le potiron est tendre, ajoutez le miel, les haricots verts et les pois cassés. Laissez cuire encore 10 minutes à feu doux pour que les haricots verts soient juste croquants. Hors du feu, incorporez la coriandre fraîche. Servez avec du couscous.

Volailles, viandes et poissons

Poulet à la chermoula

Pour 4 personnes
Préparation 10 minutes • Cuisson 20 minutes

700 g de blancs de poulet en tranches fines
2 poignées de persil plat ciselé
1 c. à s. de zeste de citron râpé
1 c. à s. de jus de citron
2 c. à c. de curcuma en poudre
1 c. à c. de piment de Cayenne
1 c. à s. de coriandre moulue
1 oignon rouge moyen (170 g) haché
2 c. à s. d'huile d'olive
200 g de lentilles corail
625 ml de bouillon de volaille
200 g de pousses d'épinards
2 poignées de coriandre fraîche ciselée
2 poignées de menthe fraîche ciselée
1 c. à s. de vinaigre de vin rouge
95 g de yaourt

1 Mélangez dans un saladier le persil, le zeste et le jus de citron, les épices, l'oignon et la moitié de l'huile. Ajoutez le poulet et remuez. Faites sauter la viande égouttée dans une grande poêle, en procédant en plusieurs tournées.

2 Faites cuire les lentilles 8 minutes dans le bouillon, jusqu'à ce qu'elles soient tendres. Égouttez-les et mettez-les dans un saladier avec les épinards, la coriandre et la menthe fraîche. Fouettez le reste d'huile avec le vinaigre, versez cette sauce sur les lentilles et mélangez délicatement.

3 Répartissez les morceaux de poulet sur les lentilles, nappez de yaourt et servez sans attendre.

La chermoula est un mélange d'épices et d'aromates qui s'emploie pour parfumer une viande ou un poisson. On peut l'utiliser en marinade ou pour badigeonner en cours de cuisson.

Blancs de poulet grillés au piment et à la coriandre

Pour 4 personnes
Préparation 10 minutes • Cuisson 15 minutes

6 blancs de poulet (660 g) coupés en deux
600 g de pois chiches en boîte rincés et égouttés
2 tomates olivettes moyennes (150 g) grossièrement concassées
2 oignons verts en tranches fines
4 poignées de coriandre fraîche ciselée
2 c. à s. de jus de citron vert
1 c. à s. d'huile d'olive

Sauce au piment et à la coriandre
8 oignons verts en gros tronçons
3 gousses d'ail découpées en quartiers
3 petits piments rouges hachés
1 poignée de feuilles de coriandre fraîche
1 c. à c. de sucre en poudre
1 c. à s. d'huile d'olive
60 ml de jus de citron

1 Commencez par préparer la sauce en mélangeant tous les ingrédients dans un bol. Laissez reposer 30 minutes pour que les arômes se développent.

2 Faites colorer le poulet sur une plaque en fonte huilée. Quand il est juste doré mais pas encore cuit, badigeonnez-le des deux côtés avec les deux tiers de la sauce. Laissez-le cuire encore 5 minutes.

3 Dans un grand saladier, mélangez les pois chiches, les tomates, les oignons et la coriandre. Fouettez le jus de citron et l'huile, versez cet assaisonnement sur la salade et remuez.

4 Nappez les blancs de poulet chauds du reste de sauce au piment et servez-les avec la salade de pois chiches.

Poulet aux amandes et aux dattes

Pour 4 personnes
Préparation 10 minutes • Cuisson 15 minutes

1 c. à s. d'huile d'olive
1 gros oignon jaune (200 g) en tranches fines
2 c. à c. de cannelle en poudre
2 c. à c. de zeste d'orange finement râpé
1/4 de c. à c. de piment de Cayenne
375 ml de bouillon de volaille
700 g de dattes dénoyautées coupées en petits dés
1 poulet grillé découpé en gros morceaux
250 ml de jus d'orange
250 ml d'eau
400 g de couscous
20 g de beurre en morceaux
35 g d'amandes effilées grillées

1 Faites dorer l'oignon quelques minutes dans l'huile. Ajoutez la cannelle, le zeste de citron et le piment de Cayenne, mélangez bien, versez le bouillon et portez à ébullition. Laissez mijoter 4 minutes avant de plonger les morceaux de poulet et les dattes dans ce mélange. Réchauffez la viande à feu moyen.

2 Faites bouillir le jus d'orange et l'eau dans une casserole. Hors du feu, versez la graine de couscous, couvrez et laissez gonfler 5 minutes. Aérez la graine à la fourchette puis incorporez le beurre.

3 Répartissez la semoule sur les assiettes de service, ajoutez la viande et nappez de sauce. Décorez d'amandes effilées avant de servir.

Poulet rôti à la marocaine et salsa d'olives vertes

Pour 4 personnes
Préparation 30 minutes • Cuisson 2 h 20

1 poulet de 1,6 kg
200 g de beurre fondu
20 tomates cerises (500 g)
1 c. à s. d'huile d'olive

Farce
4 c. à s. d'huile d'olive
1 oignon jaune moyen (150 g) haché
375 ml de bouillon de volaille
1 c. à s. de zeste de citron râpé
60 ml de jus de citron
200 g de couscous
70 g d'amandes effilées grillées
140 g de dattes sèches dénoyautées et détaillées en dés
1 c. à c. de cannelle moulue
1 c. à c. de paprika fumé
1 œuf légèrement battu

Salsa d'olives vertes
180 g d'olives vertes dénoyautées et grossièrement hachées
80 ml d'huile d'olive
1 c. à s. de vinaigre de cidre
1 échalote (25 g) hachée
1 piment rouge frais haché
1 poignée de persil plat ciselé
1 poignée de menthe fraîche ciselée

1 Pour préparer la farce, faites d'abord revenir l'oignon dans 1 cuillerée
 à soupe d'huile. Dans une casserole, portez le bouillon à ébullition
 avec le reste d'huile, le zeste et le jus de citron. Hors du feu, ajoutez
 le couscous, couvrez et laissez gonfler 5 minutes. Aérez la graine
 à la fourchette avant d'incorporer l'oignon, les amandes, les dattes,
 les épices et l'œuf battu.

2 Préchauffez le four à 200 ºC.

3 Farcissez l'intérieur du poulet avec le couscous, attachez les pattes avec
 de la ficelle de cuisine et posez la volaille dans un grand plat, sur une
 grille. Versez un peu d'eau au fond du plat. Badigeonnez le poulet de
 beurre fondu et faites-le rôtir au four, d'abord 15 minutes à 200 ºC,
 puis 1 h 30 à 180 ºC. Quand il est cuit, sortez-le du four et couvrez-le
 d'une feuille d'aluminium. Laissez-le reposer 20 minutes.

4 Pendant ce temps, étalez les tomates sur une plaque de cuisson
 légèrement huilée et faites-les rôtir au four pendant 20 minutes.

5 Mélangez les ingrédients de la salsa d'olives vertes dans un petit
 saladier.

6 Découpez le poulet, versez la farce dans un récipient et servez avec
 les tomates et la salsa d'olives vertes.

Coquelets aux épices et yaourt aux herbes

Pour 4 personnes
Préparation 30 minutes • Cuisson 25 minutes

4 coquelets de 500 g
2 c. à c. de cumin moulu
1 c. à c. de coriandre moulue
1/2 c. à c. de paprika fort
1/2 c. à c. de curcuma en poudre
1/4 de c. à c. de cannelle moulue
1 c. à c. de sel
1/2 c. à c. de poivre noir concassé
2 c. à s. d'huile d'olive
1 petit citron (140 g) détaillé en quartiers

Yaourt aux herbes
1/2 c. à c. de cumin moulu
1/4 de c. à c. de paprika fort
10 g de gingembre frais râpé
1 gousse d'ail écrasée
1 poignée de coriandre ciselée
1 poignée de persil plat ciselé
190 g de yaourt

1 Ouvrez les coquelets en les découpant de part et d'autre du bréchet.
 Aplatissez-les avec la paume de la main, côté peau tourné vers le haut.

2 Mélangez les épices et l'huile pour en badigeonner généreusement les
 coquelets. Disposez ces derniers sur un gril en fonte chaud légèrement
 huilé, couvrez-les d'une feuille d'aluminium et faites-les cuire
 15 minutes à feu moyen. Enlevez la feuille d'aluminium et laissez-les
 cuire encore 5 minutes sur la chair, puis 5 minutes sur la peau.

3 Pour le yaourt aux herbes, commencez par faire sauter à sec le cumin
 et le paprika dans une poêle puis mélangez-les dans un bol avec le
 gingembre, l'ail, les herbes et le yaourt.

4 Servez les coquelets avec le yaourt aux herbes et les quartiers de citron.
 Vous pouvez accompagner ce plat de couscous.

Salade d'agneau aux lentilles et aux épinards

Pour 4 personnes
Préparation 15 minutes • Cuisson 10 minutes

1 c. à c. de cannelle moulue
1 c. à c. de cumin moulu
1 c. à c. de piment moulu
1 c. à c. de coriandre moulue
60 ml d'huile d'olive
600 g de filet d'agneau
1/2 c. à c. de sel
1 oignon jaune moyen (150 g) haché
1 grosse carotte (180 g) coupée en dés
1 branche de céleri (100 g) coupée en dés
1 gousse d'ail écrasée
80 ml de bouillon de volaille
400 g de lentilles brunes en boîte rincées et égouttées
100 g de pousses d'épinards
2 poignées de coriandre fraîche

1 Formez une pâte avec les épices et 1 cuillerée à soupe d'huile d'olive. Étalez-en la moitié sur le filet d'agneau et saupoudrez de sel.

2 Faites cuire l'agneau sur un gril en fonte préchauffé. Quand il est à votre convenance, couvrez-le d'une feuille d'aluminium et laissez-le reposer 5 minutes avant de le découper.

3 Faites revenir dans le reste de l'huile l'oignon, la carotte et le céleri, jusqu'à ce que les légumes soient tendres. Ajoutez l'ail et le reste de la pâte aux épices. Laissez cuire à feu moyen, sans cesser de remuer, jusqu'à ce que le mélange embaume.

4 Versez le bouillon et les lentilles, réchauffez-les à feu moyen puis incorporez hors du feu les épinards et la coriandre. Servez l'agneau en tranches fines, avec les lentilles tièdes.

Agneau à la harissa maison et salade de couscous tiède

Pour 4 personnes
Préparation 40 minutes • Réfrigération 3 heures • Cuisson 1 h 30

30 piments rouges secs broyés
1 c. à c. de cumin moulu
1 c. à c. de coriandre moulue
1 c. à c. de graines de carvi
2 gousses d'ail écrasées
1 c. à c. de sel
1 c. à c. de sucre en poudre
90 g de purée de tomates
80 ml de l'huile d'olive
1 gigot d'agneau de 2 kg

Salade de couscous
500 g de potiron pelé et coupé en petits cubes
de l'huile végétale
400 g de couscous
60 g de petits pois décongelés
1 c. à s. de zeste de citron râpé
625 ml d'eau bouillante
1 petit oignon rouge (100 g) haché
2 poignées de persil plat frais ciselé
1 poignée de menthe fraîche ciselée
2 c. à s. d'huile d'olive
1 c. à s. de vinaigre de vin rouge
60 ml de jus de citron

1 Laissez gonfler les piments 1 heure dans l'eau bouillante puis égouttez-les en réservant 120 ml du liquide de trempage.

2 Faites sauter à sec dans une poêle le cumin, la coriandre et le carvi avant de les mixer avec les piments, le liquide réservé, l'ail, le sel, le sucre et la purée de tomates. Sans cesser de mixer, versez l'huile en filet fin et continu pour obtenir une pâte lisse. Réservez 80 ml de cette harissa.

3 Piquez la viande avec la pointe d'un couteau. Déposez-la dans un plat, étalez dessus la harissa, en pressant bien pour qu'elle pénètre dans les incisions, couvrez et réfrigérez au moins 3 heures.

4 Préchauffez le four à 200 °C.

5 Posez l'agneau sur une grille, dans un grand plat allant au four, versez 5 mm d'eau dans le fond du plat et faites rôtir 1 heure au four. Quand le gigot est cuit à votre convenance, sortez-le du four et couvrez-le d'une feuille d'aluminium. Laissez-le reposer 20 minutes avant de servir.

6 Pour la salade de couscous, faites rôtir au four le potiron, pendant 30 minutes environ, après l'avoir mélangé avec un peu d'huile végétale. Mettez le couscous dans un récipient avec les petits pois et le zeste de citron, couvrez d'eau bouillante et laissez gonfler 5 minutes.

7 Quand tout le liquide est absorbé, aérez la graine à la fourchette puis incorporez le potiron, l'oignon et les herbes. Fouettez l'huile d'olive, le vinaigre et le jus de citron, versez cette sauce sur le couscous et remuez délicatement. Servez avec le gigot d'agneau découpé en tranches fines.

Pratique La harissa est une pâte très relevée préparée avec des piments rouges séchés, de l'ail, de l'huile d'olive et des graines de carvi. On la trouve toute prête dans tous les commerces mais celle préparée maison est vraiment meilleure.

Bœuf grillé aux olives
avec couscous aux agrumes

Pour 4 personnes
Préparation 15 minutes • Cuisson 20 minutes

2 gousses d'ail écrasées
1 c. à c. de gingembre moulu
1 c. à s. de cumin moulu
2 c. à c. de coriandre moulue
1 tranche épaisse de rumsteck (500 g)
1 c. à s. de harissa
250 ml de bouillon de bœuf
200 g d'olives vertes dénoyautées légèrement écrasées
2 poignées de coriandre fraîche ciselée

Couscous aux agrumes
2 oranges moyennes (480 g)
250 ml d'eau
250 ml de jus d'orange
400 g de couscous
35 g d'amandes effilées grillées
1 c. à s. de citron confit haché en petits dés
1 petit oignon rouge (100 g) en tranches fines
500 g de radis roses nettoyés et émincés

1 Mélangez l'ail et les épices dans un saladier. Frottez la viande avec
 les deux tiers de ce mélange (réservez le reste) avant de la saisir sur
 un gril en fonte très chaud. Couvrez d'une feuille d'aluminium et laissez
 reposer 10 minutes.

2 Pour le couscous, commencez par peler à vif les oranges puis détaillez-
 les en tranches très fines. Portez à ébullition l'eau et le jus d'orange,
 retirez la casserole du feu, versez le couscous, couvrez et laissez gonfler
 5 minutes. Aérez la graine à la fourchette avant d'ajouter les oranges et
 le reste des ingrédients. Remuez délicatement.

3 Faites chauffer dans une poêle la harissa et le mélange d'épices réservé,
 mouillez avec le bouillon et portez à ébullition. Laissez frémir 3 minutes
 pour que la sauce réduise de moitié. Hors du feu, incorporez les olives
 et la coriandre fraîche.

4 Détaillez la viande en tranches fines et servez-la nappée de sauce,
 avec le couscous aux agrumes.

Pratique Les citrons confits sont conservés plusieurs mois dans des
 bocaux avec du sel et du jus de citron ou de l'huile. Ils ont un parfum
 subtil mais intense. Rincez-les soigneusement avant d'en retirer la chair
 pour ne conserver que le zeste.

VOLAILLES, VIANDES ET POISSONS

Boulettes d'agneau et carottes à la tunisienne

Pour 4 personnes
Préparation 15 minutes • Cuisson 15 minutes

500 g de viande d'agneau hachée
70 g de chapelure
1 poignée de menthe fraîche ciselée
1 c. à c. de poivre de la Jamaïque moulu
1 c. à c. de coriandre moulue
1 c. à c. de poivre noir concassé
1 c. à s. de jus de citron
190 g de yaourt

Carottes à la tunisienne
3 grosses carottes (540 g)
60 ml de jus de citron
1 c. à s. d'huile d'olive
1/2 c. à c. de cannelle moulue
1/2 c. à c. de coriandre moulue
1 poignée de menthe fraîche
35 g de pistaches grillées
40 g de raisins secs

1 Mélangez la viande hachée, la chapelure, la menthe, les épices et le jus de citron dans un saladier. Façonnez 12 boulettes que vous aplatissez ensuite légèrement avant de les faire dorer à la poêle dans un peu d'huile chaude.

2 Détaillez les carottes en tronçons de 5 cm que vous découpez ensuite en très fines tranches dans la longueur. Faites-les dorer sur une plaque en fonte légèrement huilée ; elles doivent rester croquantes. Mettez-les ensuite dans un saladier avec l'huile d'olive, la cannelle, la coriandre, la menthe, les pistaches et les raisins secs.

3 Répartissez les carottes sur les assiettes de service, ajoutez les boulettes de viande et servez avec le yaourt présenté dans des coupelles.

Rougets grillés en papillotes

Pour 4 personnes
Préparation 25 minutes • Cuisson 20 minutes

1 c. à c. de cannelle moulue
1 c. à c. de safran en filaments
1 c. à c. de coriandre moulue
1 c. à c. de gingembre moulu
2 c. à s. d'huile d'olive
60 ml d'eau
2 c. à s. de jus de citron
4 gros rougets (1,5 kg)
30 g de gingembre frais
4 oignons verts en tranches fines
1 piment rouge frais détaillé en petits dés
2 poignées de coriandre fraîche
400 g de petites pommes de terre nouvelles en tranches fines

1 Faites chauffer à sec les épices dans une poêle. Quand ils embaument,
 versez l'huile et remuez vivement. Mouillez ensuite cette pâte avec l'eau
 pour la diluer et incorporez le jus de citron. Faites deux entailles sur
 chaque flanc des poissons et enduisez-les généreusement de cette pâte
 d'épices tiède.

2 Pelez le gingembre frais et détaillez-le en bâtonnets. Mélangez-le avec
 l'oignon, le piment et la coriandre fraîche.

3 Découpez huit grands carrés de papier sulfurisé et superposez-les deux
 à deux sur le plan de travail. Répartissez quelques pommes de terre
 au centre de chaque carré, posez un poisson dessus et garnissez du
 mélange au gingembre. Refermez les papillotes sans trop les serrer.

4 Faites cuire les poissons en papillotes 20 minutes à feu moyen sur un
 gril en fonte préchauffé et généreusement huilé. Ouvrez les papillotes
 et faites glisser les poissons, les pommes de terre et la garniture au
 gingembre sur des assiettes chaudes. Servez sans attendre.

Pratique Si vous voulez soigner la décoration, utilisez des feuilles de
 bananier pour les papillotes. Vous les plongerez quelques minutes
 dans de l'eau bouillante pour les assouplir avant d'en envelopper les
 poissons.

Agneau za'atar et légumes braisés aux pois chiches

Pour 4 personnes
Trempage 12 heures • Préparation 45 minutes
Réfrigération 30 minutes • Cuisson 40 minutes

200 g de pois chiches secs
1 feuille de laurier
800 g de filet d'agneau
60 ml d'huile d'olive
1 c. à s. de sumac
1 c. à s. de graines de sésame grillées
1 c. à c. de thym sec
1 c. à c. d'origan sec
1 c. à c. de marjolaine sèche
1 c. à c. de paprika doux
20 g de beurre
12 petits oignons (300 g) découpés en deux
1 grosse carotte (180 g) détaillée en dés
2 branches de céleri (200 g) détaillées en dés
2 petits bulbes de fenouil (400 g) en tranches très fines
4 grosses poignées de persil frais

Assaisonnement
1 c. à s. de sumac
1 c. à c. de moutarde forte
60 ml d'huile d'olive
60 ml de jus de citron

1 Faites tremper les pois chiches toute une nuit dans l'eau froide. Égouttez-les bien avant de les faire cuire dans l'eau bouillante avec le laurier. Rincez-les à l'eau froide puis égouttez-les.

2 Mélangez dans un plat 2 cuillerées à soupe d'huile d'olive, le sumac, les graines de sésame, les aromates secs et le paprika. Retournez le filet d'agneau plusieurs fois dans ce mélange pour qu'il en soit recouvert puis laissez-le mariner 30 minutes au frais.

3 Préparez l'assaisonnement en mélangeant tous les ingrédients dans un récipient.

4 Faites revenir l'oignon 10 minutes dans le beurre et le reste de l'huile. Quand il commence à se colorer, ajoutez la carotte, le céleri et le fenouil. Laissez cuire quelques minutes à feu doux ; les légumes doivent rester un peu croquants.

5 Faites cuire le filet d'agneau sur un gril en fonte préchauffé. Quand il est à votre convenance, retirez-le du gril et couvrez-le d'une feuille d'aluminium. Laissez-le reposer 5 minutes.

6 Pendant ce temps, réchauffez rapidement les pois chiches avec le persil, les légumes et la moitié de l'assaisonnement. Répartissez ce mélange sur les assiettes de service et versez le reste de sauce. Coupez le filet d'agneau en tranches fines pour en garnir la salade tiède.

Filet de bœuf aux épices
et salade de pois chiches et citron confit

Pour 4 personnes
Préparation 20 minutes • Marinade 20 minutes • Cuisson 15 minutes

1 c. à c. de graines de coriandre
1 c. à c. de graines de nigelle
1 c. à c. de piment moulu
1 c. à c. de sel marin
1 gousse d'ail écrasée
600 g de filet de bœuf
6 grosses tomates olivettes (540 g) pelées
425 g de pois chiches en boîte rincés et égouttés
2 c. à s. de zeste de citron confit coupé en dés
3 grosses poignées de persil plat frais
3 grosses poignées de coriandre fraîche
1 c. à s. de jus de citron

1 Pilez dans un mortier les graines de coriandre et nigelle, le piment, le sel
 et l'ail. Frottez-en le filet de bœuf, couvrez et laissez reposer 20 minutes
 au réfrigérateur.

2 Épépinez les tomates et coupez-les en petits dés. Mettez-les dans un
 saladier avec les pois chiches, le zeste de citron confit, les herbes et le
 jus de citron.

3 Saisissez le filet de bœuf sur un gril en fonte légèrement huilé. Quand il
 est cuit à votre convenance, mettez-le dans un plat et couvrez-le d'une
 feuille d'aluminium. Laissez-le reposer 10 minutes avant de le découper
 en tranches fines. Servez avec la salade.

Filets de poisson à la marocaine

Pour 4 personnes
Préparation 20 minutes • Cuisson 15 minutes

1 gousse d'ail écrasée
5 g de gingembre frais râpé
1 c. à c. de cumin moulu
1/2 c. à c. de curcuma en poudre
1/2 c. à c. de paprika fort
1/2 c. à c. de coriandre moulue
4 filets de poisson blanc de 200 g sans la peau
1 c. à s. d'huile d'olive

Couscous aux fruits
400 g de couscous
50 g de beurre en petits dés
500 ml d'eau bouillante
1 grosse poire (330 g) coupée en dés
80 g d'abricots secs hachés
95 g de figues sèches en petits cubes
2 poignées de persil plat frais ciselé
40 g de pignons grillés

1 Frottez les filets de poisson du mélange d'ail, gingembre et épices.
 Versez l'huile dans une poêle chaude et faites cuire le poisson en le
 retournant délicatement à mi-cuisson.

2 Mélangez le couscous et les dés de beurre dans un récipient, versez
 l'eau bouillante, couvrez et laissez gonfler 5 minutes environ. Quand
 tout le liquide est absorbé, aérez la graine à la fourchette puis
 incorporez le reste des ingrédients.

3 Répartissez le couscous et les filets de poisson sur les assiettes de
 service. Vous pouvez accompagner ce plat de quartiers de citron et de
 fromage blanc battu avec de la coriandre fraîche ciselée, sel et poivre.

Tajines et ragoûts

Tajine de bœuf aux pruneaux

Pour 4 personnes
Préparation 20 minutes • Cuisson 2 h 30

2 gros oignons rouges (600 g) hachés
2 c. à s. d'huile d'olive
1 c. à c. de poivre noir concassé
1 pincée de filaments de safran
1 c. à s. de cannelle moulue + 1 pincée pour les pruneaux
1/4 de c. à c. de gingembre en poudre
1 kg de palette de bœuf en cubes de 4 cm
50 g de beurre coupé en petits dés
425 g de tomates concassées en boîte
250 ml d'eau
2 c. à s. de sucre en poudre
100 g d'amandes effilées grillées
250 g de pruneaux dénoyautés
1 c. à c. de zeste de citron râpé

Couscous aux épinards
300 g de couscous
375 ml d'eau bouillante
80 g de pousses d'épinards ciselées

1 Mélangez les oignons, l'huile et les épices dans un récipient, ajoutez les morceaux de bœuf et retournez-les plusieurs fois dans cet assaisonnement.

2 Portez l'eau à ébullition dans une cocotte puis ajoutez le beurre, les tomates avec leur jus, la moitié du sucre, 75 g d'amandes et les morceaux de bœuf. Couvrez et laissez mijoter 1 h 30 à petit feu. Prélevez 250 ml de liquide de cuisson et laissez mijoter encore 30 minutes.

3 Faites gonfler les pruneaux 20 minutes dans un peu d'eau bouillante avant de les égoutter. Mettez-les dans une casserole avec la cannelle, le reste de sucre et le liquide de cuisson réservé. Portez à ébullition puis laissez épaissir 15 minutes à petit feu ; les pruneaux doivent être fondants sans se défaire. Incorporez-les au tajine.

4 Pour le couscous aux épinards, faites gonfler la graine 5 minutes dans l'eau bouillante, en la couvrant. Aérez-la à la fourchette avant d'incorporer les épinards.

5 Répartissez le reste des amandes sur le tajine et servez avec le couscous.

Tradition de l'Afrique du Nord, le tajine est un ragoût mijoté. On le prépare généralement dans un plat en terre qui a donné son nom à cette recette. Mais on peut aussi le faire cuire dans une cocotte en fonte.

Tajine de poulet aux olives et au citron confit

Pour 8 personnes
Trempage 12 heures • Préparation 30 minutes • Cuisson 2 h 30

200 g de pois chiches secs
2 c. à s. de farine de ménage
2 c. à c. de paprika fort
8 pilons de poulet (1,2 kg)
8 hauts de cuisse de poulet sans la peau (1,6 kg)
40 g de beurre
2 oignons rouges moyens (340 g) en tranches épaisses
3 gousses d'ail écrasées
1 c. à c. de graines de cumin
1/2 c. à c. de curcuma en poudre
1/2 c. à c. de coriandre moulue
1/4 de c. à c. de filaments de safran
1 c. à c. de piment moulu
1 c. à c. de gingembre en poudre
750 ml de bouillon de volaille
2 c. à s. de zeste de citron confit en fines lamelles
40 g d'olives vertes dénoyautées
2 c. à s. de coriandre fraîche ciselée

Riz à la tunisienne
100 g de riz blanc à longs grains
20 g de beurre
1,5 litre d'eau

1 Faites gonfler les pois chiches toute une nuit dans un saladier d'eau froide. Rincez-les puis laissez-les cuire 40 minutes dans une casserole d'eau bouillante.

2 Préchauffez le four à 160 °C.

3 Retournez les morceaux de poulet dans un mélange de farine et de paprika avant de les faire colorer dans le beurre fondu, dans une grande cocotte. Sortez-les de la cocotte et faites revenir les oignons à la place. Quand ils sont tendres, ajoutez l'ail, le cumin, le curcuma, la coriandre moulue, le safran, le piment et le gingembre. Laissez cuire quelques minutes en remuant, jusqu'à ce que le mélange embaume.

4 Remettez les morceaux de poulet dans la cocotte, versez le bouillon et portez à ébullition. Couvrez et enfournez 30 minutes. Ajoutez les pois chiches et les épices, mélangez, couvrez à nouveau et remettez encore 1 heure au four.

5 Pour préparer le riz, commencez par le rincer abondamment à l'eau froide. Faites fondre le beurre dans une casserole, ajoutez le riz bien égoutté et remuez. Versez l'eau, portez à ébullition, couvrez partiellement et laissez frémir 10 minutes. Réduisez le feu au maximum, ajustez le couvercle et continuez la cuisson pendant encore 10 minutes. Enlevez la casserole du feu pour laisser reposer le riz 10 minutes sans jamais soulever le couvercle. Mélangez-le délicatement avec une fourchette.

6 Sortez le tajine du four pour incorporer le citron confit, les olives et la coriandre fraîche. Servez sans attendre avec le riz à la tunisienne.

Tajine de pois chiches et légumes

Pour 4 personnes
Préparation 15 minutes • Cuisson 20 minutes

2 c. à s. d'huile d'olive
2 gros oignons jaunes (400 g) en tranches épaisses
2 gousses d'ail écrasées
2 c. à c. de coriandre moulue
1 c. à c. de cumin moulu
1 c. à c. de paprika doux
2 petits bâtons de cannelle
1 pincée de safran en poudre
2 petits piments rouges frais hachés
2 jeunes aubergines (120 g) coupées en cubes
800 g de potiron pelé et coupé en cubes
400 g de tomates concassées en boîte
250 ml de bouillon de volaille
500 ml d'eau
200 g de pois chiches en boîte rincés et égouttés
2 grosses courgettes (300 g) en tranches épaisses
2 poignées de coriandre fraîche
1 c. à s. de jus de citron

Couscous
250 ml de bouillon de volaille
250 ml d'eau
60 g de beurre
300 g de couscous

1 Faites revenir l'oignon et l'ail quelques minutes dans l'huile. Incorporez les épices, remuez, ajoutez ensuite les aubergines et mélangez à nouveau.

2 Quand les épices embaument, mettez le potiron, les tomates et les pois chiches dans la sauteuse, versez l'eau et le bouillon, portez à ébullition. Couvrez et laissez mijoter 10 minutes avant d'incorporer les courgettes. Faites cuire encore 5 minutes pour que tous les légumes soient tendres.

3 Pour préparer le couscous, portez à ébullition l'eau et le bouillon, ajoutez le beurre, laissez-le fondre puis versez le couscous. Remuez, couvrez et laissez gonfler 5 minutes. Quand tout le liquide est absorbé, aérez la graine à la fourchette.

4 Ajoutez la coriandre fraîche et le jus de citron dans le tajine, mélangez doucement et servez avec le couscous.

Tajine de poulet aux dattes et au miel

Pour 4 personnes
Préparation 25 minutes • Cuisson 1 h 45

1 kg de blancs de poulet
2 c. à s. d'huile d'olive
2 oignons jaunes moyens (300 g) en tranches fines
4 gousses d'ail écrasées
1 c. à c. de graines de cumin
1 c. à c. de coriandre moulue
1 c. à c. de gingembre en poudre
1 c. à c. de curcuma en poudre
1 c. à c. de cannelle moulue
1/2 c. à c. de piment en poudre
1/4 de c. à c. de noix de muscade râpée
375 ml de bouillon de volaille
250 ml d'eau
70 g de dattes dénoyautées et coupées en deux
90 g de miel
80 g d'amandes effilées grillées
1 c. à s. de coriandre fraîche ciselée

1 Coupez les blancs de poulet en aiguillettes de 3 cm et faites-les colorer dans 1 cuillerée à soupe d'huile. Égouttez sur du papier absorbant.

2 Versez le reste d'huile dans la cocotte pour y faire revenir les oignons, l'ail et les épices.

3 Quand les oignons sont fondus, remettez la viande dans la cocotte et versez le bouillon et l'eau. Couvrez et laissez mijoter 1 heure. Retirez le couvercle et laissez cuire encore 30 minutes à feu doux pour faire épaissir la sauce. Ajoutez alors les dattes, le miel et les amandes. Parsemez de coriandre fraîche au moment de servir.

Pratique Vous pouvez préparer ce tajine quelques heures à l'avance et le réchauffer avant de servir. Il se congèle aussi très bien ; dans ce cas, supprimez la coriandre fraîche et les amandes (vous les ajouterez tout à la fin dans le tajine réchauffé).

Tajine d'agneau aux abricots

Pour 8 personnes
Trempage 45 minutes • Préparation 20 minutes • Cuisson 1 heure

250 g d'abricots secs
180 ml de jus d'orange
125 ml d'eau bouillante
2 c. à s. d'huile d'olive
900 g de viande d'agneau détaillée en cubes
2 poivrons rouges moyens (400 g) détaillés en dés
1 gros oignon jaune (200 g) haché
800 g de potiron pelé et coupé en gros cubes
3 gousses d'ail écrasées
1 c. à c. de cannelle moulue
2 c. à c. de cumin moulu
2 c. à c. de coriandre moulue
1 litre de bouillon de volaille
2 c. à s. de miel
4 poignées de coriandre fraîche
200 g de yaourt allégé

Couscous aux agrumes
1 litre d'eau
800 g de couscous
1 c. à s. de zeste d'orange râpé
2 c. à c. de zeste de citron râpé
2 c. à c. de zeste de citron vert râpé

1 Mettez les abricots dans un récipient, versez l'eau bouillante et le jus d'orange, couvrez et laissez gonfler 45 minutes.

2 Faites colorer la viande dans la moitié de l'huile, dans une grande cocotte, puis réservez-la au chaud.

3 Versez le reste d'huile dans la cocotte pour faire revenir les poivrons, les oignons, le potiron, l'ail et les épices moulues. Versez ensuite une louche de bouillon, mélangez bien, portez à ébullition et laissez frémir 5 minutes pour que le liquide réduise de moitié.

4 Remettez la viande dans la cocotte avec les abricots, le reste du bouillon et le miel. Après l'ébullition, couvrez et laissez mijoter 50 minutes ; la viande doit être fondante. Ajoutez alors la coriandre fraîche hors du feu.

5 Pour préparer le couscous, faites bouillir l'eau, ajoutez la graine et les zestes d'agrumes, mélangez, couvrez et laissez gonfler 5 minutes environ. Aérez la graine à la fourchette. Servez le couscous avec le tajine.

Souris d'agneau au potiron

Pour 4 personnes
Préparation 20 minutes • Cuisson 2 h 55

8 souris d'agneau (2 kg)
2 c. à s. de farine de ménage
60 ml d'huile d'olive
2 oignons jaunes moyens (300 g) hachés
3 gousses d'ail écrasées
1 c. à c. de cannelle moulue
2 c. à c. de cumin moulu
2 c. à c. de coriandre moulue
250 ml d'eau bouillante
1 litre de bouillon de volaille
2 c. à s. de miel
500 g de potiron coupé en gros cubes

Couscous aux olives et amandes
300 g de couscous
375 ml d'eau bouillante
20 g de beurre
2 c. à s. de citron confit détaillé en dés
90 g d'olives vertes grossièrement hachées
2 grosses poignées de persil plat frais ciselé
45 g d'amandes effilées grillées
1 poivron vert moyen (200 g) détaillé en dés

1 Préchauffez le four à 180 °C.

2 Farinez les souris d'agneau avant de les faire dorer dans l'huile chaude, dans une grande cocotte. Égouttez-les sur du papier absorbant.

3 Dans la même cocotte, faites revenir l'oignon et l'ail quelques minutes, ajoutez la cannelle, le cumin et la coriandre et mélangez encore. Quand l'oignon est tendre, versez l'eau et portez à ébullition. Quand le liquide a réduit de moitié, incorporez le bouillon et le miel. Portez à ébullition. Remettez les souris d'agneau dans la cocotte, couvrez et faites cuire 1 h 30 au four en retournant de temps en temps la viande pour qu'elle cuise uniformément. Retirez le couvercle, ajoutez dans la cocotte les cubes de potiron et prolongez la cuisson de 50 minutes environ.

4 Mettez la viande et les légumes dans un grand plat et couvrez-les pour qu'ils restent chauds. Faites épaissir le fond de sauce à petits bouillons pendant 15 minutes, en remuant souvent.

5 Pendant ce temps, préparez le couscous. Versez la graine dans l'eau bouillante, ajoutez le beurre, couvrez et laissez gonfler 5 minutes environ. Remuez avec une fourchette avant d'incorporer le reste des ingrédients.

6 Versez la sauce sur la viande et servez sans attendre avec le couscous.

Pratique La recette originale ne comporte pas d'alcool mais vous pouvez l'adapter et la rendre plus parfumée en remplaçant l'eau par la même quantité de vin rouge.

Tajine d'agneau aux coings et couscous aux pistaches

Pour 4 personnes
Préparation 20 minutes • Cuisson 1 h 30

40 g de beurre
600 g de viande d'agneau en cubes
1 oignon rouge moyen (170 g) haché
2 gousses d'ail écrasées
1 petit bâton de cannelle
2 c. à c. de coriandre moulue
1 c. à c. de cumin moulu
1 c. à c. de gingembre en poudre
1 c. à c. de piment moulu
375 ml d'eau
400 g de tomates concassées en boîte
2 coings moyens (700 g) pelés, évidés et coupés en quartiers
1 grosse courgette (150 g) en tronçons
2 c. à s. de coriandre fraîche ciselée

Couscous aux pistaches

300 g de couscous
250 ml d'eau bouillante
20 g de beurre mou
2 poignées de coriandre fraîche ciselée
35 g de pistaches grillées grossièrement broyées

1 Faites colorer la viande dans le beurre puis réservez-la au chaud. Dans la même cocotte, ajoutez l'oignon et l'ail, laissez fondre à feu moyen puis versez toutes les épices. Remuez avec une cuillère en bois jusqu'à ce que le mélange embaume.

2 Remettez alors la viande dans la cocotte, versez l'eau, ajoutez les tomates avec leur jus et les quartiers de coings. Couvrez et laissez mijoter 30 minutes après l'ébullition, puis 1 heure sans couvercle pour que la sauce épaississe.

3 Ajoutez la courgette et faites cuire encore 10 minutes.

4 Pour le couscous, faites gonfler la graine 5 minutes dans l'eau avec le beurre coupé en morceaux. Remuez de temps en temps avec une fourchette. Quand tout le liquide est absorbé, incorporez la coriandre et les pistaches.

5 Parsemez le tajine de coriandre fraîche et servez-le aussitôt avec le couscous.

Tajine de poulet aux pruneaux

Pour 8 personnes
Préparation 20 minutes • Cuisson 1 h 30

2 c. à s. d'huile d'olive
2 kg de cuisses de poulet désossées et sans la peau
3 c. à c. de graines de cumin
3 c. à c. de coriandre moulue
1 c. à s. de paprika fumé
3 c. à c. de cumin moulu
4 petits bâtons de cannelle
4 oignons jaunes moyens (600 g) en tranches fines
8 gousses d'ail écrasées
1 litre de bouillon de volaille
170 g de pruneaux dénoyautés
80 g d'amandes mondées grillées
1 poignée de persil plat frais grossièrement ciselé

1 Recoupez les morceaux de poulet en deux ou en trois avant de les faire
 colorer dans l'huile chaude, dans une grande cocotte.

2 Faites sauter à sec les épices dans une petite poêle.

3 Sortez la viande de la cocotte pour y faire revenir l'oignon et l'ail.
 Ajoutez ensuite les épices, mélangez 1 minute sur le feu, remettez
 la viande dans la cocotte, versez le bouillon et portez à ébullition.
 Couvrez et laissez mijoter 40 minutes.

4 Mettez les pruneaux dans la cocotte et continuez la cuisson pendant
 20 minutes sans couvrir pour que le fond de cuisson épaississe un peu.
 Décorez d'amandes et de persil avant de servir.

Pratique La recette originale ne comporte pas d'alcool mais vous pouvez
 l'adapter et la rendre plus parfumée en remplaçant 250 ml de bouillon
 par la même quantité de vin rouge.

Tajine de potiron et haricots verts

Pour 6 personnes
Préparation 30 minutes • Cuisson 30 minutes

20 g de beurre
1 c. à s. d'huile d'olive
2 oignons jaunes moyens (300 g) hachés
2 gousses d'ail écrasées
20 g de gingembre frais râpé
2 c. à c. de cumin moulu
2 c. à s. de coriandre moulue
2 c. à c. de zeste de citron râpé
1 kg de chair de potiron en cubes
400 g de tomates concassées en boîte
500 ml de bouillon de légumes
400 g de haricots verts coupés en deux
55 g de raisins secs
1 c. à s. de miel
1 poignée de persil plat frais ciselé
1 poignée de menthe fraîche ciselée

Couscous à la harissa et aux amandes
500 ml de bouillon de volaille
250 ml d'eau
600 g de couscous
70 g d'amandes effilées grillées
1 c. à s. de harissa

1 Faites fondre le beurre dans une cocotte, ajoutez l'huile et laissez
 revenir l'ail et l'oignon. Réchauffez ensuite dans ce mélange le
 gingembre, les épices et le zeste de citron. Quand leurs arômes
 se dégagent, ajoutez le potiron, les tomates avec leur jus et le bouillon.
 Portez à ébullition, couvrez et laissez mijoter 15 minutes.

2 Ajoutez les haricots et laissez cuire encore 5 minutes ; ils doivent être
 juste tendres.

3 Pour préparer le couscous, faites bouillir l'eau et le bouillon, ajoutez la
 semoule, couvrez et laissez gonfler 5 minutes en remuant de temps en
 temps avec une fourchette. Délayez la harissa dans un peu d'eau avant
 de l'incorporer au couscous avec les amandes.

4 Retirez le tajine du feu pour y ajouter les raisins secs, le miel et les
 herbes. Servez avec le couscous.

Tajine de poulet aux coings

Pour 4 personnes
Préparation 25 minutes • Cuisson 1 h 50

2 coings moyens (700 g) pelés, évidés et coupés en quartiers
40 g de beurre
115 g de miel
750 ml d'eau
2 c. à c. d'eau de fleur d'oranger
2 c. à c. d'huile d'olive
4 pilons de poulet (600 g)
4 hauts de cuisse de poulet (800 g) sans la peau
1 gros oignon jaune (200 g) haché
3 gousses d'ail écrasées
1 c. à c. de cumin moulu
1 c. à c. de gingembre en poudre
1 pincée de filaments de safran
500 ml de bouillon de volaille
2 grosses courgettes (300 g) en tronçons

Couscous aux herbes
300 g de couscous
375 ml d'eau bouillante
50 g de pousses d'épinards ciselées
2 oignons verts en tranches fines
2 c. à s. de coriandre fraîche ciselée

1 Mettez les coings dans une casserole avec le beurre, le miel, l'eau
 et l'eau de fleur d'oranger. Après l'ébullition, laissez frémir 1 heure à
 couvert, puis 45 minutes sans couvrir, en remuant de temps à autre.
 Les fruits doivent être roses et tendres.

2 Faites colorer les morceaux de poulet dans l'huile puis égouttez-les sur
 du papier absorbant. À la place, faites revenir l'oignon, l'ail et les épices.
 Quand l'oignon est tendre, remettez la viande dans la cocotte avec le
 bouillon et portez à ébullition. Laissez mijoter 20 minutes à couvert,
 puis 20 minutes sans couvrir. Quand la viande est cuite, ajoutez les
 courgettes. Remettez sur le feu encore 10 minutes avant d'incorporer
 les coings et 125 ml de leur sirop de cuisson.

3 Faites gonfler le couscous dans l'eau bouillante pendant 5 minutes.
 Quand tout le liquide est absorbé, mélangez avec une fourchette avant
 d'ajouter les épinards, les oignons et la coriandre. Servez avec le tajine.

Agneau et gombos à la sauce tomate

Pour 4 personnes
Préparation 20 minutes • Cuisson 2 h 10

1 c. à s. d'huile d'olive
1 kg d'épaule d'agneau désossée et coupée en cubes
2 gros oignons jaunes (300 g) hachés
7 tomates moyennes (1 kg) grossièrement concassées
1 litre d'eau
200 g de gombos

Confit d'ail aux épices
1 c. à c. de graines de coriandre
1/2 c. à c. de graines de cardamome
1 piment sec
1 c. à c. de gros sel
30 g de beurre
5 gousses d'ail en tranches fines

1 Faites colorer l'agneau dans l'huile puis réservez-le au chaud.

2 Dans la même cocotte, faites revenir l'oignon jusqu'à ce qu'il soit tendre.
 Ajoutez les tomates et l'eau, portez à ébullition, remettez la viande
 dans la cocotte et laissez mijoter 1 h 45 sans couvrir pour que la sauce
 épaississe.

3 Incorporez les gombos et laissez cuire encore 15 minutes.

4 Pour préparer le confit d'ail, commencez par piler les épices dans
 un mortier avant de les faire revenir 15 minutes dans le beurre avec
 les tranches d'ail. La cuisson doit se faire à feu doux en mélangeant tout
 le temps pour que l'ail soit confit.

5 Servez la viande avec le confit d'ail. Accompagnez ce plat de riz blanc
 et de feuilles de menthe.

Tajine de poisson

Pour 4 personnes
Préparation 20 minutes • Cuisson 40 minutes

2 c. à s. d'huile d'olive
2 gros oignons jaunes (400 g) hachés
6 gousses d'ail hachées
1 petit piment rouge frais haché
4 filets d'anchois égouttés et émincés
3 grosses poignées de persil plat frais ciselé
4 poignées de coriandre fraîche ciselée
3 grosses poignées de menthe fraîche ciselée
2 branches de céleri (200 g) en tranches fines
2 c. à c. de cumin moulu
800 g de tomates concassées en boîte
4 darnes de poisson (1 kg)
1 citron moyen (140 g) détaillé en quartiers
2 c. à s. de feuilles de persil plat

Salade de tomates aux herbes
5 tomates moyennes (750 g) coupées en petits cubes
2 c. à s. de menthe fraîche ciselée
1 poignée de persil plat frais ciselé
2 c. à s. d'aneth frais ciselé
2 gousses d'ail écrasées
2 c. à s. de jus de citron
1 c. à s. d'huile d'olive
2 c. à c. de vinaigre de vin rouge

1 Préchauffez le four à 200 °C.

2 Faites revenir dans l'huile chaude l'oignon, l'ail et le piment. Ajoutez les anchois, les herbes ciselées, le céleri et le cumin. Laissez revenir 5 minutes en remuant.

3 Versez les tomates sans les égoutter et portez à ébullition. Plongez les darnes de poisson dans cette sauce sans les superposer et faites cuire 20 minutes à feu doux après l'ébullition. La sauce doit réduire largement.

4 Pour la salade, mélangez les tomates et les herbes ciselées dans un grand plat. Fouettez l'huile, le vinaigre, l'ail et le jus de citron dans un bol, versez cet assaisonnement sur la salade et remuez délicatement.

5 Disposez les darnes de poisson et les quartiers de citron sur les assiettes de service. Nappez généreusement de sauce et décorez de persil plat. Servez la salade à part.

Desserts et thés

Salade de pêches et de dattes

Pour 6 personnes
Préparation 10 minutes • Cuisson 5 minutes • Réfrigération 2 heures

125 ml d'eau
125 ml de sucre en poudre
1 pincée de filaments de safran
4 gousses de cardamome
80 ml de jus de citron
1 c. à c. d'eau de fleur d'oranger
6 grosses pêches (1,5 kg) en tranches épaisses
12 dattes fraîches (250 g) coupées en quatre
280 g de yaourt

1 Faites dissoudre le sucre dans l'eau à feu doux, avec le safran et la cardamome. Portez à ébullition et laissez frémir 5 minutes pour que le sirop épaississe. Mettez-le ensuite à refroidir 10 minutes avant d'ajouter le jus de citron et l'eau de fleur d'oranger.

2 Disposez les pêches et les dattes dans un saladier. Versez le sirop sur les fruits en le passant dans un tamis fin pour éliminer les éléments solides. Réfrigérez 2 heures.

3 Servez la salade de fruits avec le yaourt.

Nectarines pochées
et croquants aux amandes

Pour 4 personnes
Préparation 25 minutes • Réfrigération 3 heures • Cuisson 1 h 20

750 g d'eau
220 g de sucre en poudre
1 étoile de badiane
1 lanière de 10 cm de zeste d'orange
8 petites nectarines (800 g)
190 g de yaourt

Croquants aux amandes
2 blancs d'œufs
75 g de sucre en poudre
110 g de farine de ménage
1 c. à c. de zeste d'orange finement râpé
120 g d'amandes mondées

1 Préparez les croquants aux amandes la veille. Battez les œufs en neige puis versez graduellement le sucre, 1 cuillerée à la fois, en fouettant bien entre chaque ajout. Incorporez ensuite la farine, le zeste d'orange râpé et les amandes. Étalez cette pâte dans un moule chemisé de papier sulfurisé et faites cuire 30 minutes au four (180 °C). Attendez que le gâteau soit froid pour le démouler et l'envelopper dans du papier d'aluminium. Mettez-le au moins 3 heures au réfrigérateur puis coupez-le en tranches fines et laissez dorer ces dernières 15 minutes au four à 150 °C.

2 Préparez ensuite les nectarines. Faites dissoudre le sucre à feu doux dans l'eau, avec la badiane et le zeste d'orange. Laissez bouillir 2 minutes, ajoutez les nectarines et continuez la cuisson 20 minutes à petit feu. Laissez tiédir les fruits 10 minutes avant de les sortir du sirop avec une écumoire pour les transférer dans les coupes de service.

3 Faites bouillir à nouveau le sirop pendant 5 minutes pour qu'il réduise des deux tiers. Versez-le alors dans un petit saladier. Quand il est tiède, nappez-en les nectarines. Servez avec le yaourt et les croquants aux amandes.

Prunes et figues rôties au miel

Pour 4 personnes
Préparation 5 minutes • Cuisson 8 minutes

8 petites prunes (600 g) dénoyautées et coupées en deux
6 figues moyennes (360 g) coupées en deux
115 g de miel liquide
2 c. à s. de cassonade
190 g de yaourt

1 Préchauffez le gril du four. Disposez les fruits dans un grand plat, arrosez-les avec la moitié du miel et saupoudrez-les de sucre. Faites-les dorer au four.

2 Répartissez les fruits sur les assiettes de service, nappez-les du reste de miel et de jus de cuisson. Servez avec le yaourt.

Gâteau de riz aux coings pochés

Pour 4 personnes
Préparation 20 minutes • Cuisson 2 h 20

1,25 litre d'eau
1 kg de sucre en poudre + 75 g pour le riz
4 coings moyens (1,5 kg) pelés, évidés et détaillés en quartiers
1 lanière de 10 cm de zeste de citron
1 c. à s. de jus de citron
1 petit bâton de cannelle coupé en deux
100 g de riz
680 ml de lait
300 ml de crème fraîche
1 c. à c. d'extrait de vanille
75 g d'amandes caramélisées grossièrement broyées

1 Mélangez l'eau et le sucre dans une grande casserole, laissez chauffer
à feu doux sans faire bouillir pour que le sucre fonde puis portez à
ébullition. Ajoutez alors les coings, le zeste et le jus de citron, et la
moitié de la cannelle. Laissez cuire à feu très doux pendant 2 heures
au moins pour que les coings soient parfaitement tendres.

2 Préchauffez le four à 150 °C.

3 Rincez le riz à l'eau froide jusqu'à ce que cette dernière soit très claire.
Mettez-le ensuite dans un plat avec le lait, la crème, le reste du sucre,
l'extrait de vanille et l'autre moitié de la cannelle. Faites cuire 2 heures
au four sans couvrir, en remuant toutes les 30 minutes.

4 Servez le riz tiède avec les coings pochés et les amandes caramélisées.

Carrés de semoule

Pour 28 carrés
Préparation 15 minutes • Réfrigération 3 heures • Cuisson 1 h 50

1 kg de semoule moyenne
550 g de sucre en poudre
250 ml de lait
125 g de beurre
40 g d'amandes mondées

Sirop de sucre
750 ml d'eau
2 c. à c. de jus de citron
330 g de sucre en poudre
2 c. à c. d'eau de fleur d'oranger

1 Pour préparer le sirop, faites dissoudre à feu doux le sucre dans l'eau et le jus de citron. Portez ensuite à ébullition et laissez épaissir 20 minutes. Quand le mélange est tiède, ajoutez l'eau de fleur d'oranger. Réfrigérez au moins 3 heures. Pour ramener le sirop à température ambiante, sortez-le au moment où vous enfournez le gâteau.

2 Préchauffez le four à 160 °C. Beurrez un grand moule rectangulaire (20 x 30 cm). Mélangez la semoule et le sucre dans un saladier. Faites fondre le beurre dans le lait et versez ce liquide sur la semoule. Remuez bien.

3 Étalez la pâte dans le moule et lissez la surface avec une spatule souple. Dessinez des carrés de 4 cm de côté avec la pointe d'un couteau et déposez 1 amande au centre de chaque carré. Enfournez et laissez cuire 1 h 20 sans couvrir.

4 Découpez les carrés pour former des gâteaux individuels et nappez-les de sirop quand ils sont encore chauds. Vous devrez procéder en plusieurs fois pour qu'ils en soient bien imbibés. Laissez-les tiédir dans le moule.

Prunes pochées
et crème glacée aux amandes

Pour 4 personnes
Préparation 20 minutes • Cuisson 40 minutes • Congélation 4 heures

500 ml d'eau
250 ml de jus d'orange
110 g de sucre en poudre
1 petit bâton de cannelle
4 prunes (450 g) dénoyautées et coupées en deux

Crème glacée aux amandes
500 ml d'eau
70 g d'amandes effilées grillées
1 gousse de vanille
300 ml de crème fraîche
165 g de sucre en poudre
6 jaunes d'œufs

1 Pour préparer la crème glacée, commencez par mixer les amandes avec
 l'eau. Filtrez ensuite ce jus dans une étamine. Versez le liquide récupéré
 dans une casserole, ajoutez la gousse de vanille fendue en deux
 (grattez-la un peu pour en détacher les graines), la crème et 55 g
 de sucre. Après l'ébullition, laissez infuser 30 minutes hors du feu.

2 Faites blanchir les jaunes d'œufs et le reste du sucre dans un saladier,
 versez progressivement le lait d'amande (sans la gousse de vanille) puis
 transférez ce mélange dans la casserole pour le faire épaissir quelques
 minutes à feu doux. Étalez cette crème dans un moule en métal tapissé
 de papier sulfurisé, couvrez d'une feuille d'aluminium et faites prendre
 4 heures au congélateur.

3 Pour préparer les prunes, faites d'abord dissoudre le sucre à feu doux
 dans l'eau et le jus d'orange. Ajoutez la cannelle et les prunes, laissez
 frémir 30 minutes. Quand les fruits sont tendres, sortez-les du sirop et
 pelez-les. Faites épaissir le sirop à petits bouillons pendant 10 minutes,
 faites-le tiédir un peu puis mettez-le au moins 2 heures au réfrigérateur.

4 Pour servir, coupez la crème glacée en quatre tranches, une par assiette,
 et garnissez-la de prunes pochées. Nappez de sirop et dégustez sans
 attendre.

Thé glacé au citron

Pour 2,5 litres
Préparation 5 minutes • Cuisson 5 minutes

1 litre d'eau
4 sachets de thé
1 petit bâton de cannelle
2 gousses de cardamome
4 clous de girofle
220 g de sucre en poudre
125 ml de jus de citron frais
500 ml de jus d'orange frais
1 citron moyen (140 g) en tranches fines
1 poignée de menthe fraîche grossièrement ciselée
1 litre d'eau minérale
des glaçons

1 Portez l'eau à ébullition dans une casserole avant
 d'y plonger les sachets de thé, les épices et le sucre.
 Remuez à feu doux pendant 3 minutes, jusqu'à
 dissolution du sucre. Retirez les sachets de thé
 et réfrigérez le liquide.

2 Quand le thé est glacé, passez-le dans un tamis
 pour éliminer les épices, mettez-le dans une carafe
 avec l'eau minérale, les jus d'orange et de citron,
 les tranches de citron et la menthe. Juste avant de
 servir, ajoutez les glaçons.

Thé glacé à la menthe

Pour 1 litre
Préparation 10 minutes

1 litre d'eau chaude
3 sachets de thé
6 poignées de menthe fraîche
2 c. à s. de sucre en poudre
1 douzaine de glaçons

1 Dans un saladier, faites infuser le thé 10 minutes
 dans l'eau chaude avec 4 poignées de menthe et
 le sucre en poudre. Jetez les sachets et réfrigérez
 le thé.

2 Quand il est glacé, retirez les feuilles de menthe
 pour ajouter les feuilles plus fraîches ainsi que
 les glaçons. Servez sans attendre.

Glossaire

Badiane
Gousse sèche en forme d'étoile, dont les graines libèrent un arôme et une saveur astringente d'anis. On s'en sert pour parfumer les bouillons et les marinades.

Boulgour
Il s'agit de blé séché puis écrasé en grains de différentes grosseurs.

Cardamome
On trouve cette épice sous forme de gousses, de graines ou de poudre. Elle a une saveur douce et profonde.

Carvi
De la famille du persil, le carvi a une saveur aromatique prononcée. Originaire de l'Europe et du Moyen-Orient, il se vend sous forme de graines ou en poudre. On l'utilise dans les plats sucrés et salés.

Citrons confits
Spécialité d'Afrique du Nord, ces citrons sont conservés plusieurs mois dans un mélange de sel et de jus de citron ou d'huile. Pour les utiliser, on en retire la chair et la partie blanche pour ne conserver que le zeste, que l'on rince avant de l'émincer.

Coquelet
Petite volaille n'ayant pas dépassé 6 semaines d'âge et pesant environ 500 g.

Coriandre
Parfois appelé persil chinois ou persil arabe, cet aromate est d'un vert intense et possède un goût et une saveur à la fois puissants et délicats. Ses graines séchées sont vendues entières ou moulues, mais elles ont toujours un goût différent de celui de la feuille fraîche.

Cumin
Il s'agit de la graine séchée d'une plante de la famille du persil. Elle a une saveur épicée, qui rappelle le curry. On la trouve également sous forme moulue. Les graines de cumin noir sont plus petites que celles du cumin standard, et d'un brun profond plutôt que véritablement noir. On les confond souvent avec les graines de nigelle.

Curcuma
Ce rhizome appartient à la famille du galanga et du gingembre. Il faut le râper ou l'écraser pour qu'il libère sa saveur acide et piquante. On l'utilise surtout pour sa couleur d'un jaune soutenu. Si vous ne pouvez vous en procurer du frais, remplacez-le par 2 cuillerées à café de curcuma en poudre et 1 cuillerée à café de sucre pour 20 g de racine.

Eau de fleur d'oranger
Essence concentrée obtenue à partir de fleurs d'oranger. On la trouve fréquemment au rayon pâtisserie des supermarchés, ainsi que dans les épiceries grecques et moyen-orientales.

Feta
Fromage de chèvre ou de brebis d'origine grecque, à la texture friable et au goût piquant et salé.

Ficelle de cuisine
Habituellement confectionnée de matériaux naturels tels que le coton ou le chanvre de manière à ne pas fondre ou altérer la saveur durant la cuisson, cette ficelle permet de trousser les volailles ou de fermer des papillotes.

Gingembre
Ce rhizome noueux et épais provient d'une plante tropicale. Il se conserve au réfrigérateur, pelé et mariné dans du vin blanc, et peut se congeler dans un récipient hermétique. Le gingembre en poudre s'emploie sec pour aromatiser les gâteaux, les tartes et les crèmes, mais ne constitue pas un substitut approprié au gingembre frais.

Gombo
Il s'agit d'une gousse côtelée et verte de forme oblongue, à la peau velue. Originaire d'Afrique, on emploie aussi ce légume dans les cuisines de l'Inde, du Moyen-Orient et de l'Amérique du Sud. Il se consomme seul, en ragoût, ou peut faire office d'épaississant dans certaines sauces.

Harissa
Cette pâte d'épices typique de la cuisine du Maghreb est composée de piments rouges séchés, d'ail, d'huile d'olive et de graines de carvi. On la sert avec le couscous (délayez-la dans le jus des légumes avant de la verser sur votre assiette car elle est très piquante) mais on l'utilise aussi dans les sauces ou les tajines. On la trouve en boîte ou en tube dans la plupart des grandes surfaces.

Marjolaine
Cette herbe aromatique de la famille de la menthe comporte des longues feuilles ovales et minces, dont la saveur rappelle celle de l'origan.

Moutarde (graines)
Noires Les graines de moutarde noires sont plus âcres que la variété blanche ; on s'en sert dans les currys et les sauces épicées.
Blanches Ce sont ces graines que l'on utilise pour préparer la plupart des moutardes.

Muscade

Il s'agit de la noix sèche d'un arbre à feuilles persistantes originaire de l'Indonésie. On la pulvérise habituellement avec une petite râpe pour obtenir une saveur plus intense que les versions moulues du commerce.

Nigelle

Ces grains noirs piriformes de petite taille confèrent aux plats une saveur un peu aigre.

Origan

La tige ligneuse de cet aromate aussi appelé marjolaine sauvage porte des grappes de petites feuilles d'un vert sombre, à la saveur marquée et légèrement poivrée. On l'utilise fraîche ou séchée.

Pain pita

Il s'agit d'un pain en forme de petite poche, que l'on trouve dans les épiceries fines et les supermarchés.

Paprika

Cette poudre à base de poivron rouge séché et pilé se vend sous de multiples formes et divers degrés d'intensité : doux, piquant, fumé, etc.

Pâte à brick

Pâte feuilletée aux couches extrêmement fines que l'on peut acheter fraîche ou surgelée.

Pâtisson

Membre de la famille des courges, le pâtisson, de couleur vert pâle à jaune vif, a un rebord dentelé et une forme légèrement aplatie. Quand on le récolte jeune, sa chair est ferme et blanche.

Pignons

Il s'agit des amandes qui se développent dans le cône de différents types de pins. Ces petites graines de couleur crème sont meilleures quand on les fait griller à sec avant de les utiliser.

Piments

Il en existe plusieurs variétés, de goûts et de formes différents. Munissez-vous de gants de caoutchouc pour les égrener et les émincer car ils peuvent irriter la peau. Retirez les graines et les membranes intérieures si vous voulez en atténuer un peu la chaleur.

Piment de la Jamaïque On le trouve entier (c'est une baie d'un brun foncé de la taille d'un pois) ou moulu. Sa saveur rappelle un mélange de noix de muscade, de cumin, de clou de girofle et de cannelle. On s'en sert dans les plats salés et sucrés.

Pistaches

Ces noix vertes à la saveur délicate s'entourent d'une coque bivalve blanche et dure. On les trouve dans le commerce fraîches ou salées, avec ou sans coquille.

Safran

Stigmates d'une plante de la famille des crocus, il se vend sous forme de filaments ou de poudre. Il confère une couleur jaune orangé aux plats. Les safrans de grande qualité sont parmi les épices les plus chères du monde.

Sumac

Cette épice astringente d'un brun rouge provient des baies d'un buisson qui fleurit sur le pourtour de la Méditerranée. Elle apporte une note acidulée, rappelant un peu le citron, aux assaisonnements, sauces d'accompagnements et grillades. On la trouve dans les épiceries moyen-orientales et la plupart des supermarchés.

Tahini

On se procure cette pâte de graines de sésame dans les épiceries moyen-orientales, les magasins de diététique et certains supermarchés.

Vanille

Gousse C'est une longue gousse séchée, que l'on récolte sur une orchidée croissant en Amérique centrale, en Amérique du Sud et à Tahiti. On se sert des minuscules graines qu'elle renferme pour aromatiser les desserts et les crèmes.

Extrait S'obtient à partir de gousses de vanille qui ont été infusées dans de l'alcool.

Vinaigre balsamique

Il s'agit d'un vinaigre tiré d'un vin local italien de cépage Trebbiano, qui subit un procédé spécial avant d'être laissé à vieillir, dans le meilleur des cas, jusqu'à 25 ans dans de vieux fûts de bois, ce qui lui confère une délicieuse saveur sucrée et acide. On en trouve cependant désormais de toutes provenances et de toutes qualités dans le commerce.

Za'atar

Ce mélange odorant se compose de graines de sésame entières grillées, de sumac et de divers aromates séchés, tels que la marjolaine et le thym. On le trouve dans les épiceries moyen-orientales et dans certaines boutiques de gourmets.

Table des recettes

maraboutchef

réussite garantie • recettes testées 3 fois

Vous avez choisi "Tajines, couscous…", découvrez également :

Et aussi :

ENTRES AMIS
Apéros

RAPIDES
Recettes au micro-ondes
Recettes de filles
Salades pour changer

CUISINE DU MONDE
Spécial Wok
Cuisine thai pour débutants
Recettes chinoises
Sushis et cie
A l'italienne
Cuisiner grec

CLASSIQUES
Pain maison
Grandes salades
Recettes de famille
Spécial pommes de terre
Pasta
Tartes, tourtes et Cie

PRATIQUE
Recettes pour bébé
Cuisiner pour les petits

SANTÉ
Desserts tout légers
Cuisine bio
Recettes Detox
Recettes rapides et légères
Recettes pour diabétiques
Recettes anti-cholestérol
Recettes minceur
Recettes bien-être
Tofu, soja et Cie
Recettes végétariennes

GOURMANDISES
Les meilleurs desserts
Tout chocolat…

Traduction et adaptation de l'anglais par : Gilles Mourier et Élisabeth Boyer
Packaging : Domino / Relecture : Jean-Pierre Leblan

Marabout - 43, quai de Grenelle – 75905 Paris CEDEX 15

Publié pour la première fois en Australie
en 2006 sous le titre : "Morocco and the foods of North Africa"
© 2006 ACP Publishing Pty Limited.
Photos de 2e et 3e de couverture et page 1 : © Frédéric Lucano, stylisme : Sonia Lucano
© 2006 Marabout pour la traduction et l'adaptation.